FULL FRAME

PHOTOGRAPHY ESSENTIALS

FULL FRAME

DAVID NOTON

D&C
David and Charles

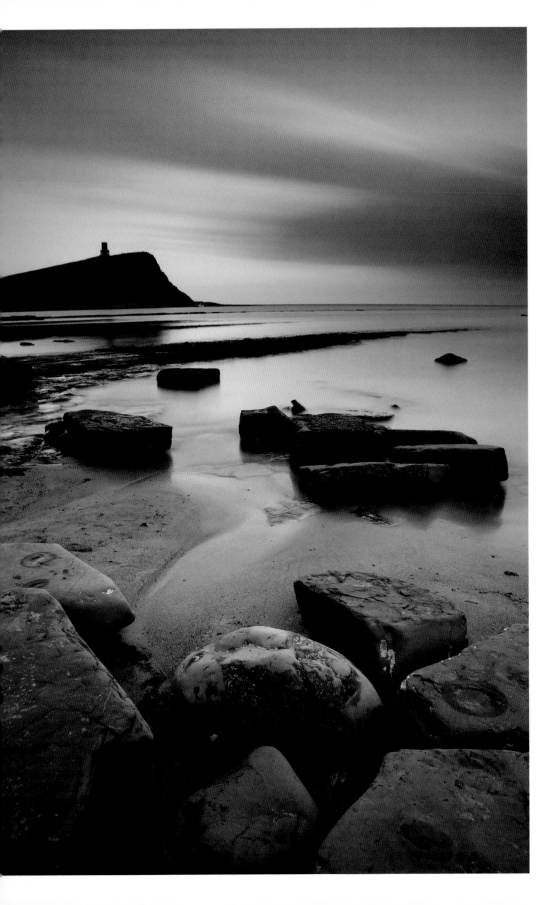

For Susan Noton,
my mother, and Michael
Hatcher, Wendy's father.
If only they could have seen
how it all worked out.

A DAVID & CHARLES BOOK
Copyright © David & Charles Limited 2010

David & Charles is an F+W Media Inc. company
4700 East Galbraith Road
Cincinnati, OH 45236

First published in 2010
Reprinted 2011

David Noton has asserted his right to be identified as author
of this work in accordance with the Copyright, Designs and
Patents Act, 1988.

A catalogue record for this book is available from the British
Library.

ISBN-13: 978-0-7153-3614-4 hardback

ISBN-13: 978-0-7153-3615-1 paperback

Printed in China by RR Donnelley
for David & Charles
Brunel House, Newton Abbot, Devon

Commissioning Editor: Neil Baber
Editor: Sarah Callard
Senior Designer: Jodie Lystor
Production Controller: Beverley Richardson

David & Charles publish high quality
books on a wide range of subjects.
For more great book ideas visit:
www.rubooks.co.uk

Contents

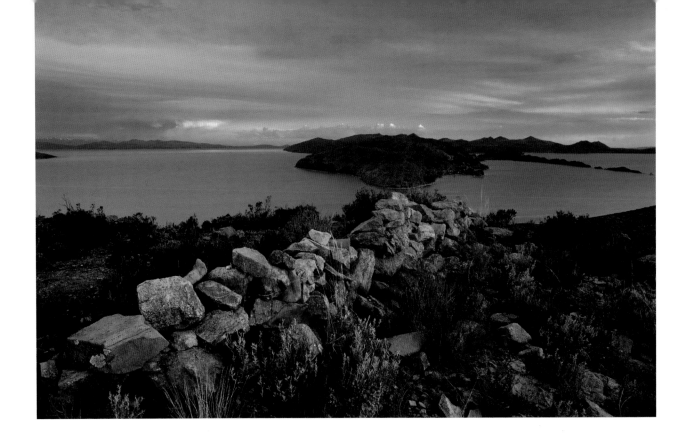

Introduction

The light is to die for; crystal clear, golden and pure at this altitude. It feels like all of South America is spread out below; Lake Titicaca sparkles, the altiplano stretches away to the south, and the snowy mass of the Andes rears up to the east as the sun sets over Peru.

Finally, after all the planning and travelling we're here, on a hill top on the Isla del Sol, behind the camera, composing, exposing, doing the job. It's the start of our Bolivian adventure, and ahead of us lie weeks of dusty travelling and photographic opportunities that will no doubt both inspire and test our resolve. As the light dips below the horizon I stand back and contemplate the scene. These special moments of photographic satisfaction are so transitory. It's the beginning of the end, the last trip for *Full Frame*, a project that has taken us around the world in search of photographic enlightenment and fulfilment. I don't want it to end.

Ten journeys in search of the ten *Full Frame* challenges were spawned by a photographic mid-life crisis and a list scribbled on the back of an envelope on a summer's evening in the garden. It was 2008 and my first book *Waiting for the Light* with accompanying exhibition seemed to be going down well. It was all grown up stuff, a bit bewildering quite frankly but all very satisfying. Inside my head, however, a mental worm was turning and whispering: what next?

I give myself a hard time. Someone's got to. Now and then it's necessary to take a step back and have a long hard look at my photography. Is it any good? How does it compare with the stuff I was doing ten years ago? Bettter? Worse? Different? This may be self indulgent navel gazing – the result of which isn't exactly going to cause the world to spin off its axis – but if I'm to continue evolving as a photographer I need to know.

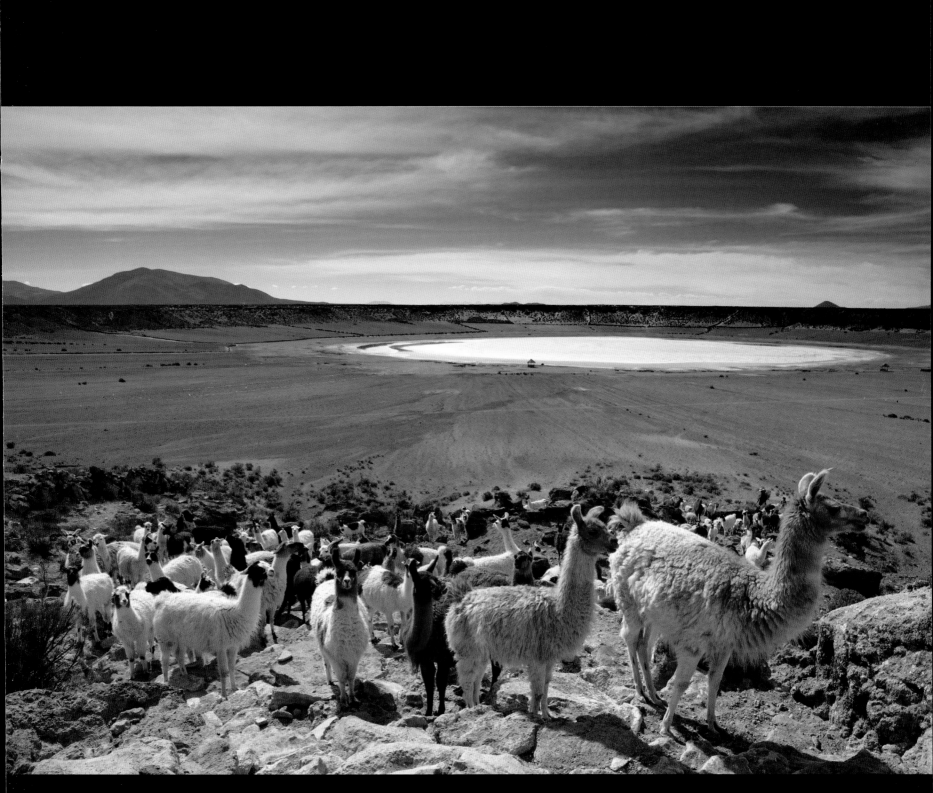

Of course, objectively assessing our own work is Mission Impossible for all of us, but it's got to be done if we're to keep improving as photographers. The trouble is it is so easy to settle into a routine built on the safe bedrock of past successes. We start working, looking and thinking in a certain pre-conceived way that produces predictable results. Experience is a great asset, no doubt about it, and if it works, don't fix it. But without evolution our photography stagnates, and all the pictures start to look the same.

Full Frame is all about that evolution. How a photographer keeps improving is the core theme, and that is a key question for all of us who have discovered that The Meaning of Life is contained on a memory card in the back of a camera.

A few days later we're bouncing and jolting down barely traceable tracks across the altiplano, deep into Bolivia's remote and sparsely populated south west. We stop seemingly in the middle of nowhere, our guide wants to show us something. We wander away from the 4x4 and suddenly the arid land drops away; before us lays a huge volcanic crater, with a herd of llamas grazing in the bottom.

It's a fabulous view, all the more impressive for its unexpectedness. As I'm rummaging in my camera bag I'm aware the herd is being driven up the escarpment towards us, life just keeps getting better. This is the sort of unpredictable situation that we hoped for; this is the adventure of South America in a nutshell. And adventure is one of the key ingredients that drives my photography forward.

It started in Morocco, in search of exotic colour, both literally and figuratively. Bali tested my single mindedness. South Africa was a journey out of the comfort zone to tackle a whole new genre. Laos seemed a write-off before inspiring and changing the whole way I approach a trip.

Working my own back yard in Dorset was a test to see beyond the familiarity. Umbria has been an evolving deep and meaningful relationship. Provence inspired as it has countless generations of artists. Snowdonia took me back to basics, and Canada, well you shoot best what you love most, enough said?

And now Bolivia is providing a shot in the arm of adventure. Each trip presented totally different environments, opportunities and challenges. What started as a fairly nebulous concept in Morocco gained momentum with each subsequent trip until here in Bolivia I believe fervently in the relevance of the message to all photographers and travellers: how do we keep evolving?

One hundred pictures is the end result, with the story from behind the lens of each triumph and disappointment. For every image there's the history of its birth and a hard kernel of practical photographic advice. Each trip represents a challenge, and each image represents how that challenge was met. Beyond the impact of all the disparate destinations, fresh techniques and technical challenges kept Noton's Theory of Evolution bowling along.

Shooting wildlife with unfeasibly long lenses, exposing for infra red, stitching panoramas, travel portraiture with super-fast optics and merging exposures to control contrast all kept my mind whirring as I endeavoured to get my head around it all.

The flexibility of modern digital cameras has opened up a whole New World of photographic opportunities; we can make pictures and react to situations now that would not have been possible in the film era. It is a great time to be a photographer. Deploying that flexibility and capability in Vang Vieng, Jasper, the Kruger, Marrakesh and on the Cote d'Azur has been exhilarating. It's also been fun, a word that just keeps cropping up throughout. And that really is what *Full Frame* is all about.

David Noton

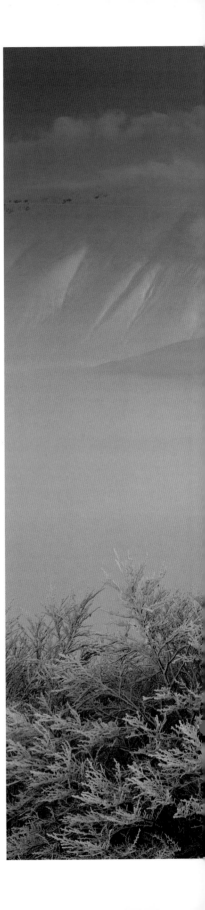

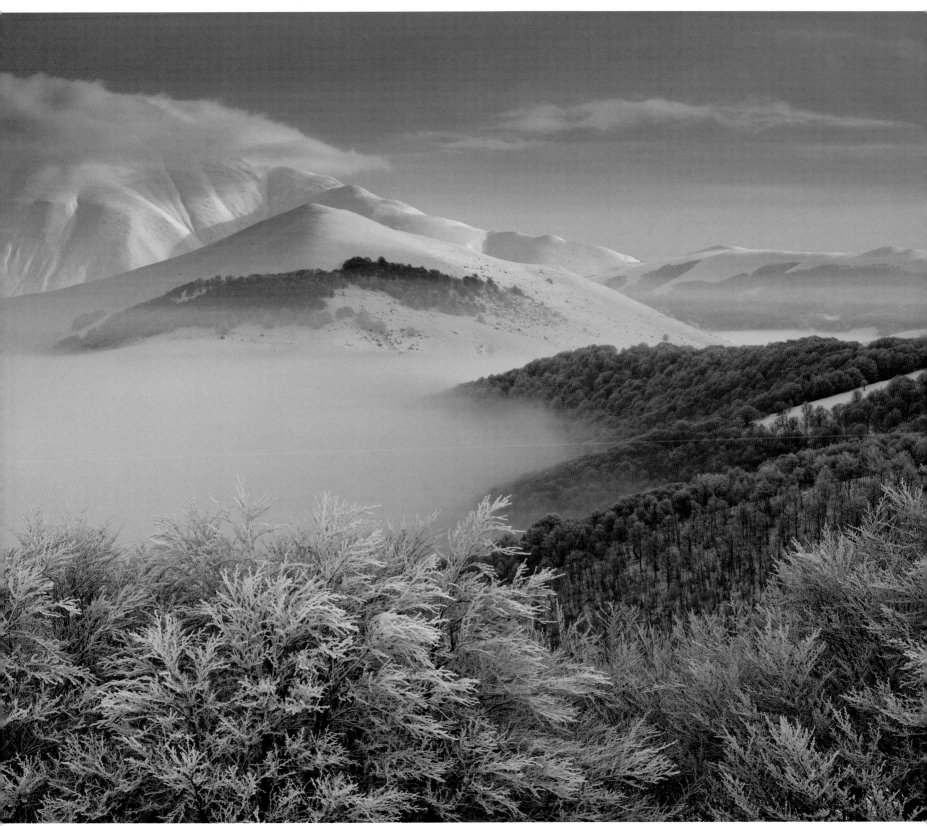

Morocco
1.Colour

It's the first morning out on patrol and Morocco seems so colourful and exotic. When I first arrive somewhere new everything is fresh and unfamiliar. Even after a lifetime of travel the culture shock can still be daunting but this is a golden time, as all the visual novelties of a new destination stand out in vivid relief. The longer I stay, the more comfortable I get and the more the icons become the norm until I stop even noticing them. It's that fresh visual stimulus that I love about travel – the rebooting of my photographic vision. I respect photographers and artists who stick with one subject in a lifetime's exploration of its creative possibilities, but that's not for me – I think I'd stagnate. I need the shot in the arm of new and exciting destinations.

Coming from the muted hues of England in winter to vibrant Morocco assaults the senses. Blue-walled towns, tanneries, bustling markets full of bright textiles, tajines, riads, lemons, souks, goats in trees, mosques, Berbers … We've only come over the water from Spain but Europe already seems a world away. This is definitely Africa and the sights, sounds and smells are intoxicating. I can't wait to start exploring the photographic potential with rejuvenated eyes. This is why I travel – for this buzz – but it's not just about the visual appeal. Every trip throws up a different set of possibilities, pitfalls and challenges. The potential is huge, but Morocco will not be an easy place to work in. I will need to evolve a working practice here that suits the environment, as I do with every trip. The name of the game is constant evolution, and that's what this book is all about.

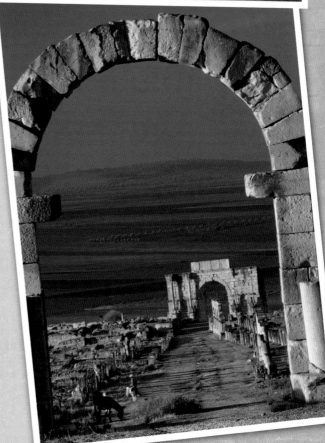

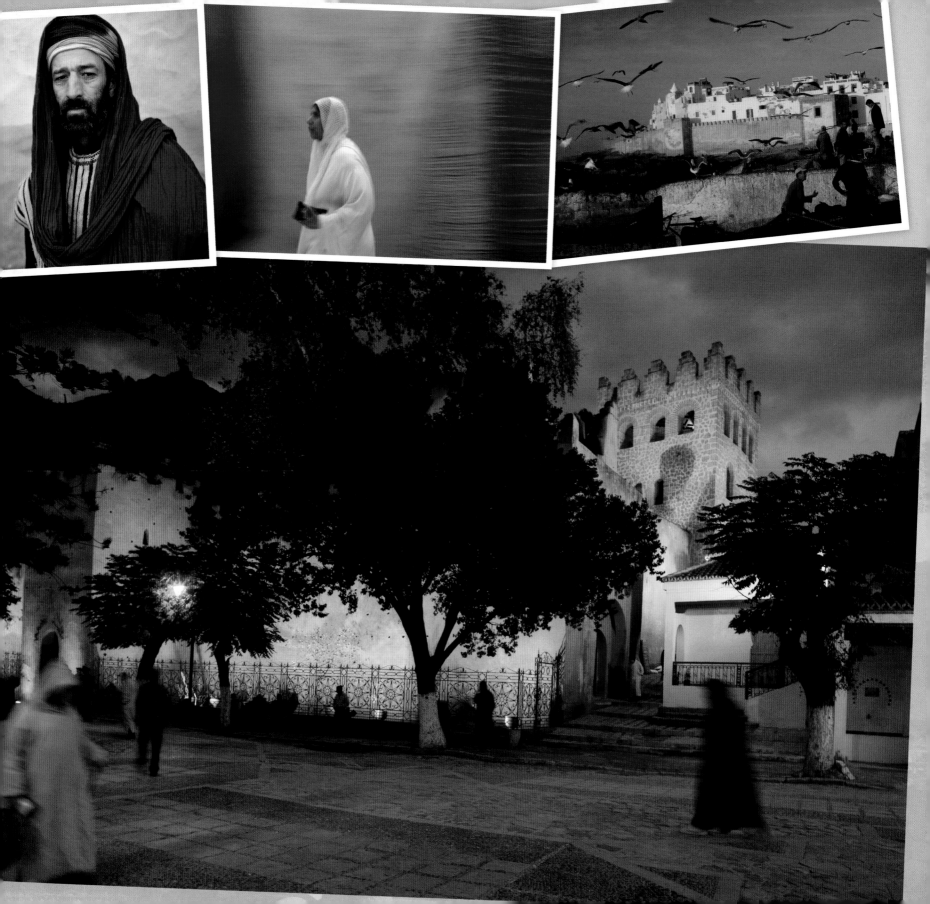

MOROCCO 1/12 – THE LAUNDRY RUN

BEFORE Chefchaouen in northern Morocco is a town so obviously built for the prime function of providing visual stimulation to photographers jaded by the grey streets of northern Europe. The town's narrow streets, stone walls, doorways, archways and dwellings are all built in the distinctive Moorish architectural style and then daubed in the most beautiful tone of sky blue. We came to Morocco for colour and here it is.

I'm prowling the blue alleys on a winter's morning revelling in the light. There is one issue that has become very clear to me though – the people here don't like being photographed. This will be my biggest challenge and I will have to find a way to work around the problem. I never trample over cultural sensitivities in search of The Shot, but at the same time, as a photographer ,I have to make pictures happen. I'm adopting two approaches here to get around the locals' hostility to my lens. First there's the 'reportage' approach, showing people in their environment going about their daily business. In this case it's all about bold shapes and colour and, to avoid too much antagonism, I'm not showing people's faces; they are just figures in the townscape in motion. The second approach is the 'engage and ask' method, i.e. spotting a likely looking subject, establishing contact and then after a decent interval seeking permission for a set-piece portrait. I used to struggle with this and one rebuff would set me back all day but after more than 20 years I've developed a thicker hide.

DURING I have to admit I do feel a bit furtive lurking in this alleyway. I have the 24–70mm lens bolted on at 50mm – it is my most used lens. An ISO of 200 gives a usable hand-held exposure. After a lengthy vigil, a lady walks past on her way to the communal laundry dressed from head to toe in pale yellowy-orange; colours that contrast pleasingly with the blue of the walls and doorway. I wait until she reaches the perfect position before squeezing off a frame. I hang around a bit longer. With that beautiful doorway, it's such a good spot I want to see if there is more to be had here, but already I know that exposure was The One.

AFTER I cropped a bit of the confusing detail out of the top of this shot, making a letterbox-shaped image. Generally I don't crop, as I think it's good discipline to compose using the whole image area, but the dead tones and confusing details at the top and bottom of the frame added nothing to the shot. Otherwise it's a straight shot with no filters or fancy post-production. If in doubt, keep it simple.

A woman with her washing
*Chefchaouen, Morocco
Canon EOS-1Ds MKII,
24-70mm lens, ISO 200,
1/100sec at f/8*

Portrait of a metalworker
*Chefchaouen, Morocco
Canon EOS-1Ds MKII, 85mm
lens, ISO 800, 1/100sec
at f/1.2*

MOROCCO 2/12 – THE METALWORKER

BEFORE In a tiny workshop off an alleyway in Chefchaouen, a metalworker is hunched over a plate, meticulously banging out a design. There's hardly any room but we're straight in there with Wendy inspecting his craftsmanship while I eye up the photographic potential. I often like to rove on my own but equally it is so useful to have Wendy with me to distract people from the intimidating presence of the camera. She is genuinely interested in local crafts and this helps to establish a fleeting rapport. We often end up buying things we don't need to aid my prospects before the inevitable request for photography, but I feel this is a much better way to work than an ugly pay-to-shoot transaction. This way we support their craft and self-esteem and, crucially, I get the opportunity and time to weigh-up and execute the shot I want. But there's a limit to how many intricate plates and other ethnic art that we can cram into our house, isn't there? Apparently not.

DURING Inside the workshop it's like the Black Hole of Calcutta. Do I try and go wide to utilize the ambience of the space or go tight on his hands as he hammers out his design? As he demonstrates for Wendy, I try both unsuccessfully; it's just too cluttered. It would be easy now to give up and walk away – most situations don't come together photographically as I want but then most situations need working to extract their potential, whether landscapes, reportage, portraits or wildlife. I switch from a wide-angle 16–35mm to a super-fast 85mm f/1.2 lens wide open and focus on his face. Engrossed in closing the sale with Wendy he seems oblivious to the camera. The courtyard outside is in open shade and diffuse light is filtering through the door. I move around so the doorway supplies pleasing side lighting on his face and capture a compelling portrait.

AFTER Travel portraiture is not easy – not only do you have to make the most of chance encounters, you also have to use whatever light is available, which you have no control over. Just consider the skill and attention to detail that a photographer in a commercial studio brings to bear on lighting a bride's face. The most appealing light for a portrait is a wide, diffuse side or three-quarter illumination such as a studio flash head with a wide softbox provides. This can then be supplemented by other key lights and/or reflectors. This kind of set-up just isn't conceivable in an artisan's cubby hole in Chefchaouen. But that diffuse light can be replicated by a window or door, as long as harsh sunlight isn't beaming straight in. The first thing to do in a situation like this is to analyse the light. Where is it coming from? How soft or hard is it? There are so many variables to consider – a photographer never stops learning about light … or acquiring plates.

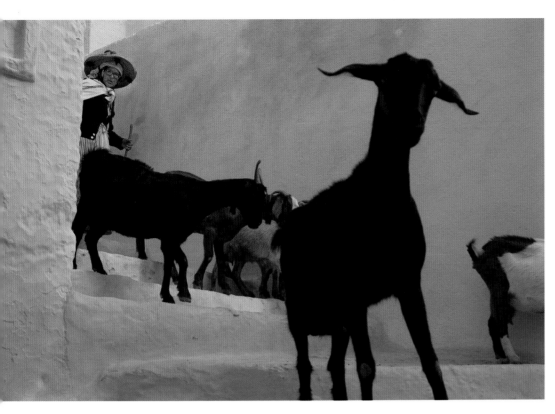

Goat herder and her flock
Chefchaouen, Morocco
Canon EOS-1Ds MKII,
24–70mm lens, ISO 400,
1/125sec at f/8

MOROCCO 3/12 – FURTIVE GOAT HERDER

BEFORE I'm lurking in a doorway, waiting for something to happen. I can hear bells approaching. It's a herd of goats being driven through the blue lanes of the town. I pick my spot at the bottom of some steps with a clean background and wait. I've got the 24–70mm lens on, that versatile glass that I'd never be without. Typically on a shoot like this I carry a full-frame body with the 16–35mm, 24–70mm and 70–200mm lenses, all relatively fast at f/2.8 maximum aperture. With this spread I'm covered for most eventualities. In an environment like Morocco I usually pack the 85mm f/1.2 as well, in case of portrait opportunities, and sometimes a 14mm super-wide or 15mm fisheye. It is tempting to carry too much, but a bulky bag only holds me back. In cramped alleys and busy markets I need to be mobile. When events unfold I don't want to be caught changing lenses and fiddling with filter rings. For a reportage shoot like this, the tripod is left back in the riad. A sturdy tripod is one of the most important pieces of kit a photographer will own, but when working quickly it's just an inconvenient burden. Once the set-piece, previsualized

dawn shoot is done, the legs go back to bed and I'm a roving opportunist. At least that's how it is here – every trip is different as I evolve my working practices to suit the situation.

DURING I am poised at the foot of the steps as the clanking of bells gets louder. The first goat rounds the corner and stops, peering indignantly at me. I fire off a frame but the camera remains glued to my eye. The composition looks good with the stark black shape of the goat against the blue wall, but where's the shepherdess? She appears fleetingly, spots me and instantly retreats, but not before I've exposed one frame. Women here definitely do not like being photographed.

AFTER It's two years on from that Moroccan trip, the first for Full Frame. I've just chosen the 12 pictures from that trip for this book and it was a simple decision; the best ones instantly jumped out at me. If only the editing process was always so easy. Choosing the best isn't simple; there's usually too much emotion, time and sweat invested in each picture to be wholly subjective about it. If I've spent days working on one image I want to believe it's a winner, even if all the evidence and the rest of the world suggests otherwise. These days I often have to select a few images to be sent back from the field for the website or newsletters within hours of shooting, and it's incredibly difficult to choose. But with the passage of time it gets easier to be ruthless. Maybe I should wait a year before editing all my shoots?

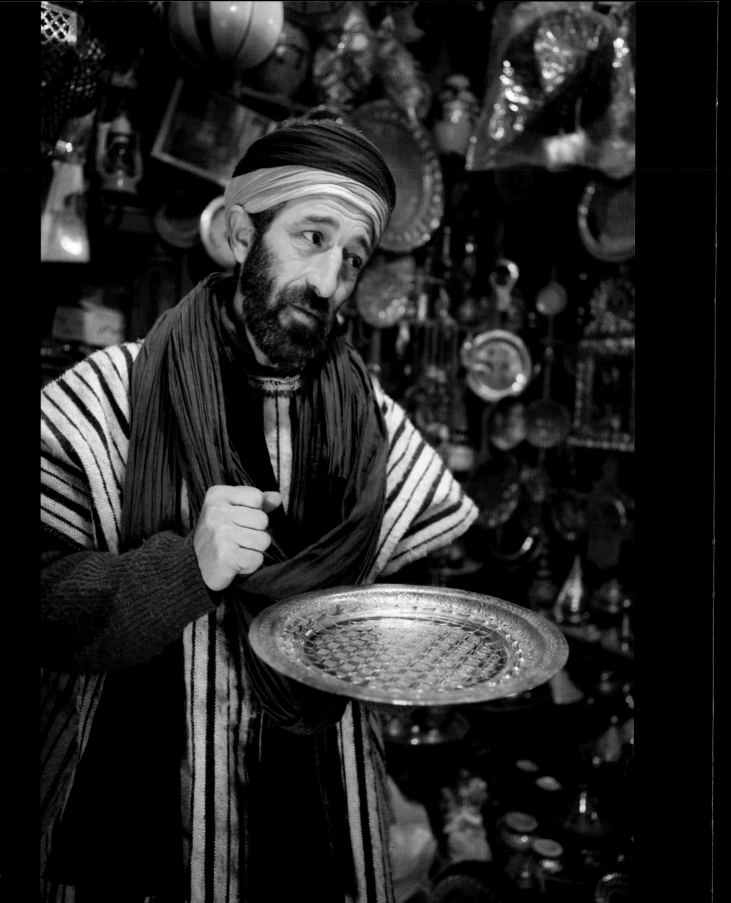

A trader displaying his wares
Chefchaouen, Morocco
Canon EOS-1Ds MKII,
24–70mm lens, ISO 1600,
1/40sec at f/2.8

16 Morocco/Colour

MOROCCO 4/12 – THE SALESMAN

BEFORE He could sell coals to Newcastle, camels to Egypt or barbecues to Australia. He is currently in full flow with his sales pitch to Wendy. He claims to be Tuareg, as they all do – it makes them appear more exotic. He's complimenting Wendy on negotiating like a Berber woman while trying to fleece her blind. We'll become well used to this ruse. And Wendy is feigning interest in yet another plate …

DURING The light is horrible, with a mix of tungsten and daylight sources giving a fairly unappealing ambience. As I shoot, I know this will not be the best picture I've ever taken, but he is just so typical of the Moroccan hard sell that I have to. Despite the mixed lighting I keep the camera's White Balance (WB) set to Daylight. I could use Auto WB but, as I'm shooting RAW, all that will affect is the display on the monitor and the colour temperature at which the RAW image will be imported into my conversion software (Capture One). Generally I prefer to leave the camera's WB setting to Daylight and leave any colour balance adjustments to the RAW conversion stage where I'll have far finer control.

AFTER Wendy did buy the plate. It's now acting as a coffee table in our lounge.

Road to Marrakech

We arrive in the dark after the long journey from Andalusia. Actually the physical distance isn't far, one that you could eat up on a lonely French autoroute in few hours, but that's not reckoning on the ferry across the Straits of Gibraltar and an African border crossing. Bringing our motor into Morocco is an adventure but the paperwork needed to leave from Ceuta, a Spanish enclave in North Africa, is daunting. One thing that winds me up more then anything else on our travels is dealing with petty officialdom and here it is chaos, with a mass of people and cars all queue jumping while vying to gain the attention of aloof officials in various cubicles. I have to keep reminding myself that this is Africa.

On this adventure we've teamed up with Dave Waterman, my former mentor. Many years ago when I was a photography student in Gloucester, I knocked on Dave's studio door and during the summer of 1983 carried his bags and pestered him with questions. In the latest twist of his long and varied career he now runs photographic safaris to Morocco from his base in Andalusia, so we're blatantly using his local knowledge for our own ends on this jaunt. We've got two weeks to roam around Morocco in his 4x4, listening to Frank Sinatra and George Formby. Hmm. Even given Dave's musical foibles its not enough time - it never is. Thankfully Dave's an old hand at this and none of it fazes him. Just as we proceed with a sheaf of stamped papers through customs, our last hurdle, we notice a flat tyre. So in amongst all the hooting and mayhem, Dave and I are down in the dust, changing the wheel. Hot, sweaty and covered in grime, we finally enter Morocco.

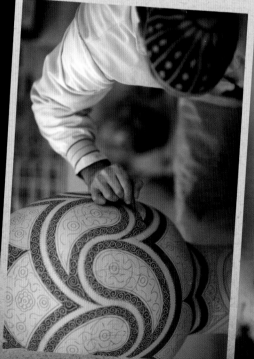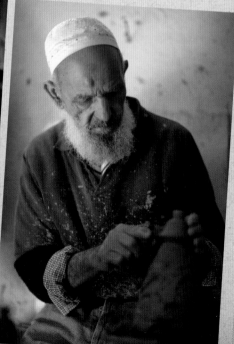

MOROCCO 5/12 – HOODY AT SPEED

BEFORE I'm pacing the alleys again, on the hunt. It's early in the trip and I'm anxious to get a good momentum going. So much of this game is about what is going on in the head. When a trip is going well, with good situations evolving and I'm working at my best, there's nothing like it, it's photographic heaven. But this state of nirvana only comes about if I relentlessly keep pushing to make the most of every photographic opportunity, never walking on by, constantly honing and improving on what I've already shot. It takes time and energy – lots of it. Think you can mix photography with a relaxing family holiday? Forget it! As soon as I arrived and saw these blue alleys I had it in my head to make an image using motion blur with the wonderfully textured walls as a backdrop. It's always best to head out on a photographic mission with a specific idea in mind.

DURING Mid afternoon and I'm lurking again. As people walk past this side-alley entrance I'm experimenting with panning the camera using slow exposures against the blue wall. Backgrounds are so important. As a general rule, it's best to keep them simple – unwanted clutter always ruins compositions. A good backdrop can make an image, and in this case the combination of the motion blur and the enticing tones in the wall combine to make a simple, evocative image. I spend a good hour working on it, experimenting with different shutter speeds, dealing with the odd street urchin and suspicious glance. An exposure of 1/8sec seems to do the trick here, but of course the amount of motion blur desirable is purely subjective.

AFTER What shutter speed you use to create pleasing motion blur depends on just how much blur you want, the speed of your subject and how close you are to them. I tend to find my location then practise on passing pedestrians with different shutter speeds, assessing the results on the monitor to get the feel I want. If she's available (and I'm in favour) I use Wandering Wendy for these tests. This is one of the few times I use shutter priority exposure mode. If you're contemplating this, be prepared for an afternoon kneeling in gutters being stared at. Getting a smooth panning action takes practise, and every take on random passers by is different as there are many variables beyond your control. Be ready to wait and shoot consistently to get the one picture that really stands out. If using a lens with Image Stabilization, switch it to panning mode, which stabilizes the lens in the vertical plane only.

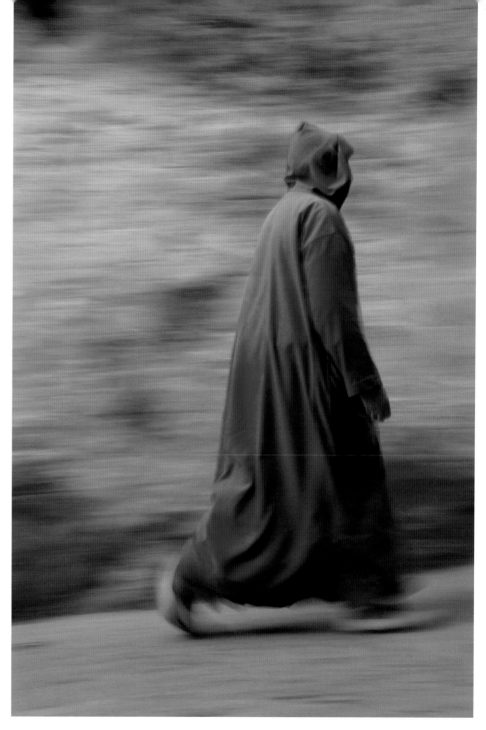

Street scene
*Chefchaouen, Morocco
Canon EOS-1Ds MKII,
24–70mm lens, ISO 100,
1/8sec at f/16*

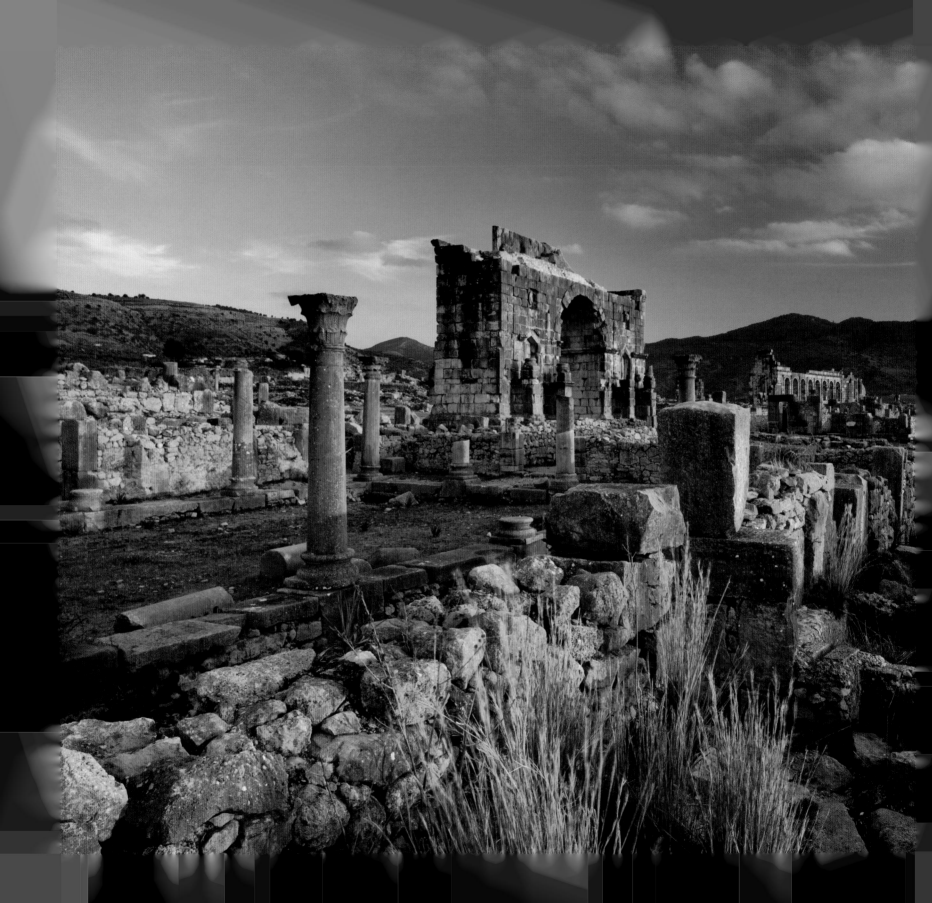

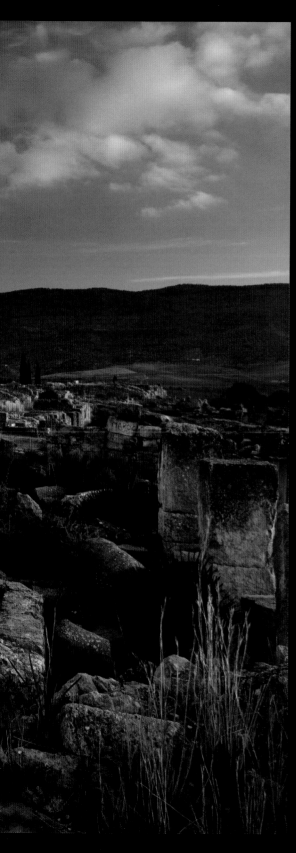

MOROCCO 6/12 – ROMAN RELICS

BEFORE From the tightly packed alleys of Fes to the ancient Roman ruins of Volubilis, set high up on the plain. It's late afternoon and I'm working the location, revelling in the peace and quiet away from the bustle of the medinas. It's a relief to be making a shot without the suspicions of passers by. There are a few tourists about, but it's a big complex and it feels like I have it to myself. The ruins are the most evocative I have seen, being so untouched and free from 20th-century clutter. To the west there's nothing but distant olive groves so I can afford to wait until the sun has dropped almost to the horizon. After working hand-held and spontaneously in the frenetic streets of Fes I can now revert to the measured pace of a landscape photographer: walk, look, think, previsualize, plan, wait, and finally, shoot.

DURING With a set-piece architectural shot like this it's important that all the strong vertical lines appear perpendicular. These ingenious ancient columns deserve my respect, so I'm using the 24mm tilt-and-shift lens to ensure that all is square. After finding my viewpoint, I set up on the tripod and ensure that the camera is entirely level using the hot shoe-mounted spirit level. As the intended view is looking slightly down, I dial in a little drop shift, which physically moves the lens down while keeping the sensor plane vertical. The temperature and light are gorgeous and it's so good to be working meticulously and thoughtfully, waiting for the best light again.

The lusciously golden and increasingly soft side lighting paints the scene and a few clouds drift in from the west. I'm in luck – now is prime time. A polarizing filter saturates the colours. In the middle distance the triumphal column erected by Emperor Marcus Aurelius in AD217 glows in the warm light. Using this lens, the exposure has to be set manually, as moving the lens off-centre confuses the metering system. The best option is to meter manually with no shift dialled in then recompose and expose. Check the histogram, assess exposure, adjust if necessary and shoot again.

AFTER Converging verticals are a problem whenever shooting buildings. You can ignore them, accentuate them or correct them – the choice is yours. Shift lenses are expensive and specialist but so useful for this kind of work, from Delhi to New York. Of course, converging verticals can be corrected in post-production by physically distorting the image in Photoshop. With the most common problem of converging verticals, caused by looking up at a tall building, you can physically stretch the top dimension of the image to straighten things up. But there is a limit to how far you can go without significant loss of quality, as you're essentially throwing information away. My opinion is that it's always better to get it right in camera if you can, and Live View is very useful for double-checking uprights.

The ancient Roman ruins with the Triumphal Arch and Basilica beyond
Volubilis, Morocco
Canon EOS-1Ds MKII, 24mm tilt-and-shift lens, polarizing filter, ISO 100, 1/6sec at f/16

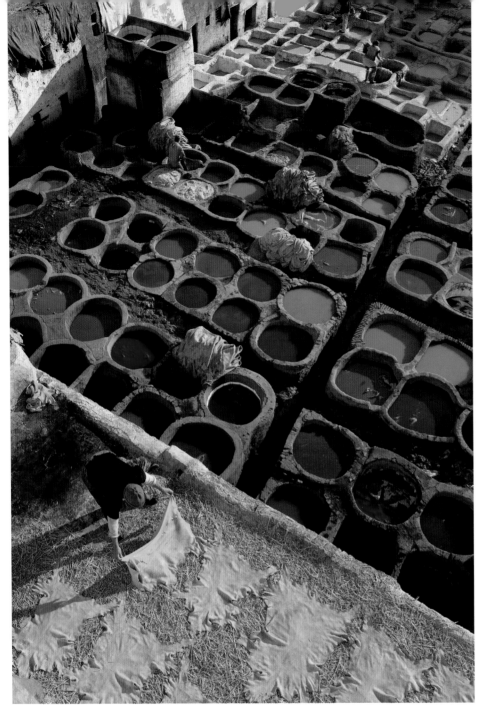

the location and picking our vantage points but this morning, in the half-light before sunrise, it all looks very different. I challenge anybody to find their way through the narrow, twisted alleys of Fes. I hit on the bright idea of following the donkeys laden with hides – they must be heading for the tannery. Wrong tannery. So, a few dirhams in Abdul's hand and we're back on track, just in time as the sun is up and the first stalls overlooking the rows of pots open.

If you ever get downhearted in life just consider these tanners. They spend all day up to their waists in pots of noxious chemicals working stinking animal hides with their legs. It's hot, smelly, and as for health and safety, forget it. We've negotiated our way on to a balcony overlooking this scene and are hurriedly rummaging in our Lowepros.

DURING The light is getting harsher, but as time passes the activity below intensifies. A tanner starts laying out his hides in a wonderfully colourful, graphic display. The bright wall below us acts as a reflector, bouncing the light back into the scene and dropping the contrast. We work the view methodically for several hours – if a situation is a good one it's best to stick with it and explore every possible composition in pursuit of the definitive image. I've got my lens trained on the evolving vista below, eyeball darting around all the visual elements, concentrating, waiting, exposing as the tanner slaps the wet hides down, muttering, watching the exposure displays, occasionally checking for 'blinkies' (highlight alerts, see page 33) on the monitor. Dave is crouching nearby, like most ex-Fleet Street wallahs he's a Nikon devotee. Generally, I hate sharing a scene with another photographer, but in this case, I let him off. Eventually, with a couple of full 4GB cards, the light is just too harsh. Now then, how do we find our way back?

AFTER With a situation like this it's easy to take a lot of exposures as the situation develops. Usually the pictures get better as you get 'zoned in' to the shoot. That was true here, despite the fact that the light was getting increasingly harsh as time passed. Trying to sift through the shoot to pick out the best image is a daunting challenge. Clearly, unless you want to spend the rest of your life in front of a computer, just concentrating on a few of the very best saves processing hundreds of similar shots. Start with the best and work backwards. Be ruthless. If a shot isn't as good as another, delete it. What's the point of keeping the also-rans?

A tanner laying out his hides to dry

The tanneries, Fes, Morocco
Canon EOS-1Ds MKII,
24–70mm lens, ISO 160,
1/125sec at f/9

MOROCCO 7/12 – A TANNERY

BEFORE Two professional photographers with the combined experience of some 70 years, and we're lost. We're relying on 11-year-old Abdul to guide us through the maze of the medina to the tanneries. We were here, or rather there, yesterday, checking out

MOROCCO 8/12 – THE BARBER OF ESSAOURIA

BEFORE I'm prowling the streets of Essaouria. We leave today and I want just one more evocative portrait. I'm working light with just the body and the 85mm f/1.2 lens slung over my shoulder. Generally, I don't get emotionally attached to kit, I use the right lens for the job, but I do have to admit to having a special relationship with this super-fast optic. It's the perfect tool for travel portraiture. Not only does the fast maximum aperture of f/1.2 give incredible flexibility in low-light situations but the non-existent depth of field gives a wonderfully out of focus background.

I've been on the hunt for a couple of hours now, adopting the engage and ask approach (see page 12) – unsuccessfully it has to be said. Five straight rejections have left me dispirited. I'm wondering whether to pack it in and go for a beer. I'll just give it a few more tries. I pass a barber's shop and glance in; a bright-eyed, open-bearded, biblical face peers back. I circle back, poke my head in and chat for a minute; 'Une photo s'il vous plait?' He nods and I'm in.

DURING The light filtering in the doorway gives a pleasingly soft directional light, if somewhat dim. The barber's shop is a tiny cubicle of clutter – dark and cramped – but crouching in a corner with the lens wide open at f/1.2 the background is a pleasing blur. Backgrounds can make or break pictures, either giving a sense of place, being entirely neutral, or distracting from the subject disastrously. I'm thankful of the short stubby lens in the confined space and despite the gloom, the super-fast aperture gives me a workable shutter speed of 1/125sec without having to up the ISO from 100. The background, the light, the exposure, the composition – I'm contemplating all of these factors as we chat. After a few stilted poses with scissors he eventually relaxes and his eyes bore into my lens. I focus on the nearest eye and expose. Check composition. I get three frames off before he smiles, revealing possibly the worst set of teeth in Africa. Never mind, the picture is made. I express profuse gratitude and leave, all the curt refusals forgotten.

AFTER Morocco is such a colourful place that it seems perverse to go mono, but with this particular image the colour added nothing. Black-and-white images force us to concentrate on form and texture, such as the beautifully directional but diffuse side lighting on this barber's beard. Behind the lens I half had it in mind to convert the image to black and white. Now in the editing stage, a quick desaturation of the RAW image convinces me. Some say the way to convert digital colour images to mono should involve Channels and the Colour Mixer in Photoshop, but I just take the destaurated RAW image and tweak the Curves and Levels as usual to enhance the tonal range of the picture.

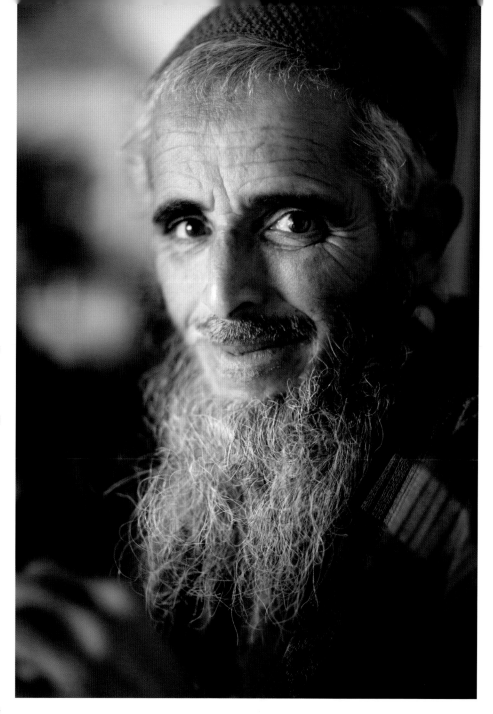

Portrait of a barber in his shop
Essaouira, Morocco
Canon EOS-1Ds MKII, 85mm lens, ISO 100, 1/125sec at f/1.2

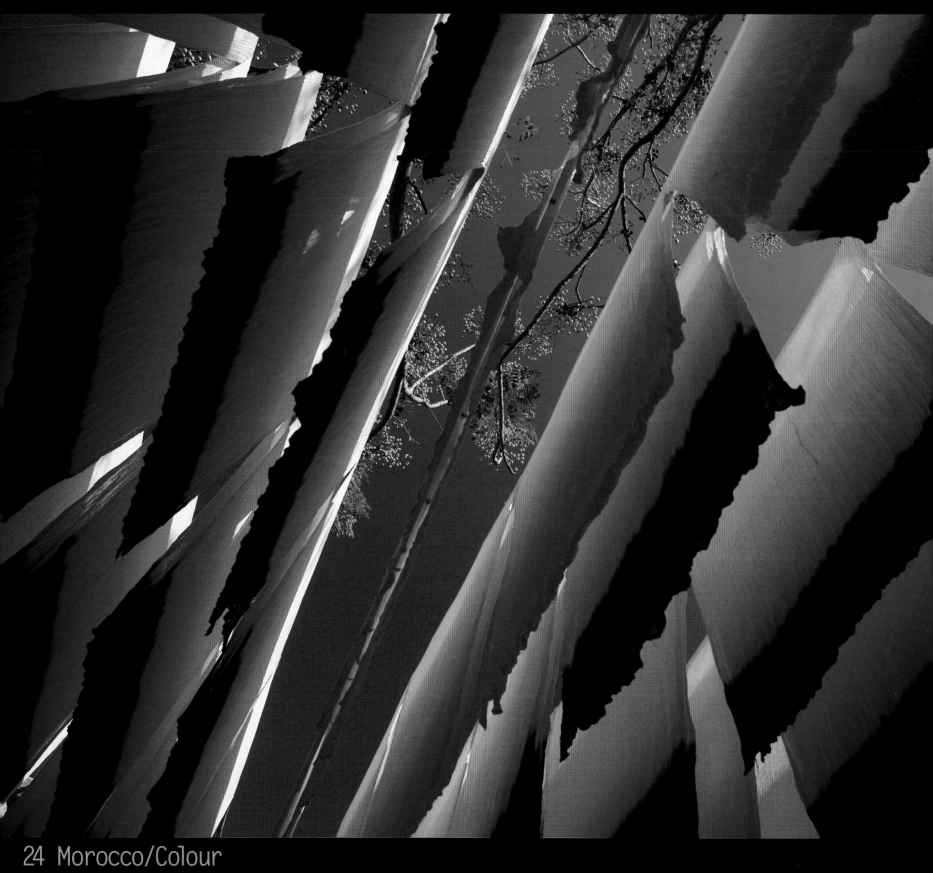

MOROCCO 9/12 – SKEINS OF SILK

BEBEFORE The souks of Marrakech are a cramped rabbit's warren of alleyways, courtyards and communities, all with their own crafts. The tanners, metalworkers, cobblers and weavers all have their own souk. We're wandering in the late morning being hassled to buy everything at a special price, just for us. It's colourful and exotic, although it's fair to say I've not warmed to Marrakech. The aggressive commercialism of the hawkers, snake charmers and musicians in the Place Djemaa-el-Fna the previous evening left a bad taste in the mouth. But away from the tourist hot spots it is still possible to find quiet courtyards where craftsmen beaver away. In the dyers' souk we come across rows of brightly coloured textiles hung out to dry in the bright sun.

DURING The light is hard and harsh. Time was I wouldn't even be carrying my camera at this time of day, but lately I've realized the folly of that self-imposed restriction. Beneath the hanging shawls, looking straight up with a wide-angle and a polarizer, this graphic composition leaps out. Am I getting all arty in my old age? I compose, move a bit to get stronger diagonals, expose and check my histogram display. With a high-contrast scene like this there is little scope for adjustment – the histogram confirms that all available shadow and highlight detail is being recorded. This is one of those occasions when I can just leave the camera's autofocus and aperture priority exposure mode to do its stuff. I check that the shutter speed isn't dropping too low to give a sharp image then just get on with making a bold composition.

AFTER This is our designer, Clare's, favourite shot of mine. That's designers for you, its all shape and colour with them. Actually, working with people like Clare is an eye opener, as they look at pictures in an entirely different way. We photographers tend to become obsessed with the details. Browsing through most camera magazines they seem to be full of a certain type of image, the look of which appeals mainly to other photographers. But someone like Clare will go for the simplest, boldest, most graphic abstract, ignoring all those images of waves lapping around rocks.

I am constantly intrigued by which images light different people's fires. When we staged the Waiting for the Light exhibition, I used to surreptitiously watch reactions as people wandered around the gallery. I could never predict which image would get whom excited, even with friends I knew well. What turns viewers on photographically can rarely be anticipated. Ultimately we can only produce work to our own taste, but that's not to say our visual preferences can't be influenced by others and be constantly evolving. It would be so easy to settle into a groove with all my pictures starting to look a bit predictable and safe. Getting out of that rut is what this book is about.

Skeins of silk hung to dry in the dyers' souk
Marrakech, Morocco
Canon EOS-1Ds MKII, 16–35mm lens, polarizing filter, ISO 100, 1/50sec at f/7

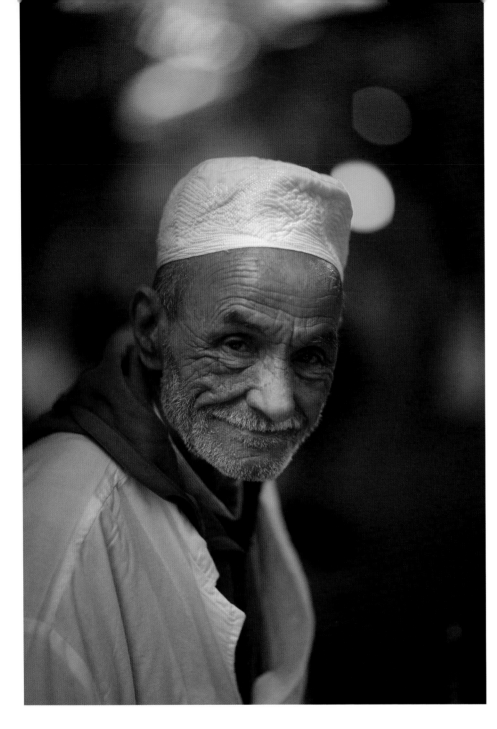

at a premium and grappling with a zoom on a long lens isn't easy among the heaving throngs. In these locations, 85mm is the perfect focal length for environmental portraits. The classic lens for portrait work is in the 100–135mm range – great for a full-frame headshot – but the slightly wider 85mm allows you to include more of the surroundings.

What really caught my eye with this lens, though, was the maximum aperture of f/1.2. I always think of an f/2.8 as being fast, but f/1.2 is 2½ stops quicker. The advantages of that speed in dark souks are obvious, but of more significance are the depth of field implications. Although I like to include some background to give a sense of place, the problem is that annoying details can detract from the subject so I almost always shoot wide open at maximum aperture. This way the background is dropped out of focus leaving indistinct but evocative shapes and colours.

DURING I'm picking my way through the narrow twisted maze of Marrakech's medina. A diffuse shaft of light permeates the awnings above, spotlighting a man setting up his date stall. 'Je peux prendre une photo, s'il vous plait monsieur?' Although Morocco's official language is Arabic, French is widely spoken. He nods. Camera up to my eye, exposure mode set to aperture priority, I do a test exposure to check my highlights aren't burning out. At f/1.2 the depth of field is non-existent; when focusing on the eyes, the tips of the nose and ears are soft, so my focusing has to be spot on. This kind of street portraiture is so fast. One part of my mind is looking at the technical side – where the red markers in my eyepiece are indicating the focusing point is and checking the exposure – while the other half is looking at the composition and lighting, and interacting with the subject. Absolute familiarity with the camera controls is crucial. Shots will be lost if time is spent peering at the buttons or monitor. At the fourth frame he gazes straight into my front element as I squeeze the shutter. That's the one; I know it instantaneously without needing to look.

AFTER Not all my subsequent encounters are quite as harmonious. As soon as a camera is spotted, the hustling and the constant demands for dirhams begins. But it goes with the territory, I just have to deal it, make the pictures and get the job done. The Place Djemaa-el-Fna is a whirl of snake charmers, musicians and fortune-tellers. As the sun dips, backlighting the smoke from the barbecues, and the calls to prayer from the minarets of the mosque echo across the square, it's all I hoped Morocco would be.

Portrait of a man in the souk
Marrakech, Morocco
Canon EOS-1Ds MKII, 85mm
lens, ISO 100, 1/160sec at f/1.2

MOROCCO 10/12 – IN THE SOUK

BEFORE I spent a fortune on this 85mm optic. Why? I already have a 70–200mm f/2.8 and for a lens of its focal length the 85mm is big and heavy. Well, firstly, in crowded markets, space and time are

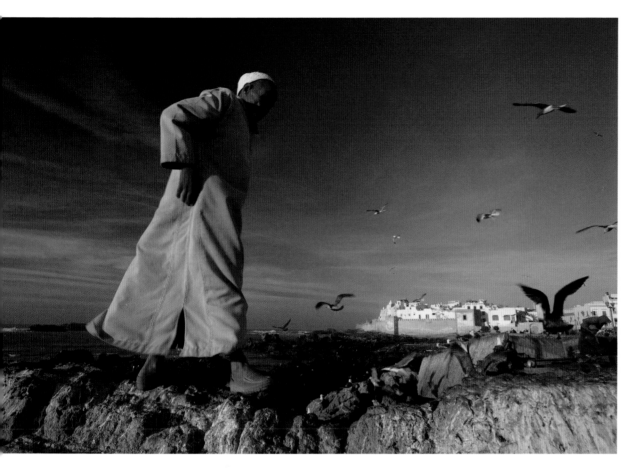

A man on the sea wall with seagulls flying overhead

Essaouira, Morocco
Canon EOS-1Ds MKII,
16–35mm lens, ISO 200,
1/100sec at f/9

MOROCCO 11/12 – THE DECISIVE MOMENT

BEFORE When I've spent all day travelling it's always tough to know where to head on arrival. Thoughts of a cool beer in the late afternoon sun seem just too attractive. Sometimes at the end of a trip, with full memory cards duly backed up, that is exactly what happens, starting afresh the next day is the best option. But with only two nights here in Essaouria I need to make the most of it, so after the long drive it's straight out to catch the evening light. I may not produce anything of worth today but at least I'll get a feel for the place, enabling me to formulate ideas for tomorrow.

I like Essaouria instantly. With its walled setting by the pounding sea, it's far more laid back than Fes or Marrakech. Down by the harbour fishermen are gutting the day's catch and dense flocks of squawking seagulls hover overhead. This looks like a choice spot.

DURING I become aware of the challenge of working this location immediately. It's no wonder that the fishermen wear

hats. Everything is pasted in glutinous, sulphuric, evil-smelling gull guano being dropped by the hovering squadrons above. I'm not suitably attired for this shoot – hard hat and boiler suit would be the order of the day. I don't believe I have ever read in Canon's technical specifications any mention of their gear's ability to function in these conditions. One splat on my precious kit could really ruin my day. But you don't make great pictures without immersing yourself in reality. Cameras are made to be used, not fondled and cosseted in protective environments. They're just tools to be doused in gull excrement if necessary. So I'm trying to get intimate with one of the gulls perched on the wall with the walled town and coast beyond. I've got the wide-angle 16–35mm lens on and just as I've framed up the shot the gull flies off. But in its place along the wall comes a fisherman and my shutter fires as he crosses the frame.

AFTER This was one location I thought had many options, so I resolved to work it over two afternoons. Sometimes events come together as I could never predict. This gent wandering into shot with the seagulls in the air and the town beyond has all the elements, and he's in exactly the right position in the frame. This was the decisive moment for this picture; if he were further to the left or right the composition would be unbalanced. I can't say this shot was preconceived, it was an intuitive reaction to an opportunity. But the more I put myself in these kinds of situations the better I get at reacting to them. Luck? As golfer Gary Player once said, 'The more I practise the luckier I get.' Sometimes in busy environments it pays to set up a shot with an interesting composition and just see who or what wanders through.

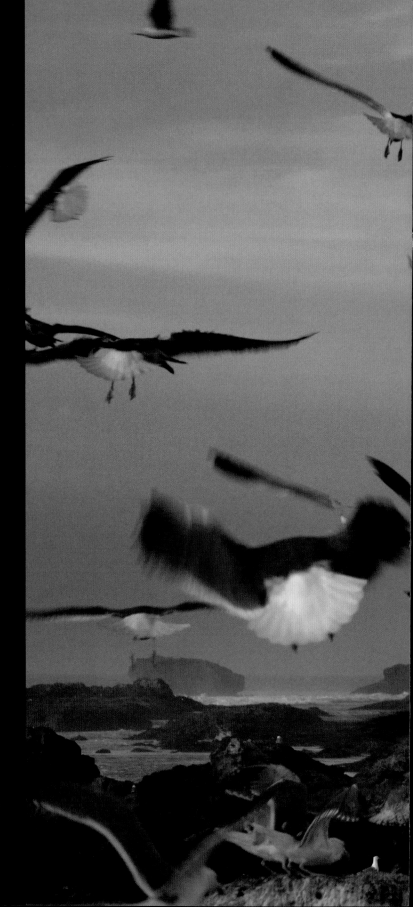

MOROCCO 12/12 – AERIAL BOMBARDMENT

BEFORE After my wide-angle opportunity with the fisherman (page 23) I've pulled back. This is a great location that warrants working to exploit the full potential. Incredibly, so far I've missed a direct hit from the aerial bombardment and the evening light is getting better as the sun drops over the Atlantic. Morocco in the winter has a benign climate – balmy, pleasantly warm and comfortable – an ideal escape from the grey winters of northern Europe.

DURING I want to use a long lens to flatten the perspective and emphasize the dense flocks of gulls with the walled ramparts of Essaouria beyond. To get this angle I'm perching precariously on a wall, so using a tripod is out, and anyway a fast-ish shutter speed is necessary to freeze the motion of the birds. I'm using a polarizing filter to accentuate the colours and the light is softening attractively but weakening all the time as the sun dips into the mist out to sea. With my 70–200mm f/2.8 lens at a focal length of 125mm I need an aperture of f/10 for the depth of field necessary to keep everything crisp, from the nearest gull to the town beyond. The shutter speed is worryingly slow now but this is where a combination of Image Stabilization (IS) and the ability to increase the ISO without any worries about noise saves my skin. Pressing the shutter lightly, I hear the IS whirr into action. I give it a second to activate and I can see the lens become more stable through the viewfinder. Brace, shoot, forget all the technical stuff now, just concentrate on the activities of Bomber Command above the fishermen.

AFTER This is the kind of shot I would really have struggled to make ten years ago. Image Stabilization is a handy development that's come about since then. It's no substitute for using a tripod but when everything else is against me it is so useful. At the longest focal length with the highest magnification I estimate it gives me an extra 2 stops of leeway, so going down to 1/60sec hand-held is achievable, just. Ideally I prefer not to, but if it's the difference between making a shot and not then what have I got to lose? It pays to be sceptical about manufacturer claims and not rely on Image Stabilization or Vibration Reduction too much, but coupled with the ability to increase the ISO to levels we previously thought ludicrous, it makes the modern DSLR with longish zoom a very flexible tool.

Seagulls flying over the harbour
Essaouira, Morocco
Canon EOS-1Ds MKII,
70–200mm lens, polarizing
filter, ISO 800, 1/85sec at f/10

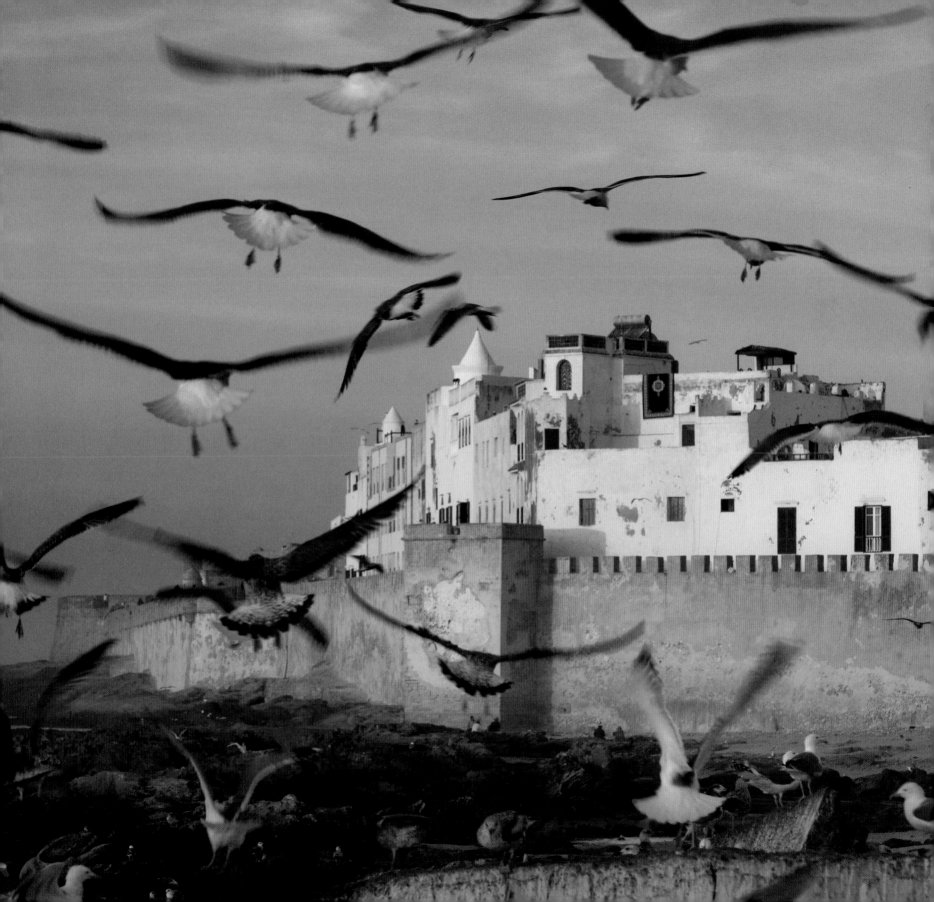

Bali

2.Persistence

It would be easy to assume that life for a roving travel photographer is just one stunning vista after another. I wish. The harsh reality is that for every soul-enhancing vigil overlooking the world's most beautiful places there have been many, many days and nights of travel, tedium and mind-addling hassle. On average, for every productive dawn or dusk photo session there will be three or four where it just doesn't come together.

Usually it's the weather that's the problem. We photographers are just so picky; we want the world just right with crystal clear light and dramatic skies. But human factors can also scupper the plans – closures, delays, crowds, illness, security restrictions, public works and restorations all have and will cause me grief. One trip to Florence was written off due to scaffolding and green tarpaulins on every important building. And how many times have I been moved on by the Tripod Police in the name of the War on Terror? Sometimes this game seems like Mission Impossible, and those few and fleeting moments of tranquillity overlooking a misty morning scene seem like a very small part of the whole. And that's not taking into account those days where I just don't deliver. So, the special times when a preconceived shot comes together in a perfect fusion of nature and photographic expertise are often triumphs of sheer dogged persistence.

In this digital age it's so easy to blast away indiscriminately. There is a notion that if enough pictures are taken, at least one is bound to be good. It never works – all you end up with is memory cards full of mediocrity condemning yourself to days, weeks or months spent wading through the dross. Actually I now take fewer frames then I did in the film era. That's partly due to not needing to bracket exposures any more but also a reaction to the saturation of the photographic market with content over quality. Firstly, I don't want to spend the rest of my life shackled to the computer, and secondly, I'd always prefer to come back from a shoot with one outstanding image than a hundred average ones.

But to make that one great image, all must be right. The idea in the first place, followed by the location and lighting must all slot into place. Substantial reserves of patience are often required. If a location's photographic potential is that good I'll wait until Mother Nature delivers. I once spent ten days in China waiting for one shot. Worth it? Well, my sanity suffered, but what's the alternative? Always moving on, wistfully regretting a missed opportunity, or staying put and eventually triumphing from perseverance?

I had a two-week slot available and the tropical serenity of Bali beckoned. I boarded the plane at Heathrow with the germ of an idea for one shot gestating. It was a start…

BALI 1/4 – RICE FARMER

BEFORE I've been in Bali for 24 hours and I've not yet got that crucial first exposure nailed. I'm twitchy and impatient to get going. I need a plan but already one thing has dawned on me; Bali is deserted. Is it the global recession, or have I come at the wrong time of year?

It's the rainy season, but I knew that before I came. An afternoon deluge with dramatic skies and crisp light before and after is the usual tropical wet season routine but that doesn't seem to be the order of things here. There's a glimmer of sun in the morning followed by leaden grey skies more reminiscent of Wales than Bali. From my rooftop with its view over the rice fields around Ubud, I should be able to see the brooding volcano of Gunung Agung on the skyline, but it's lost in the black clouds. I need to be patient.

DURING I head out of town and into the rice fields. The light is steely grey, flat and diffuse – lousy for landscapes, great for portraits. An hour in I come across my first farmer. I point to my camera and the barest of nods comes back. I compose and activate the auto-focus. I'm shooting with the 85mm lens wide open at f/1.2 for minimal depth of field. This lens is stunningly fast and crisp but it is difficult to use at this aperture. No matter how sound my technique, if I'm working quickly a fair percentage of exposures will have the focus point on the ear or tip of the nose

instead of the eyes. I need to be so careful. I expose five frames before the moment has passed and I trudge back in the fading light, happy that I'm underway.

AFTER I nearly always use evaluative or matrix metering. Evaluative metering divides the image area into multiple segments to ascertain the best exposure to record the full tonal range. Any one sector that is out of kilter with the rest, like a bright sun, will be ignored. That's not to say it gets the exposure right all the time; I still need to check it and apply exposure compensation as required.

In this case, the first frame showed alerts blinking in the brightest part of his headgear indicating burnt-out highlights. I dialled in -1/3 stop compensation and continued shooting. A small area of white was still blinking, but I wasn't worried. The monitor shows a JPEG, despite the fact I shoot RAW. RAW images have more exposure latitude than JPEGs, so I was confident I could recover the highlights at the conversion stage. Exposure latitude is a margin for error not to be abused but handy to know about. As a rule, RAW files have robust shadows but fragile highlights. What that means is watch your highlights; it's easy to burn them out. Generally, I try and give the maximum exposure without losing highlight detail. That's why the 'blinkies' are so useful.

Rice farmer
Near Ubud, Bali, Indonesia
Canon EOS-1Ds MKIII, 85mm lens, ISO 200, 1/1000sec at f/1.2

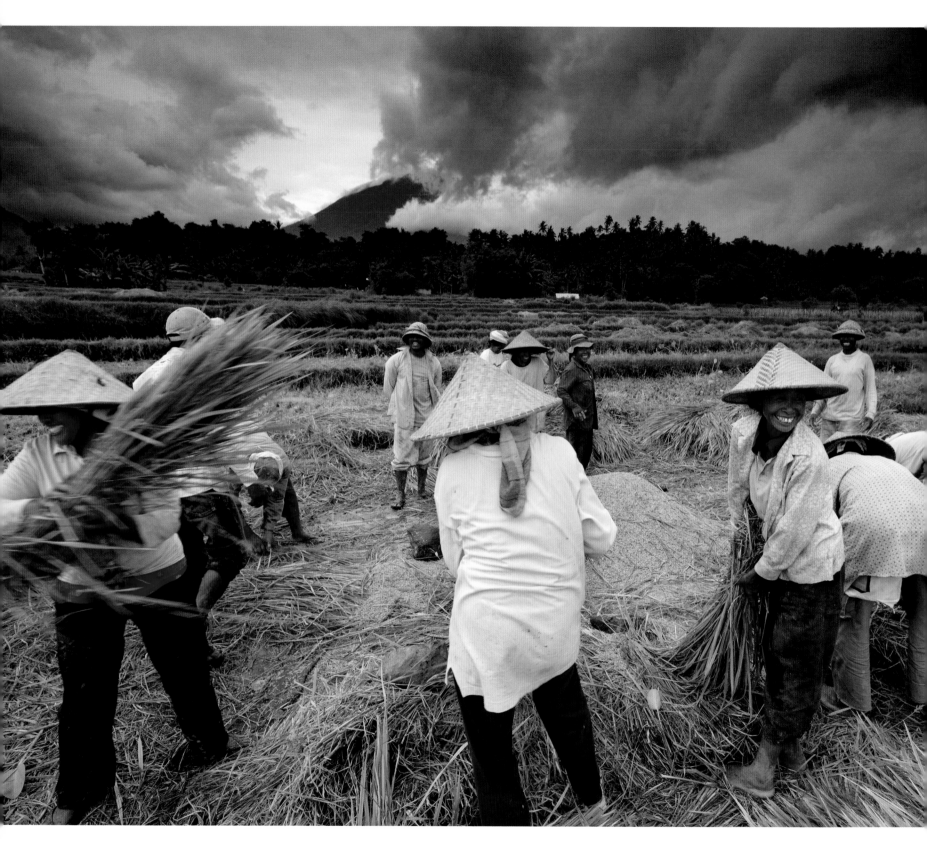

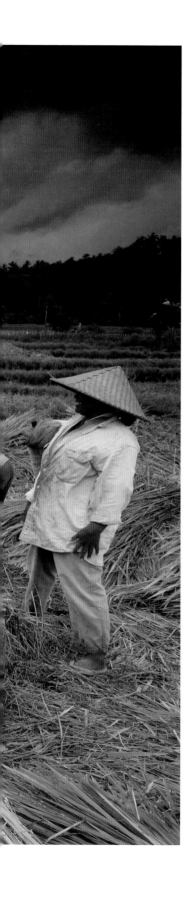

BALI 2/4 – RICE THRESHERS

BEFORE I'm sitting outside a Buddhist temple watching the world go by. The midday sun has broken through briefly and a guy with a professional looking set-up is shooting the scene. I ask myself why – the harsh vertical light is gruesome. Does he know something I don't or is he just frustrated and desperate? One of my self-imposed rules used to be 'Thou shalt not shoot at midday' but when I went digital that all went out the window. I started carrying a camera around in all sorts of situations. Of course, for landscapes the rule still largely applies, but in open shade, in doorways and alleyways, under cloudy skies and even with hard, direct light there are opportunities for bold, simple images. This temple in this light isn't one of them but, like him, I feel the need to expose, so I pick up my bag and head out again.

DURING The black clouds have closed in and I'm marching into the countryside with the familiar weight on my back. In a field, a party of women in conical hats are threshing rice, chatting as they work. I approach and gesture to them to ask for permission to photograph. No discernible group decision seems to be made so I take that as a yes and delve in my bag for the 16–35mm lens and a 0.6 neutral density graduated filter.

When working hand-held, multiple exposures aren't an option, I have to do it all in one frame. Although the sky is heavy and grey, the brightest parts of the cloud will still burn out without a filter to constrain them. There are some nifty filter effects in Photoshop, but if highlight detail is lost at the capture stage no amount of manipulation can get it back. Filters are contrast control devices, and this one has a difference of 0.6 of density between the clear part at the bottom and the dark part at the top. This enables me to hold the drama of the sky while exposing for the landscape.

I work the situation for a few minutes until I get the distinct impression I'm starting to outstay my welcome. Time to move on.

AFTER One of the most frequent questions I am asked is how do I decide which filter to use and when? In theory, the way to ascertain it is to take a meter reading off a mid-tone in the sky and another off a mid-tone in the landscape to determine the contrast range and then choose the appropriate grad. For example, 0.3 equates to 1 stop, so if there were a 3-stop difference between the muddy bits and the fluffy bits, a 0.9 ND grad would be the answer. In practice, there often isn't time for such deliberations and really you can't beat experience and trial and error. I suggest doing tests and trying all the alternatives, using Live View, if you have it, to help you judge the effect.

Workers threshing rice in the fields
Near Sibetan, Bali, Indonesia
Canon EOS-1Ds MKIII, 16–35mm lens, 0.6 ND grad filter, ISO 100, 1/100sec at f/9

BALI 3/4 – A HAPPY FARMER

BEFORE I'm at Tirtagangga surrounded by the hills and lush rice fields tumbling down to the sea with Lombok visible on the eastern horizon. It sounds idyllic, but being in paradise in incessant rain is a surreal experience magnified by the fact that everywhere I stay I'm the only guest. Has there been a nuclear holocaust I don't know about, or is everyone else sensible enough not to come to here in the wet season?

I'm out trudging over the hills, scouting for locations. It feels good to be on the move. I have a hearing- and speech-impaired guide called Ahmed to show me around. I'm not quite sure how I ended up with him, he approached me in the square, but he knows his patch, and it's illuminating what he can impart to me with just a gesture and a grunt.

A farmer carrying a sack of rice on his head
Near Tirtagangga, Bali, Indonesia
Canon EOS-1Ds MKIII, 85mm lens, ISO 100, 1/1300sec at f/1.2

DURING One thing that always strikes home is what beasts of burden most agricultural workers are in Asia. Trudging through the muddy fields we come across men and women labouring at backbreaking work, tending their tiny patches of hillside. I endeavour to shoot them all and am met unfailingly with bemused yet beaming smiles. The heavy grey skies are perfect for this type of agricultural reportage.

I've been using this Canon EOS-1Ds MKIII for a year; not long in the grand scheme of things but it's rare now for a body to remain in frontline service for longer than three or four years. Not because of wear and tear but more due to the fact that camera technology is advancing so quickly.

AFTER How important is the actual camera? Well it's only a tool, and a cheap and basic camera in the hands of someone with perceptive eyes will always outperform the latest DSLR in the hands of someone with no imagination. But all things being equal the importance of the hardware is usually overestimated. What is crucial is that whatever camera is used, it's really used – it's out getting rained on, dropped and battered. Wendy gets some incredible pictures with her humble compact, not only because she has a unique vision for colour, shape and texture but also because the camera is with her all the time. Unless a camera is portable it's useless, and only you can decide what you're prepared to carry through life.

That's all well for me to say as I have the very best system available. Or do I? Which camera is currently top is the subject of endless discussion on Internet forums. The Nikon Vs Canon debate just runs and runs. But of course, its not just about the camera; when you opt for a particular model you're also buying into a system of lenses and accessories and, unless money is no object, chopping and changing between systems is just not feasible. So once the decision is made it's best to ignore all the techno-babble and just get on with the photography. That's the fun bit.

The Importance of Being Earnest

I'm sitting on a balcony at Tirtagangga in eastern Bali watching the rain dripping from the lush vegetation all around me. It has been raining incessantly for days. I'm hardly testing the capacity of my back-up harddrive – I've shot virtually nothing since my first muddy foray. I had to move on from Ubud to preserve my sanity; too many evenings were being spent losing the will to live in restaurants sparsely patronized by none but honeymooning couples staring into each other's eyes.

When things are going well these trips develop an unstoppable momentum and good photo sessions come thick and fast. Life is never better than during those rare and all too brief interludes. Conversely, when the Gods of Light are in a strop a trip can stall fatally. Well OK, not fatally, but when you've travelled across the globe just to stand by the tripod in a rice field it's difficult to be philosophical about the endless black clouds and futile vigils.

This trip is not working. What can I do? Drink beer while sinking into a morose torpor? Or stay positive and keep doing what I do; plugging in the location searches, never letting an opportunity pass and just trusting that sooner or later the clouds will part at the right time to bathe green terraces tumbling down to theLombok Strait in gorgeous golden light? My phone bleeps. It's a text from home: Wendy is out shooting in perfect snowy winter conditions in Dorset. That's it, tonight the beer option wins.

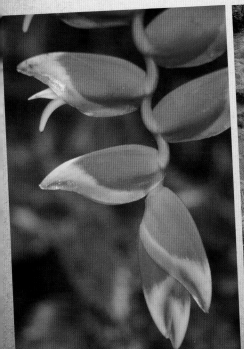

BALI 4/4 – STORM CLOUDS PARTING

BEFORE The day dawns on the last morning of the trip. Tonight I fly home. I'm back on my rooftop near Ubud for one more try. The intervening two weeks since I first did this have not been a total waste; I've shot images, mostly under grey skies, and caught up with the writing. But I can't say I'm at all satisfied with the results from this trip.

The one key image that I had in my mind before I even got here has eluded me, and this was the place to do it. It will be a wrench to leave without shooting this location, which I found on the first day; it's a stunner. I trudge up the steps in the darkness, more out of habit then hope, and there's the familiar heavy cloud overhead. Another dawn patrol, another tripod vigil; these are the routines of my life. I set up the tripod but opt to keep the camera under cover – more rain is inevitable. Or is it? To the west the sky is clear. Will that gap reach the eastern horizon in time for a rendezvous with the rising sun? There is hope.

To the north, the pyramidal peak of Gunung Agung looms large, dominating the landscape. I know exactly the shot I want – the first direct sunlight of day side lighting the rice fields with a dramatic sky and a slightly long lens perspective emphasizing the scale of the brooding volcano on the skyline. This crystallizes how I work: I start with an idea, do the legwork, find the location, previsualize the image, plan the shoot and then keep coming back until

Mother Nature obliges. It usually works. Sometimes it doesn't, and I leave rueing the shot that got away. Right now, at 5.30am on a rooftop in Indonesia, waiting for the light, shuffling by the tripod, I'd say I've a 50 per cent chance of exposing this morning. I'm now getting the buzz of a possible shot coming together.

DURING The dawn sky is evolving into a masterpiece of nature. Lenticular clouds are forming over Gunung Agung. The camera is on the tripod now, with a spirit level in the hot shoe, the cable release on, all framed up and composed with the 70–200mm lens, mirror lock activated, aperture priority exposure mode set, a polarizer and a twitching photographer. Check all settings – ISO at 100? Check the tripod is tight. Check again. Look to the east. The light is coming. Deep happiness.

AFTER The sky makes the picture. So this is a lucky shot? Hah! No one can say I didn't work this location, coming back time and again until the conditions were right. Luck is where preparation and opportunity combine. Persistence is a landscape photographer's greatest asset. Ultimately this trip boiled down to this single shot made on the day I left. So, two weeks and some 16,000 miles of travel for one shot. Worth it? You bet.

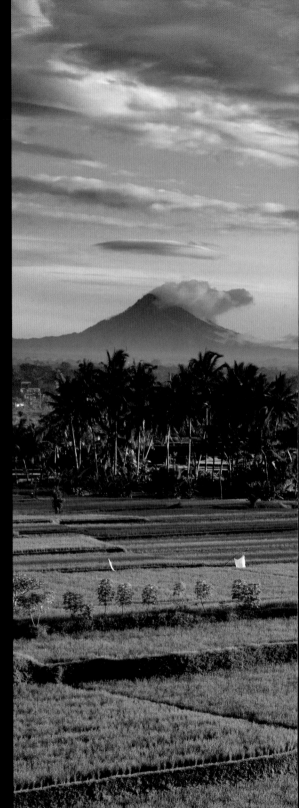

Storm clouds clearing over the volcanic peak of Gunnung Anung and the rice fields at dawn
Near Ubud, Bali, Indonesia
Canon EOS-1Ds MKIII, 70–200mm lens, polarizing filter, ISO 100, 1/50sec at f/8

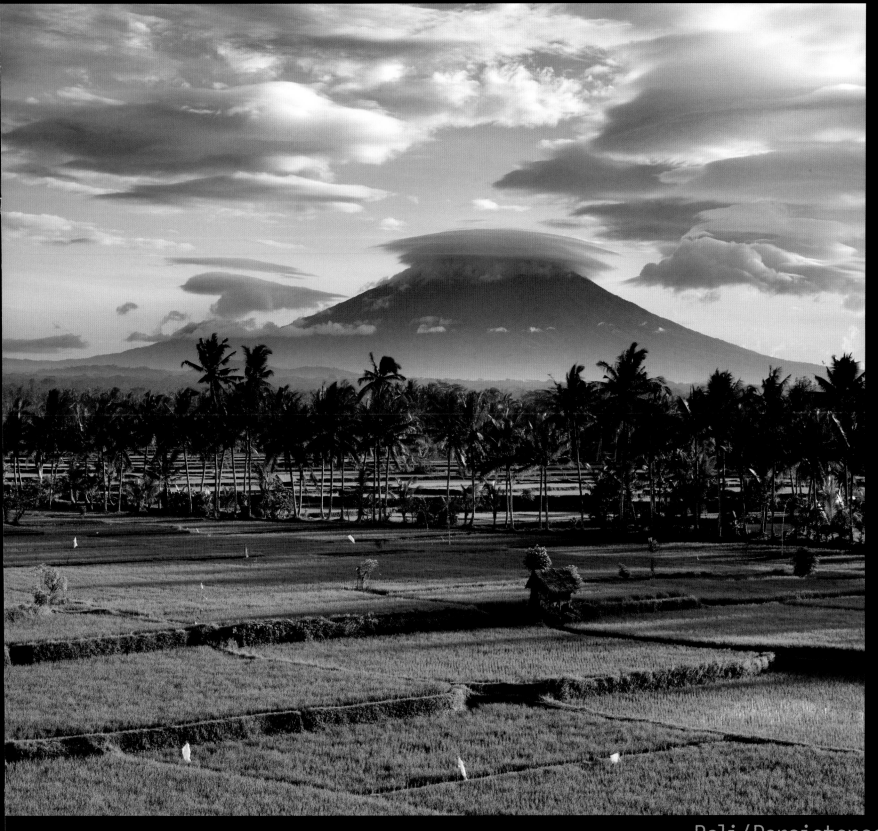

Bali/Persistence

South Africa
3. Challenge

It has not taken us long to settle into a routine. The alarm goes off at 4am but I'm already awake, listening to the sounds of Africa as dawn seeps through the bush. We crawl out of our pit, gulp down a coffee in the half-light and jump in our trusty and dusty Land Rover – Wendy in the driver's seat, me behind with the camera and long lens on a monopod. The gates to the camp open at 4.30am and we trundle between them, out and into the wilds of Kruger National Park.

We set off on one of the game drives but it's a lottery what we will see – it could be nothing. Gorgeous light might be backlighting the mopani trees and dry riverbeds beautifully but the wildlife may be having a day off and so we'll sit, watching and waiting in the gathering heat before returning deflated for breakfast. Or we might witness a family of vervet monkeys frolicking, or lions stalking, or giraffes strolling. We have surrendered our destiny to the rhythms of nature. It is such a different way of working to my norm. Search, previsualize, wait, and finally, when the light is right, shoot – that is the basic checklist for a landscape shoot. Here, playing at being a wildlife photographer, it's totally unpredictable, often frustrating and occasionally euphorically exhilarating.

Wildlife photography began as a daunting prospect for me. The top wildlife photographers have spent a lifetime perfecting their craft. They're usually experts on animal behaviour and think nothing of spending months crouching in a hole. Who was I to think I could just show up with a long lens and a Land Rover and compete with them? But in reality I know that is nonsense – my photography has nothing to do with what anyone else is doing and I would never try to emulate them. Maybe as a landscape and travel photographer I could bring a different approach to the subject of wildlife? I wanted to use details, graphic shapes, backgrounds and movement, just as I do in the Andes or on the streets of Hanoi. This trip was all about getting out of my comfort zone by trying something new and challenging. What had I got to lose? If it didn't work I could shrug my shoulders and return to my landscapes knowing it had been fun. And if I did manage to produce just one wildlife image of worth it will have been a success. I also I knew if I finished my photographic career without shooting leopards with a long lens I'd feel I'd missed out. So here we are on the banks of the Shingwedzi River at dawn watching, hearing and smelling Africa awakening.

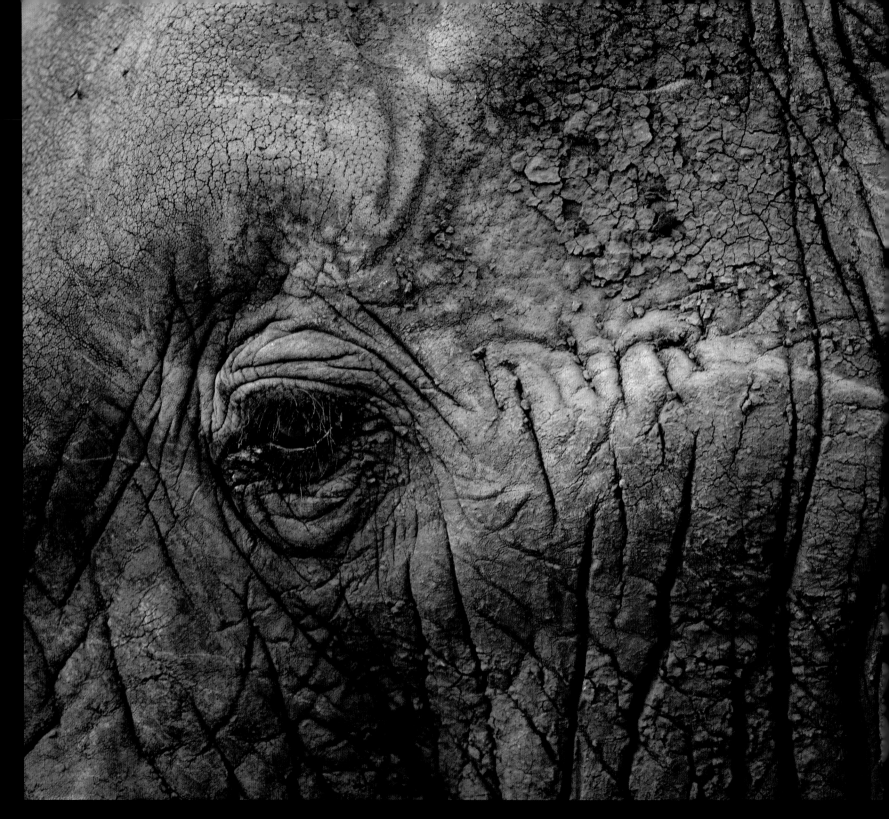

SOUTH AFRICA 1/13 – ELEPHANT EYE

BEFORE We drive along the dirt road slowly, scanning left and right. Being confined to a Land Rover has taken a lot of getting used to. For me, part of the great joy of photography is being part of the landscape, striding across it in search of the ultimate vista. Try that here and you'll end up as breakfast. But, in fact, it's not just about protection. The animals aren't fazed by cars, but a human figure in the bush will send them scarpering. We've done bush walks with armed guides, but you see far more animal activity from a Land Rover than you do on foot.

DURING Time is getting on and we need to get back to camp before dark. As the light fades, just a few hundred meters from the camp gates we come across an elephant munching on a whole tree. We approach gingerly, but thankfully it's preoccupied with supper.

 The elephant's face fills my frame in the cool light of dusk. I dial in ISO 1600 and the old film photographer in me screams. I used to think of ISO 400 as high speed with horrible grain and contrast, but in this digital age it seems anything is possible. I am amazed at the noiseless quality of pictures shot at high ISOs – it's liberating. Even at ISO 1600, at f/4 the exposure is down to 1/100sec – worryingly slow when using a long lens. But the combination of a monopod and Image Stabilization (IS) is a powerful one. I compose, take up first pressure on the

shutter and the focus locks on. Wait for the IS to engage and shoot. Recompose, shoot. The texture of the elephant's skin is incredible, like the surface of the moon. The head comes up, the ears forwards – time to move on.

AFTER It's important to differentiate between using high sensor sensitivity settings out of laziness, because you can't be bothered to carry a tripod, and utilizing the technology available to make a shot that in the past just wouldn't have been possible. The latter was clearly the case here.

 There are cameras available with mind-boggling capabilities – up to ISO 6400 – but there's a trade off between high ISOs and 'noise'. Noise is when the even gradations of tone and colour are disrupted by random dots of colour. The other factor is pixel density, and this will be determined by your camera. A full-frame sensor with 12MP will have a lot less densely packed pixels than a 24MP camera. Higher pixel density means more information and higher resolution with greater scope to reproduce large-scale images. Lower pixel density deprives you of some of that information but allows for stupendously high ISOs. Personally, I'll always go for the high-density option – I want all the information I can get. This image was shot at ISO 1600 and I challenge anyone to spot any noise. I can't think of any recent situation where I've needed to go higher than that.

Detail of an African elephant's face and eye
Kruger National Park, South Africa
Canon EOS-1Ds MKIII, 500mm lens, ISO 1600,
1/100 sec at f/4

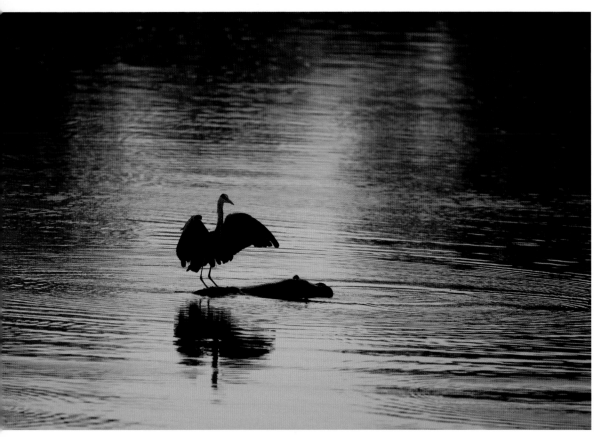

Grey heron landing on a hippo's back
Shingwedzi River, Kruger National Park, South Africa
Canon EOS-1Ds MKIII, 500mm lens, ISO 1000,
1/2700sec at f/4

DURING The orangey hues spreading through the African sky at sunrise reflect in the Shingwedzi River. Four hippopotamuses are wallowing in the muddy waters. From the back of the Land Rover I've got the 500mm lens trained on them, waiting for something to happen. It's a nice shot, but it needs something else. My eye remains glued to the eyepiece, thumb hovering over the auto-focus button, finger on the shutter release. My left index finger rests over the focus lock button far down the end of the camouflaged lens poking out of the window. In from the left swoops a heron. I press the focus button and the Image Stabilization whirrs into life. Lock focus on the hippos. The heron alights on the back of a hippo, which seems totally unperturbed. Expose. The hippo sinks below the surface, the heron flies off in search of another berth and I feel a warm glow.

AFTER For this trip I did contemplate bringing along the small-sensor EOS-1D MKIII for the extra reach it would give me with the long lens (see page 93), but then thought why bother? I've never thought of those APS/Dx formats as anything other than a cropped image area, so it seemed logical to stick with the full-frame quality and crop as and when required, keeping all that 21MP information in reserve.

This morning on the riverbank 500mm wasn't quite enough, so I cropped in a touch, slightly guiltily it has to be admitted. I have subconsciously constructed a set of commandments for my photographic conduct over the years and 'Thou shalt not crop' is one of them. It's far better to use the whole image area and get the composition right in the eyepiece to start with, but that wasn't an option here, so I've done it and still have a large 16MP image. Clearly there's a time and a place for cropping.

SOUTH AFRICA 2/13
– THE HITCHHIKER

BEFORE At home I have two significant collections. One consists of bookshelves stuffed with travel guides and photographic books. The other is a cabinet of some 30 single-malt whiskies. Put the two together and inspiration flows – flights are usually booked the next morning. This trip to South Africa was conceived about a year ago over a glass of Lagavulin and a Wild Places of Southern Africa guidebook.

Once the dates were in the diary, I had the difficult job of dividing the trip into legs and ascertaining the time needed. Experience has taught me that it's better to concentrate on a few select priorities – if you're spending too much time on the road you're not spending enough time behind the lens. So, we operate a three-day rule; we never stay anywhere less than that. But any plans we make have to be flexible as they will probably be changed numerous times on the trip. Detailed deliberations about where to sleep and eat for every night of the journey are a waste of time. We need to react to the local conditions and be adaptable.

SOUTH AFRICA 3/13 – MONKEY CRECHE

BEFORE Often the best way to work is to drive to an attractive spot by a river or waterhole then sit and wait for Africa to come to us. We're sitting in the Land Rover in the late afternoon, Wendy with her binoculars, me with my camera. It helps having two pairs of eyes on watch. This has been our routine for a week now; it's a simple life and it's so much fun, I'm wondering why we've never done it before.

It's late December, early summer here in the Kruger. Everything is green and lush and all the animals have their young in close attendance. The perceived wisdom is that it's better for wildlife viewing to come in the dry season of the South African winter when the animals are drawn to the waterholes and the sparser vegetation is easier to see through. But I've no regrets about coming here now. I love using the lush greenery to shoot through or as a backdrop, and to have the frolicking young about is a real treat.

DURING There's a family of vervet monkeys playing in a tree. I peer through the eyepiece and quickly scan the information in the viewfinder display: exposure, ISO, metering mode, frames left on the memory card and battery status. I've been using autofocus and Image Stabilization a lot and editing in camera, all of which puts great demands on the battery, but I've had no problems yet. Developments in battery capacity have been one of the less glamorous but crucially important of recent advances but it still pays to keep an eye on power reserves. I always have a fully charged spare in reserve, but I wouldn't want to be changing batteries just as the wildlife erupts into action.

The more we do this, the more we realize erupting action is actually very rare. Most animals spend inordinate amounts of time doing very little – sleeping, munching, grooming and lazing in the shade. They don't expend energy unless they have to, apart from the young. These adult monkeys seem to have an expression familiar to all parents – that of resigned patience as the youngsters scamper over them. For a moment, a harmonious family grouping comes together, the autofocus locks on and I expose.

AFTER The South Africans love their braais, or barbecues. Every night back at camp we sit by the glowing barbecue under the stars while reviewing the day's shooting. As soon as a memory card is full I back it up to my M80 portable hard drive. It's got a screen and so I can view my RAW files on it without mains power. The ability to assess what's working and what isn't is handy. It's encouraging to know that there is good stuff being backed up – it makes it all doubly worthwhile and aids the motivation to spring out of bed at 4am again. Plus, I can monitor my progress so far and improve as we go … in theory.

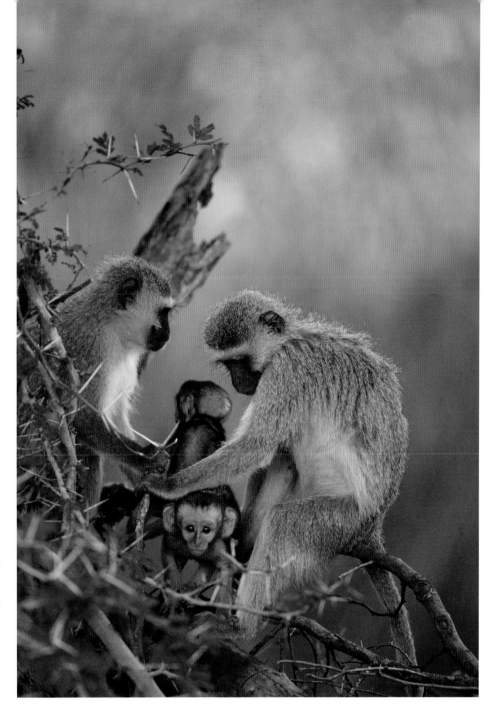

Two adult female vervet monkeys with babies in the bush

Kruger National Park, South Africa
Canon EOS-1Ds MKIII, 500mm lens, ISO 400, 1/400sec at f/4

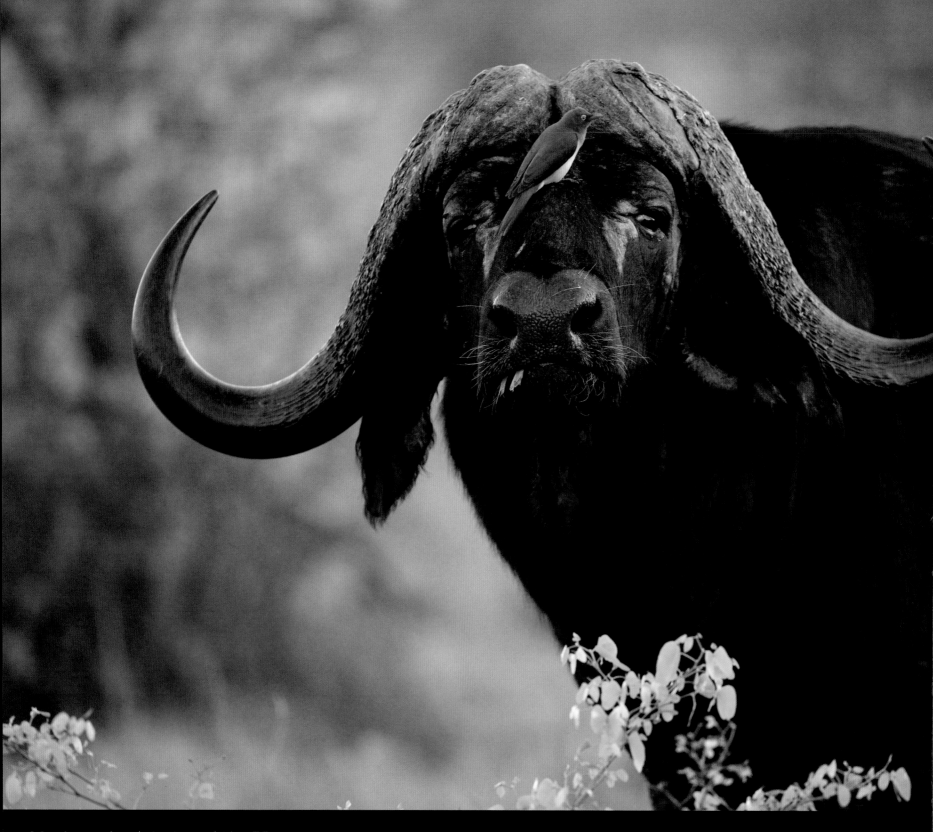

SOUTH AFRICA 4/13 –
A MUTUAL DEPENDANCY

BEFORE We walked out of arrivals at Johannesburg Airport and there was a man holding a sign with my name on it, with a huge case. Inside was a camouflaged Canon 500mm f/4 IS L lens. You'll have seen these immense telephotos with front elements the size of dinner plates bolted on to sports photographers' cameras. They are incredible optics – I used to drool over them – but they are big, expensive and heavy. For this trip I needed the right glass, and the

mode will be fine.

My eyes flick around the information in the viewfinder, checking the exposure. Is the aperture wide open? Is the shutter speed fast enough? Is any exposure compensation still dialled in from the previous shot? Is the ISO setting OK? After a few weeks of working like this my camera craft feels well oiled. The oxpecker lands on the nose of the indifferent buffalo and the shutter clicks.

Out of Africa

There's impala to the left, with a calf so young it's still wet. I swivel the camera round, bashing Wendy in the driver's seat on the back of the head with the lens hood yet again. Not more impala! The first afternoon out shooting from Punda Maria camp they seemed an exotic novelty, and I was so glad to get underway with some wildlife exposures after all the planning and travel. Now they have become an everyday sight and I'm trying to ration myself to an impala quota, only shooting them if it's a unique situation. But it's tough to resist that addictive pressure on the shutter release, and it's not as if I'm spending money on film and processing.

Memory space is, however, an issue. I started this trip with 23 4GB cards and 80GB of backup space on my portable hard drive. Both are filling up alarmingly quickly. I'm rapidly realizing that shooting wildlife with a 21MP camera puts heavy demands on memory space. Five weeks of this lie ahead, so I have to edit in camera as I bounce along on the back seat, deleting images off the card to save space. I've never done that before and it feels wrong, but needs must.

There's an elephant crossing the road ahead. We inch closer, as I become a contortionist trying to lock on with the 500mm out of the window. These super telephotos aren't exactly nifty. There's a trumpeting sound and out of the bush charges the bull, head up, ears forward, trunk raised – definitely not having a good day. Wendy backs up speedily as I try to frame the stroppy bull from a bouncing vehicle at the wrong angle. Afterwards there follows a frank discussion about what our priorities should have been: our lives or the shot? It's clear to me – some people think photography is a matter of life or death but I take it a bit more seriously than that. Strangely, Wendy doesn't quite see it that way. That's the second time this has happened. We're still alive and incredibly still married but maybe we should get a bit better at reading elephant body language.

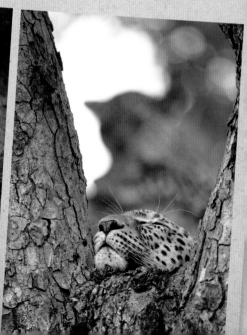

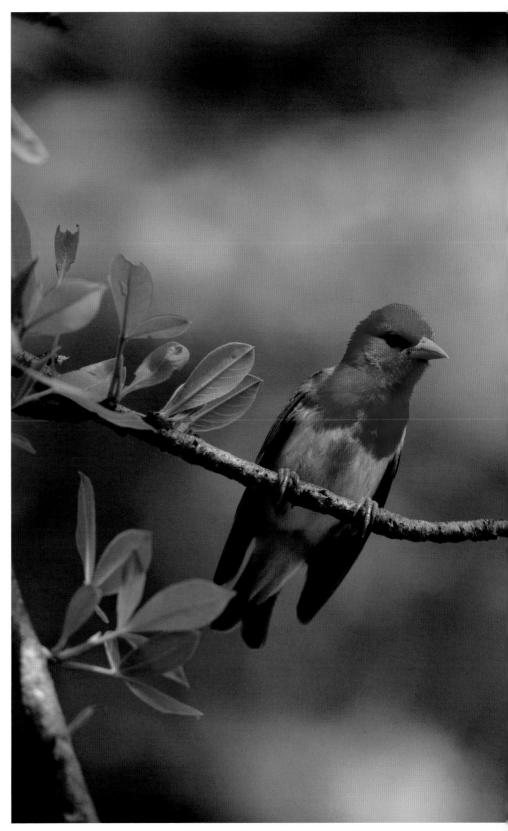

Red headed weaver bird
Kruger National Park, South Africa
Canon EOS-1Ds MKIII, 500mm lens, 14mm
extension ring, ISO 160, 1/320sec at f/4

SOUTH AFRICA 5/13 – WEAVER BIRD

BEFORE After what feels like an eternity of being vehicle bound I'm desperate to get out with the camera on my own two feet. Within the perimeter of Mopani Camp there's a huge baobab tree and I devote one dawn session to just shooting this immense growth. The tree itself is a unique subject that occupies me for an hour, but it is also home to whole communities of wildlife, including these incredibly coloured weaver birds.

DURING Wildlife photographers who devote themselves to shooting birds are presenting themselves with a big challenge. Birds are just too small. Elephants, giraffes and buffalo are all sizable beasts that I've got a chance of filling the frame with. But even with a 500mm lens you have to be so close to birds to avoid the 'tiny speck in the distance' syndrome. Here with these birds I'm below them beneath the spreading branches of the baobab tree shooting up using the sharp early morning light. The contrast of the three primary colours is superb – the red of the birds' plumage, the green vegetation and the deep blue of the African sky – it's a full-throttle colour image.

Between the long lens and the camera I've got a 14mm extension ring fitted, enabling me to focus close enough; the birds are only a couple of metres above me. Straining with the heavy camera/lens combination to shoot hand-held at this angle is hard work and sitting in a Land Rover for the last two weeks hasn't been great conditioning. Photography is a strange game; it can sometimes be intensely physical, at other times totally sedentary. The monopod doesn't extend quite high enough for this shot so I'm supporting the entire weight with my aching arms as I watch the birds flit about. Inevitably after a period of time a pattern begins to become apparent in the birds' movement. One keeps coming back to this twig, and that's my opportunity.

AFTER Extension rings are a really handy item to have stashed away in the depths of the camera bag. For those into close-up imagery a dedicated macro lens is the answer, but for me it's an occasional enthusiasm that doesn't warrant permanently touting around a specialist lens. Extension rings are compact, light and inexpensive and enable any lens to focus very close.

SOUTH AFRICA 6/13 – POST-COITAL GIRAFFES

BEFORE This afternoon the light is a bit flat and hazy, not great for landscape work but for wildlife the lower contrast could be advantageous. We trundle about, stop, wait and listen at a few waterholes but nothing's happening, so we go off into the bush. Close by, two giraffes are mating and I feel like a voyeur, but it's all over quickly. Photographically it's useless; the giraffes' never-ending necks stick up from the scrubby bush against a white, burnt-out sky. This just isn't working. But then they start walking together through the bush, almost in formation. Wendy has got the vehicle moving, following their movement. This is an opportunity for a shot that I've had in mind since we arrived.

DURING I go into tracking mode. Shooting through the trees will confuse the AF so I switch to manual. I set the Image Stabilization to mode 2, where the lens movement is stabilized in the vertical plane only. I drop the ISO down to 100 and dial in a smaller aperture. Logically I should go for shutter priority exposure mode,

but I'm rushing so I just dial in enough aperture to give me a shutter speed of 1/6sec. How do I know what shutter speed to use? It all comes down to experience. Of course you can do test shots, look at the results on the monitor and adjust accordingly, but now there's not time.

The giraffes are moving at a steady pace. Wendy is doing her best to keep us moving in parallel but the potholed track makes a smooth tracking motion difficult. Panning, where the camera is rotated to keep pace with the movement, is a basic photographic skill. Tracking, where both the subject and the camera are in motion, is more difficult. I'm bouncing all over the place but I stick at it, shooting some 50 frames as we move through the bush. I'm filling the frame with their torsos only – who says I need to show all of them? What is crucial is the fore and background – colour and motion blur will make this shot and distracting details will kill it. The giraffes peel off deeper into the bush and the chase is over. I quickly scroll through the images – there's lots of hopeless fudgy blur but one leaps out – it's a possible.

AFTER My laptop has become as essential as my lenses and camera. I can view images immediately on the camera back and also on my portable hard drive but sometimes it's advantageous to process RAW images in the field, just to see what's working and what isn't. I would never tackle the main task of processing and editing on the laptop, that's all done on calibrated systems back in the office, but the ability to review a shoot and test-process a few is handy. With this tracking shoot I need to assess what, if anything, worked so if another opportunity presents itself I will have learnt from this attempt.

Giraffes on the move
Kruger National Park,
South Africa
Canon EOS-1Ds MKIII,
500mm lens, ISO 100, 1/6sec
at f/16

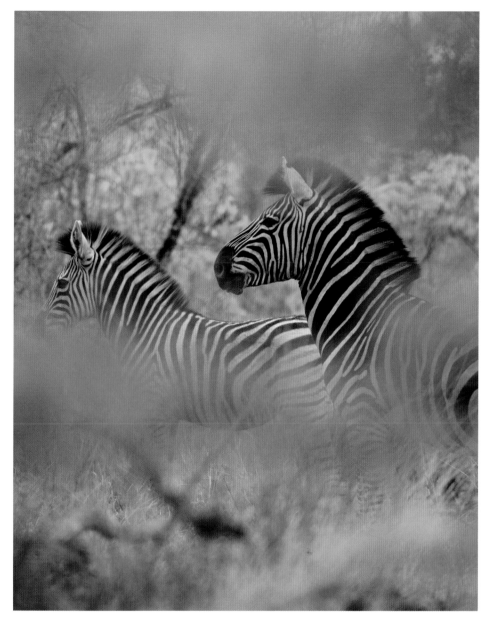

Zebras in the bush
Kruger National Park, South
Africa
Canon EOS-1Ds MKIII,
500mm lens, ISO 400,
1/250sec at f/5

SOUTH AFRICA 7/13 – ZEBRA CROSSING

BEFORE Every trip has its own unique challenges and how we get around is usually one of them. For this trip, we've rented a fully equipped Land Rover. It has got a fridge, roof tent, barbecue, compressor, kitchen sink, spare wheels, table and wine glasses – everything for the outdoor life. I get boyishly keen talking about it, but I've always had a taste for taking 4 x 4s to the places they were designed for. Most of the time we don't need four-wheel

drive but it is reassuring to have the capability, and it's great for working from. The logistics and 'nitty gritty' preparation needed to get us here, watching this group of zebras in the late afternoon light, has been significant, but I do enjoy that aspect of the job. Just as well because the photography – the actual time spent behind the lens – seems like a tiny part of the whole. There is far, far more to this game then cameras and lenses.

DURING Zebras are wonderfully graphic animals. We're watching a group grazing in amongst the mopani trees, but shooting through the vegetation sends the camera's autofocus system into a wobble. It keeps whizzing between the leaves and the zebra, unsure which to lock on to. Overriding its indecision is becoming a pain so I switch to manual.

The vegetation in the foreground makes some wonderful green blobs in the frame. With these kinds of images the out-of-focus elements are as important as the sharp bits. It's another session nailed. Our slightly random approach to wildlife photography seems to be working. The trip has a tangible rhythm and momentum now; it's a satisfying stage to be at. The only really tough decision to make each evening is what to slap on the barbie. It won't last of course but for now we're revelling in it.

AFTER Evening, and we're sitting back at camp listening to the night fall over Africa. The amount of life here is staggering, just on the campsite we can sit and watch all manner of wildlife pass by. Right now every insect in Africa is making a beeline for Wendy. It always happens; I sit unmolested in perfect harmony with nature while repeated waves of mosquitoes and bugs feed on her flesh. I can't blame them; if I were an insect I'd devour her too. She's frantically rubbing in repellent, but it's usually a hopeless cause. This trip she seems to have made a breakthrough through – 'Skin So Soft' as used by the SAS seems to be working.

The sounds of Africa permeate our conscience. Camped up close to the perimeter fence at Punda Maria, the night is full of all sorts of snorting, rustling and tromping noises seemingly right outside our tent. And then a lion starts roaring, the call resonating through the bush. The call is instantly picked up by others in the pride and the hairs on the back of my neck stand up.

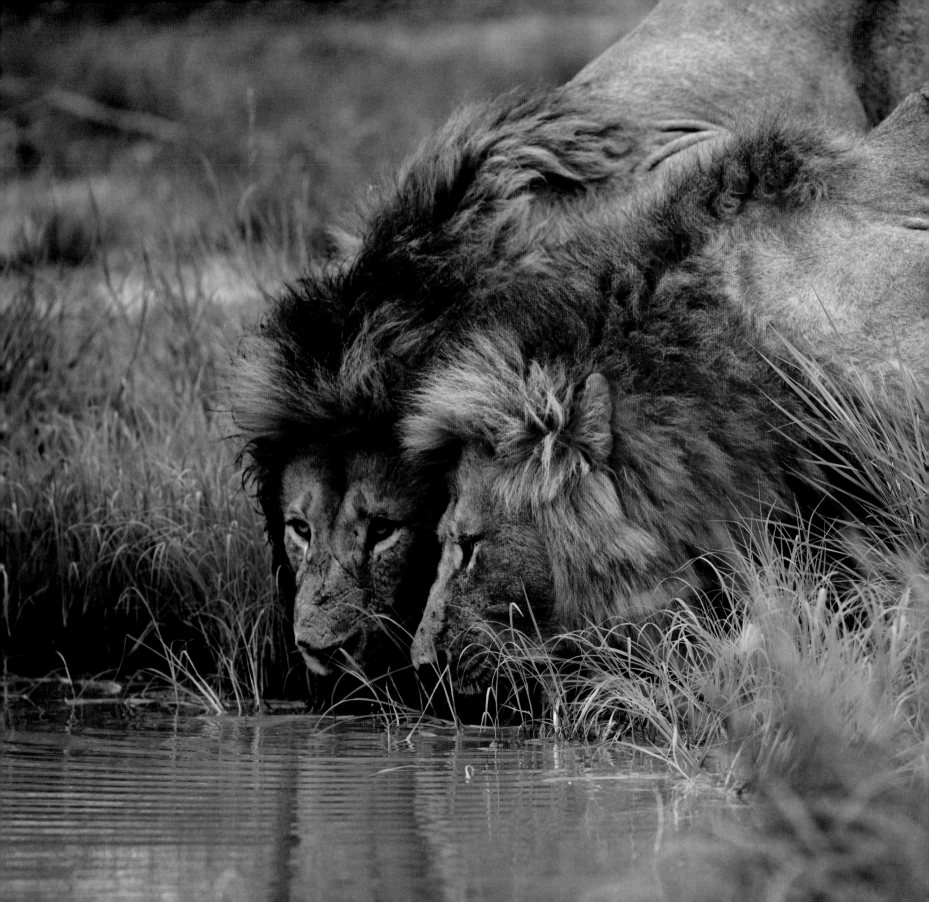

BEFORE You can't beat local knowledge. Our independent wanderings in the Kruger have been a success, but for the last few days we're at Ngala Game Reserve on the fringe of the Park where we have the benefit of both a guide and a native tracker. JP is our guide and we instantly hit it off. His knowledge of the bush is formidable and he immediately understands my requirements as a photographer. Richard is our tracker; he is a man of few words but meaningful gestures. He sits on a perch overhanging the front quarter of our open-topped Land Rover communicating with JP with the merest nod or hand signal. JP is in radio contact with the other guides in the reserve, reporting sightings and movements. With this level of expertise batting for us, we feel that good things should happen.

We've had some great wildlife encounters so far, with the exception of big cats. Now the advantage of having Richard and JP on our side becomes evident. Richard points to a tree several hundred meters away; there's a leopard in it, apparently. At this distance we can see nothing; how did he know that? Edging closer, the forms of two leopards dozing in the branches become clear.

DURING A short while later and we've found three male lions, all brothers. Several hours spent watching them, shooting them sleeping, then yawning and frolicking has passed like five minutes. It's an eerie experience to be sitting in an open-topped vehicle just metres from lions, but they seem totally unfazed. They look right through us as if we don't exist.

Just as the sun is about to disappear, two of the brothers come down to the water to drink. JP has anticipated this and we're in a prime spot. As they stoop to drink I lock on, ISO 800 in the fading light, wide open as usual. The last weak but golden rays of light illuminate the flanks of the nearest lion. As I'm shooting I know this is about as good as it gets. Stay calm, make the shot, pay attention to the details. The tones of the warm light on the lions' manes contrast with the lush greens of the vegetation and the symmetry of their two poses combine fleetingly. That was it – that could be The Shot of the trip.

AFTER Driving back to camp in the darkness, Richard is sitting up front on his perch with a high-powered torch scanning the bush. To me it seems like a pointless activity, what can we possibly see? He's on the lookout for the telltale pinpricks of light reflecting back from the retina of creatures of the night. We're trundling along at a reasonable speed when Richard gestures to stop. There in his light is a tiny bush baby staring back at us. How did he pick that up? I am totally in awe of his powers.

Lions drinking from a waterhole at dusk
Ngala Game Reserve, Kruger National Park, South Africa
Canon EOS-1Ds MKIII, 500mm lens, ISO 800, 1/125sec at f/4

BEFORE Last night something ate Wendy's safari hat and this morning a black mamba, the most deadly snake in Africa, was discovered in the swimming pool. I think the pool attendant is somewhat freaked out. On this morning's game drive, JP revealed himself as the font of all knowledge on dung beetles; I'm wondering if we can race them. Later we watched flocks of vultures feeding on a carcass. A clear pecking order was in evidence as they queued in an orderly manner that would do Sherborne Post Office proud as they waited for their turn with the rotting flesh. The light was too harsh by then but I carried on shooting regardless, the practise of follow-focusing the giant birds as they swept in on final approach was handy, and fun.

DURING It's official – leopards are the most beautiful creatures on earth. Here at Ngala we keep coming across them and it's a real treat. By the looks of their bellies, now must be a fruitful time for them with lots of young, vulnerable springbok and the like about. They do spend an inordinate amount of time sleeping off their meals in trees though, and that makes them difficult to photograph. The combination of a dozing leopard on a shady branch against a burnt-out sky is a photographic nightmare. Despite our repeated encounters I don't yet feel I've made a worthwhile leopard shot, and it's starting to rankle.

We come across another leopard in a tree with a kill. She's panting with the effort of digestion and her belly is distended. I ask JP to ease us into a position where she's backlit by the late afternoon sun and we settle down to watch and wait. Then, inexplicably, she descends from the tree and sprawls on the ground not five metres from us. She is still backlit with some dappled vegetation between us; this is a perfect opportunity for a leopard portrait. For a moment, which seems to last minutes, she and I share direct eye contact. Captivating.

AFTER The quality and direction of the light is fundamentally important for all types of photography. Front, back and side lighting, with various permutations of all three, all have their pros and cons, but it is particularly tricky to preconceive the lighting of wildlife, as animals are contrary creatures who rarely read the script. I just don't know where they're going to end up. A skill that we're learning as we go is working with the driver, first Wendy and now JP, to manoeuvre into a position that is a good vantage point but that also avoids the harsh full-frontal glare of the African sun. Backlighting is my chosen default setting for wildlife. It gives pleasing rim lighting to this leopard.

Leopard resting in the bush
Ngala Game Reserve, Kruger National Park, South Africa
Canon EOS-1Ds MKIII, 500mm lens, ISO 200,
1/200sec at f/4

Yawning lioness in the bush
Ngala Game Reserve, Kruger National Park, South Africa
Canon EOS-1Ds MKIII, 500mm lens, ISO 125, 1/250sec at f/4

SOUTH AFRICA 10/13 – LION SIESTA

BEFORE Our time in Kruger National Park is coming to a close. Time is the currency we are all short of and despite having five weeks here in South Africa, it's not enough, it never is. The trip is not yet over, we go from here to the Drakensberg Mountains, but the wildlife phase of it shortly will be. We've just been watching an elephant chasing a hippo? Why? Time of the month or just for fun? It's these kind of unpredictable events that have made this trip.

DURING On today's menu to finish we have a pride of 11 lions dozing in the shade. Richard is sitting up front looking bored; he's seen it all before. JP in contrast is perky; he's getting a buzz from being an important factor in the making of these pictures. Every strong image that comes up on the screen I show to him. It's not just motivational for us, it is for him too. I find the ability to show a glowing image on the monitor immediately to people who have helped us an invaluable and unforeseen bonus of the digital age.

The light is beautifully dappled under the trees and the usual out-of-focus elements do their trick. It's a formula I've used a lot here but I'm getting better at it all the time. As usual, the camera is in aperture priority exposure mode. The first thing I consider is depth of field – I want as little as possible for the diffuse effects in the fore and background so I'm wide open at f/4. I then consider shutter speed and if necessary increase the ISO to give me a usable shutter speed.

Some people have a misplaced belief that using manual exposure mode is somehow more serious and 'proper'. Actually manual mode gives no more control than auto, it's more ponderous and the time spent readjusting both aperture and shutter speed can make the difference between an evening of euphoria or a dismal night lamenting the shot that got away. As the light changes, the ability to dial in plus or minus exposure compensation speedily makes auto exposure a very flexible mode.

AFTER Dusk in the bush is a time of tranquillity as Africa cools and settles for the night. Here that time is doubly special with the great South African tradition of sundowners. JP and Richard select an area surrounded by open ground deemed to be safe for us to dismount and proceed to set up an impromptu bush bar. I'm really warming to these guys. They have the lot – gin and tonic, Castle beer, Sauvignon Blanc and the rest. What a way to work! Sipping my cold one I'm watching a single rhino watching us. I am so glad we decided to tackle the whole wildlife challenge here. Already I'm planning our next African adventure – the Zambezi, the Kalahari, the Okavango…?

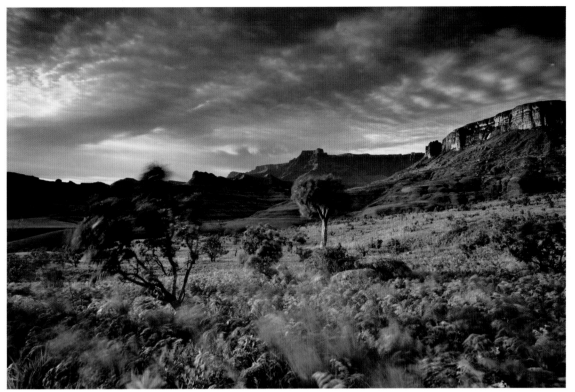

The Amphitheatre
Royal Natal National Park,
Drakensberg Mountains,
KwaZulu-Natal, South Africa
Canon EOS-1Ds MKIII,
16–35mm lens, 0.9 ND grad
filter, ISO 50, 0.6sec at f/14

SOUTH AFRICA 11/13
– THE AMPHITHEATRE

BEFORE Finding photographic paradise – gorgeous light, dramatic skies and evocative locations – is rarely easy. It takes time and effort, but there are worse ways to spend a day than tramping the trails of the Drakensberg Mountains. Coming down from the escarpment after a long day, we come across The View. Lush sugar bushes and cabbage trees carpet the valley and beyond them rises the Amphitheatre.

Late afternoon, and the sun has disappeared behind black clouds massing over the mountains. It's a daily occurrence here; the midday sun heats the bare rocky massif, which then proceeds to build its own weather system, with rain late afternoon and overnight before clearing again in the morning. The trouble is, those stormy skies have so far still been lurking at dawn, and crisp early morning light is what I need. It's Day 5 and I've yet to nail The Shot.

DURING Pre-dawn on Day Six , I stick my head out of the tent and scan the sky, which doesn't look promising. But the puritan work ethic forces us up the hill on yet another dawn patrol. I extend the tripod legs, more out of habit than hope. There's a fresh breeze blowing and the cloud cover starts to marble, the odd gap appears. Maybe, just maybe. Camera out and on the head, check I've returned to default settings – I don't want to be shooting a landscape at ISO 1600. The 16–35mm lens on, filter ring attached, holder with 0.6 ND grad, spirit level, cable release. Frame and compose, check everything's tight, select mirror lock up. The greenery is swaying nicely in the breeze. I dial in ISO 50 and reach for the 0.9 ND to slow the exposure further. The cloud cover is dissolving into ripples spreading across the sky – this is looking really good.

Strong light comes arcing across the landscape, transforming the scene. These are the moments I live for – these few seconds of liquid gold illumination. I'm working the camera as quickly as I can, checking my exposures with the histograms, watching the highlights. The light gets harsher as the sun quickly rises. I recompose to expose a vertical, try a different composition, but in my heart I know the first light was the best.

AFTER Are filters necessary in the digital age? Exposure blending, whereby multiple frames of different exposures are combined, is a useful technique – I use it frequently. But sometimes, when the world is swaying in front of the lens, it all has to be done in one frame. Maybe I'm a dinosaur but I believe that's a good discipline to have anyway: get it right in-camera and time spent in front of the computer is minimized. With this shot, the movement of the vegetation would make getting a perfect seam between two or more exposures that withstood examination at 100 per cent magnification nigh on impossible. And so the humble, dyed resin neutral density filter lives on.

SOUTH AFRICA 12/13 – TUGELA RIVER

BEFORE I'm standing in a river at dawn, waiting for the light. The waters surge around my knees, now pleasantly cool after their descent from the heights of the escarpment. After weeks of being confined to a Land Rover shooting wildlife it's good to be back on foot in landscape mode. I don't believe there's anything in the immediate vicinity here that is likely to eat us, but you never know. The twilight is seeping through the sky as I rummage in my Lowepro for the cable release, struggling not to drop the whole lot in the rushing water. The torrent is causing me some concern; will the tripod be stable? The Giotto's legs are firmly anchored on rocks but I'm worried the river's energy will cause vibration. This lightweight carbon fibre tripod still causes me unease, even after months of hard duty in foreign fields. There's only one way to find out. I do a test shot and zoom in on the monitor. All looks crisp; I'm in business.

It's an evocative setting, far more dramatic and impressive than the pictures I'd seen previously led me to believe. From the endless veld of KwaZulu-Natal, the Drakensberg Mountains rise up in a long jagged escarpment of soaring cliffs, deep gorges and waterfalls. It is a uniquely African landscape; the vegetation, the geography and the nature of light are totally different from the soft countryside of my home county of Somerset.

DURING I'm waiting for the light to paint the landscape as it creeps down the cliffs of the Amphitheatre. With the 16–35mm f/2.8 lens on I'm as wide as I can go. Oh, the joys of full-frame exposures! I'm using a 0.9 ND filter to slow the world down and a 0.9 ND grad to hold back the exposure on the sky. The clouds over the mountains are now picking up the subtle pinks and mauves of dawn, and the highest cliffs are starting to glow golden. This is what I've been waiting for. I've dialled in the lowest possible ISO of 50 to enable me to record a bit of movement on the babbling Tugela. A six-second exposure at f/14 blurs the water sufficiently without having to use a smaller aperture with the attendant diffraction problems. Expose, check exposures, expose again. Clouds on the eastern horizon are starting to march in, fizzling out the light. I wait, contemplating the scene, scanning the sky, hoping for a break. Half an hour later it's clear it's over, that glimmer lasting just a few minutes was the decisive moment. How long do we have to wait until the next one?

AFTER By mid morning the sun burns through and the temperature soars. We're out hiking, high up in the hills with sweaty backs, location searching. This is the daily routine of a landscape photographer. Shoot, location find, shoot. Mother Nature interrupts the actual photographic sessions randomly, but the never-ending task of finding promising locations goes on and on relentlessly.

The Tugela River and Amphitheatre at dawn
Royal Natal National Park, Drakensberg Mountains,
KwaZulu-Natal, South Africa
Canon EOS-1Ds MKIII, 16–35mm lens,
0.9 ND and 0.9 ND grad filters, ISO 50, 6.2sec at f/14

SOUTH AFRICA 13/13 – STORM BREWING

BEFORE What is the perfect length for a photographic trip? About six weeks: long enough to really get into it, to be adventurous, self-indulgent and to forget about the real world. In truth there's never enough time – compromises have to be made and agendas curtailed – but go any longer than six weeks and I find myself losing the edge, slowing down and getting blasé about yet another stunning vista. Plus the editing mountain starts to look increasingly imposing. We are near the end of this highly productive trip with a full-to-capacity hard drive. Now, in the last few days I will try to squeeze out a few more shots knowing that whatever I make will be a bonus.

The Drakensberg range rises up from the rolling farmland of KwaZulu-Natal as a long rocky ridge, punctuated by gorges and cliffs. It's a big landscape with endlessly changing skies – a photographer's delight. After weeks camping out, we've rented a comfortable chalet with a fantastic view of it. It's a good place to finish and I can work this scene over the next two days to see what I can make of it in different lighting situations. It often it pays to use whatever is on your doorstep, so that's exactly what I'm going to do.

DURING As the day wears on, ominous clouds start to build. The sun is setting, but it has long since been lost behind the towering clouds. It doesn't look hopeful, nature may impose an evening off whatever my good intentions.

So I sit on the deck, watching the dusk settle. Thunder can be heard to the west and the odd flash of lightning flickers over the mountains. I've got the camera ready on the tripod just in case.

The colour temperature of the ambient light is soaring as the light fades, giving the scene a cool, threatening mood. Clouds are rolling off the escarpment, marbling and swirling. I frame the composition to emphasize the anger of the heavens. I'm using the 24–70mm f/2.8 lens with a 0.9 ND grad to help balance the exposure difference between the sky and the landscape. But with no light on the valley it is still too much of a contrast range to handle in one exposure so I'll have to do two and blend them together on the computer (see page 64). For just a few minutes the sky is a marbled canvas, blue and swirling, absolutely beautiful in its elemental simplicity.

AFTER Afterwards I scroll through the shoot. Look at that sky! No one will believe this image isn't an example of Photoshop manipulation or HDR wizardry. There is no doubt I ventured well beyond my own photographic comfort zone on this trip. Tackling wildlife photography risked a substantial investment of time and money. Was it worth it? Without a doubt. I feel photographically refreshed and motivated to do more in other tantalizing wild destinations. Ultimately it was also plain fun for both of us, and that is what photography should be all about.

**A moody evening sky over the
Tugela Valley with the Drakensberg
Mountains beyond**
KwaZulu-Natal, South Africa
*Canon EOS-1Ds MKIII, 24–70mm lens, 0.9 ND
grad filter, ISO 100, two merged expsures*

Laos
5.Wide open

I have an ongoing love affair with South East Asia. I came to the region on one of my earliest extended solely photographic trips when I was cutting my teeth as a travel photographer and in fact I'm here now, writing this book in Thailand. Quite frankly it's difficult for a year to pass without inventing the excuse for a few weeks in Siam, Cambodia, Vietnam or Malaysia. With Bangkok being such a gateway to all points east it's not difficult to engineer at least a protracted stopover to score some noodles. So I've got to know the area well from Hanoi to Singapore and the folders from this area in our constantly swelling library of images are correspondingly extensive. Burma is the main destination that still awaits us, when they stop shooting monks there it will be a possibility. But one former province of French Indo-China had been neglected: Laos. Now was the time.

Thoughts on what the objectives of the trip should be were embarrassingly vague. Perhaps over-familiarity with the region bred insouciance. A hectic schedule in the month before departure meant we were on the flight to Bangkok before I'd really had time to think about the trip at all. Almost by default I settled into a kind of comfort zone for aspirations from a shoot. Evocative landscapes featuring forest-clad mountains and temples bathed in lush, crystal-clear tropical light seemed like the way to go; the odd market and portrait would help. It was a trip done almost as an afterthought. Just before we left, a chance acquisition of one lens sewed the seed of an idea that would eventually flourish, but for now it lay dormant.

In the event I had a rude awakening. Little of what I'd lazily assumed should be the objectives would be possible. It was a journey that in the end tested and pushed my photography more then any other in recent years. There are times when, as in Bali, I need to stick with an idea through thick and thin and hopefully triumph through persistence. But sometimes the tide of events is against me and no amount of stubborn doggedness will change it. Turn what seems like adversity to advantage. Be flexible, go with the flow and make things happen. It all sounds slightly Buddhist really. How apt.

LAOS 3/9 – LAO LADS

BEFORE I'm riding back to base after a fruitless dawn patrol. The sun is up and but struggling to make an impression on the ash-laden sky. Little particles of burnt matter gradually fall from the sky, it's like a volcano has erupted. Passing through a typical Lao village, a woman is sauntering along leading her infant. She smiles at as I approach and for no explicable reason I decide to stop and talk to her. Imagine doing that at home – stopping the car and talking to a perfect stranger for no reason in a language she can't understand. But here it feels a perfectly natural thing to do.

DURING So I stop and, as we converse with all of three common words, I leisurely open the Lowepro on the saddle of my moped, take out my camera body, detach the body cap, attach the 24mm lens, fiddle with the wide-angle adaptor ring, attach the filter holder and slip in the 0.9 ND grad. I then proceed to take shots of her with infant – it's rubbish. But often I need to work the situation and the first fairly useless images are just something I've got to go through to warm up. It's almost like I'm buying time.

As usual, by stopping here I've become an object of curiosity and three lads have come from nowhere to gawp. I turn the camera on them, which sets them into fits of laughter. From the corner of my eye I see some cattle being driven down the street. I angle myself around to use the dirt road as a backdrop with the cattle, village and mountains all quintessentially Lao elements. I'm using the 24mm glass wide open again at f/1.4. I'm getting hooked on this approach – the background is wonderfully blurry, giving a sense of place without being distracting.

AFTER Extremely fast wide-angle lenses such as this one rarely have a completely even coverage when used at maximum aperture. The edges and corners of the frame appear darker than the centre. Stop down a few notches and the problem is sorted. Fast lenses are usually stunningly crisp, as this one is, so it's a tempting but expensive bit of glass to have in the bag. Working wide open the uneven coverage is noticeable. I could easily correct it using the vignetting control in my RAW software, but I choose not to. It's all part of the feel this lens is giving my images when used this way in this light. Sometimes a new lens or format will serve as a catalyst for a whole new way of looking. It's all part of the evolutionary process.

Three young boys
Near Vang Vieng, Laos
Canon EOS-1Ds MKIII, 24mm lens, 0.9 ND grad filter, ISO 100, 1/1600sec at f/1.4

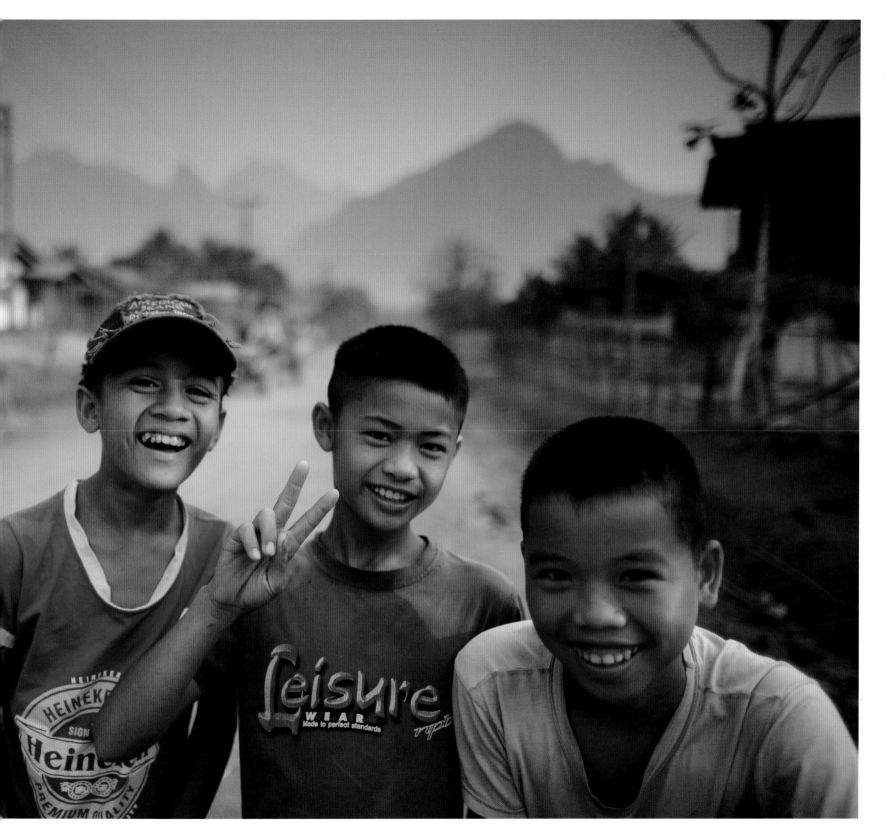

BEFORE The view at Vang Vieng is spectacular. There's just one problem; we can barely see it. An inconvenient truth has crept up on us since we've arrived; the air quality is absolutely appalling. Thick heavy smog lies over northern Laos and this time I'm not rueing Mother Nature's contrariness – this is all the work of man and the finger of blame points at Lao farmers. Their practice of 'slash and burn', established over generations to stimulate new growth, leaves whole swathes of countryside looking post-apocalyptic and dumps huge amounts of ash into the atmosphere. It seems an incredible act of short-sighted eco-vandalism but it is happening across vast tracts of Asia. Quite apart from the rape of the countryside this was bad news for us; any shots with distant views would be impossible under this layer of airborne grot.

DURING It's the first evening here and I'm composing a shot using these boats as graphic shapes in the foreground with the river and Karst mountain landscape at dusk beyond. I've got the super-wide 14mm f/2.8 lens on and, as the sun settles into the murk, I make a series of exposures. This lens is fully corrected so unlike my 15mm fish-eye lens it doesn't distort at the edges of the frame. It's so wide, though, that using filters with it is impossible; the front element is a bulging sensuous curve. So I do two exposures about 3 stops apart, one for the landscape and one for the sky. I'll merge them subsequently in Photoshop.

But as I'm exposing I know that this isn't really working. The shot could be strong with the last light filtering through a dramatic evening sky, but if this is the norm we've got to think again.

AFTER Exposure blending is a handy technique to learn that is actually very simple. With both images open in Photoshop I just roughly select the sky from one shot using the Lasso tool, feather the selection over, say, 250 pixels and then drag and drop the selection into place as a layer on the other image. That's one very simple and fast way, but you can make the process as complicated as you like with all sorts of tricks using masking and erasing to really confuse the issue. I'll stick with the simple, speedy solution. It works for me.

Boats on the Nam Song River
Vang Vieng, Laos
Canon EOS-1Ds MKIII, 14mm lens, ISO 100, two merged exposures

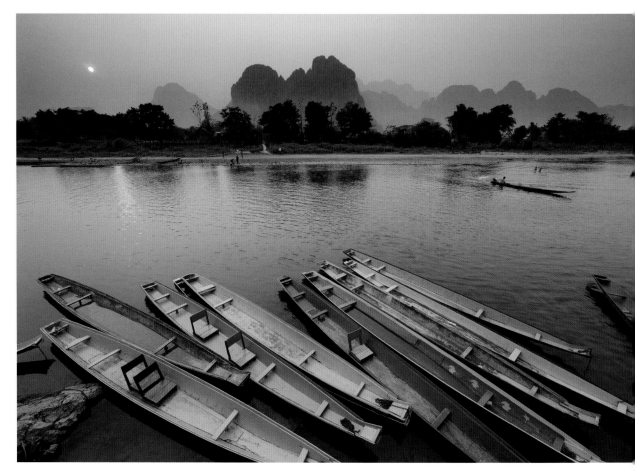

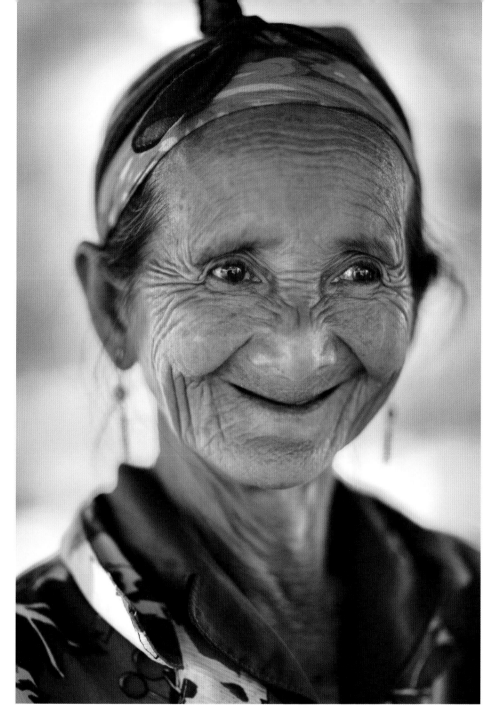

Portrait of a woman
Near Vang Vieng, Laos
Canon EOS-1Ds MKIII,
85mm lens, ISO 100, 1/400sec
at f/1.2

LAOS 2/9 – A GRACIOUS SMILE

BEFORE Now that I have a plan the whole tone of the trip has changed. I sense a lifting of a burden; we have clear objectives that will make the hazy conditions an asset rather then an obstacle. The opportunities for travel portraits won't just fall in my lap, we'll have to go in search of them. Every potential opportunity will have to be seized, there'll be no walking by, no wistful regrets about the shot that I let slip by. I'm aided immeasurably by the people themselves, who seem to have such open, friendly faces. They have no hang-ups about being photographed, in fact some have even thanked me for taking their picture. It's a real treat.

DURING There is a hut by a ford that we keep ending up at. It's a great place to sit in the shade and watch the world go by, plus the smiley lady makes the best fried rice we've had. Mrs Smiley is a real character whose face is wonderfully expressive but the lighting is challenging. We're under a shelter so the light on her face is diffuse, but the background is brightly lit by the harsh midday sun. The contrast range between the two is massive. I could ask her to move and set up a shot with a darker background but that would kill the spontaneity. So with the 85mm lens wide open at f/1.2 I see what I can do.

On the first test exposure 'blinkies' in the background indicate tortured highlights. I dial in a touch of underexposure but my hands are tied, I daren't go too low or her face will record as a dark blob against the brightness. It is inevitable that I will lose some detail in the background. I'm not averse to a high-key feel to the image but a totally burnt-out backdrop won't work. I'll go for it and just see what detail I can recover in processing, leaning heavily on the exposure latitude of the RAW image.

AFTER I made two conversions of the same RAW image: one concentrating on her face, and the other on the background. It soon became apparent that the colour just distracted; in black and white the tones on her face were far more appealing. Because the camera exposure was a delicate balancing act, the face conversion needed lightening using the Curves tool. The background conversion had the Levels dropped right down and every bit of highlight recovery available dialled in to aid the abused highlights. I was amazed by how much I could recover. All of this was done to the original RAW exposure in Capture One and the two conversions were then merged in Photoshop. I'm pleased with the final result; it just shows what can be done with a feeling for the exposure latitude of the medium. Here again I'd learnt something useful, and squeezed a picture out of a situation I'd never have attempted some years ago.

LAOS 4/9 – A LAO MONA LISA

BEFORE After the last few shoots I have realized that my whole approach to this trip has to change. Unless this blanket of heavy ash-filled air is blown away by cleansing tempests, I'm going to have to work with the hazy, soft light, not fight it. This light is lousy for landscapes but great for portraits, and the people here are friendly, open and responsive to photography, so let's go with that.

For this trip I have acquired a super-fast 24mm f/1.4 lens and I want to experiment with environmental travel portraits using this optic wide open to locate the subject in the landscape with just enough detail in the background to give a sense of place. It's a plan, and as it gathers steam in my head I'm filled with uplifting resolve.

DURING I get to my spot before sunrise, giving myself time to think through my approach. Preparation is everything in photography. The backdrop of mountains and river is quintessentially Lao. I want to use the river scene as a backdrop, but out of focus. With the 24mm, I'll shoot wide open at f/1.4, using single shot autofocus. I'll need a 0.6 ND grad on to hold the sky, but I'll have to be careful with the composition to avoid the gradation intruding on to the crown of the subject. At this aperture ISO 100 is plenty fast enough. I do a test exposure, and dial in +2/3 exposure compensation using aperture priority evaluative metering, and I'm ready. All I need is a subject.

A Lao tractor trundles through the ford. Kids cycle past on their way to school. A few children emerge from a house to stare, point and giggle. One girl stands apart from the group, watching me intently. I know instinctively she is the face of Laos. As I kneel down to position her in the frame, the soft warm light from the rising sun weakly side lights her face with a wonderfully diffuse glow. At this focal length I need to be uncomfortably close but it doesn't bother her. I half depress the shutter, lock focus on her eyes and recompose. Done. Five frames are exposed, all with that haunting look. That's it, that's The Shot of the trip.

AFTER Over a period of time I get to know when an image has really worked. There is something about this picture that connects with people. Often when I'm giving talks I can hear a collective sigh go through the audience when this image comes on the screen. I don't think it's anything to do with me; it's her. She's my Mona Lisa. Her beguiling expression leaves a lot to the imagination. I can't help wondering what her future will be. There was so much for me to learn from how this image came together. Here I am after a quarter of a century as a pro, still learning as I go. Maybe I'll start getting the hang of it soon.

Portrait of a young girl
Near Vang Vieng, Laos
Canon EOS-1Ds MKIII,
24mm lens, ISO 100,
1/800sec at f/1.4

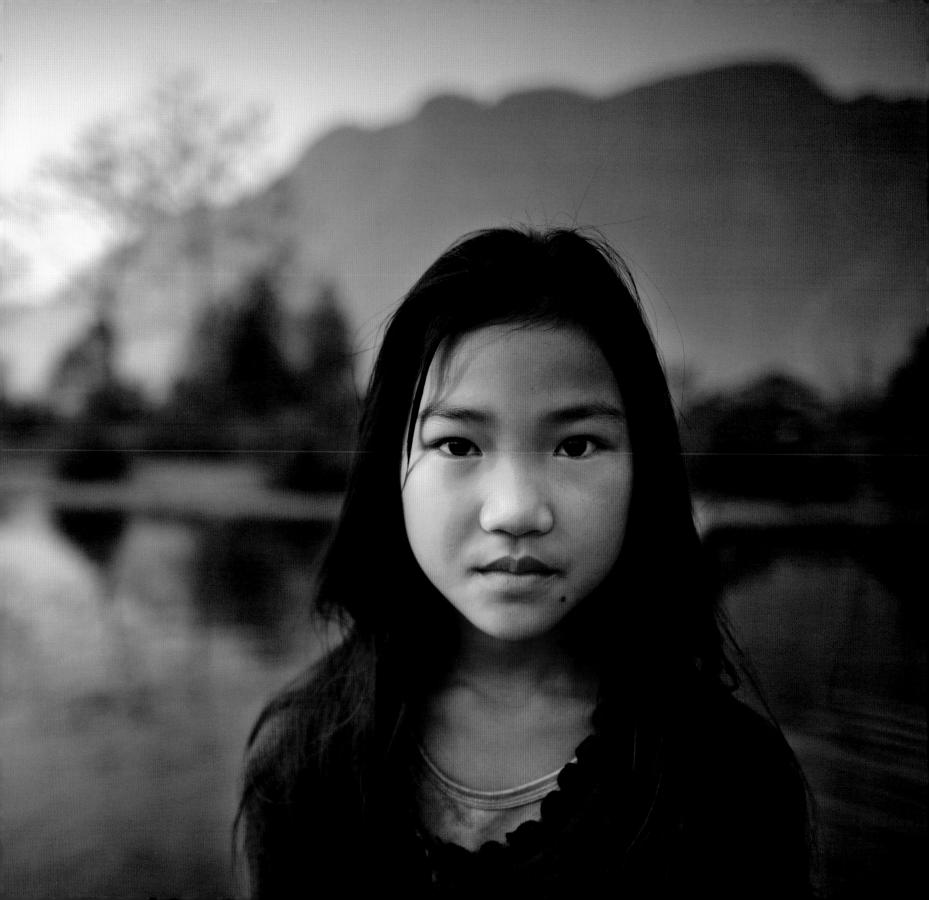

Smoke on the Water

Airports are a pretty good place to get a feel for the state of governance of a country. The amount of gold braid on the immigration officials' shoulders and caps, the demands for hard cash in US dollars for a visa to get into the country, the size of the stamp in the passport, and the look of blank incomprehension and indifference by the clerk at the hotel information desk when we asked for some information on hotels said it all.

Welcome to the Lao People's Democratic Republic; did anyone ever seriously think communism works? Luckily the airport was the only place we had to deal with Lao officialdom. Walk through the doors and you're into a sleepy, largely forgotten backwater of South East Asia where PDR could equally stand for Please Don't Rush. Immediately in the capital, Vientianne, the French influence is evident; baguettes for sale and market squares lined with cafés with more then a hint of Lyon nestle in amongst the tuk tuks and noodle stalls. It's an exotic mix.

Laos has the dubious distinction of being the most bombed country in the world, a legacy of its disastrous proximity to the Ho Chi Minh trail in the Vietnam War. That legacy is still manifest in the number of invalids we see hobbling around. Mines and cluster bombs still litter the countryside. I'm trying not to think about that too much when I trudge through fields in search of locations.

We're now in Vang Vieng, a fairly charmless town strung out along the road heading north to Luang Prabang. It's very much on the backpacker trail and rows of bars show endless repeats of *Friends* to bored gap-year trekkers. Rats, Ritz crackers and rice are for sale in the market, you can get your laundry done for 8000 Kip a kilo, have a banana pancake and buy the local whisky by the shot, glass or bucket. But what Vang Vieng lacks in ambience it makes up for in scenery. The town sits on the banks of the Nam Song River and the view across the flowing waters to the dome-like Karst Mountains looming above the fields and villages of rural Laos is to die for. That countryside will be our playground this trip.

Procession of monks through the town at dawn to collect gifts of food
Luang Prabang, Laos
Canon EOS-1Ds MKIII, 24mm lens, ISO 100, 0.5sec at f/10

LAOS 5/9 – MONKS IN MOTION

BEFORE We have moved on to Luang Prabang. A long day in a cramped minibus brought us here through the singed countryside. The twisting mountain roads revealed sweeping but hazy views of the fire-scarred landscape. Here on the banks of the Mekong River the smog is even worse then Vang Vieng, but sleepy Luang Prabang has a totally different feel. It's a UNESCO World Heritage Site full of temples. And LP is famous for two things – monks and silk.

I would challenge any photographer to come to South East Asia and not shoot pictures of monks. It would be like going to Venice and not shooting gondolas. They are so colourful and evocative of the region and all things Buddhist. Every morning at dawn all the monks in Luang Prabang walk in procession through the town to collect gifts of food from the public. So the immediate future seems bright and orange despite the gloomy light. I feel a monk-fest coming on.

DURING I'm crouching on a mat on the pavement at dawn with a bowl of sticky rice by my side. This is a new one. A long line of orange-sashed monks is shuffling by, each carrying their own bowl to accept the donations. Every so often I take a handful of the rice

and deposit it in one of their passing bowls. Then I get back to the business of exposing wide-angle panning shots as they pass. I get all alternative with the composition here and chop their heads off. Long lines of orange snake around the town. Another few monks pass; time to go back to rice ladling.

The theory is I'm supposed to remain lower then the monks as I offer up the gift. The enforced low perspective is giving a unique angle on it all. I started off shooting long lens compressed perspective shots of the approaching line of monks but now I've gone wide and slow and I'm seeing vibrant splashes of blurry, swirly orange on my monitor.

AFTER The art of composition is one of those things that can't be taught. There are guidelines, rules and theories of course. But essentially the blindingly obvious fact remains that composing a picture is just about the arrangement of shapes in a pleasing fashion within the frame, and the simpler and bolder that arrangement the better. The number one error novice photographers make is including too much clutter within the frame. The best pictures are the simplest. Composition is the art of knowing what to leave out.

Another way to give compositions an immediate boost of boldness is to change viewpoints. Pictures taken from a safe distance at head height rarely set the world on fire. As with this morning's monk march-past, an unusual vantage point can enliven pictures. I had a photography tutor at college whose simple words of wisdom have forever stuck with me – bend your knees.

LAOS 6/9 – RUSH HOUR

BEFORE The mountainous countryside I was photographing from the riverbank on the first night needs exploring, so the next day we're trundling through it on a pair of motorbikes looking for locations. I'm still hopeful the haze is a temporary factor so when we come to a crossing of a small river surrounded by the enticing Karst landscape, I'm optimistic of being able to explore its potential for a strong landscape.

DURING Next morning at dawn we're back at our spot. The sun will soon be up but the sky is a featureless hazy nonentity. This shot just isn't going to work as I originally conceived in this light. But despite that I set up the tripod and camera anyway – what else can I do? On goes the body, the cable release, the 24–70mm lens, hot shoe mounted spirit level, wide-angle adapter ring, filter holder and lastly a 0.9 ND graduated filter; all the bits and pieces. I have spares of all of these. Every trip there's likely to be one hardware glitch, either by loss or damage. On one trip I mislaid the spirit level and really missed it – I'm useless at judging level horizons by eye. I now carry three in reserve. Caps and rings are always mysteriously going walkabout. Far more serious would be a lens or camera failure. It happens, particularly when they're getting banged about in dusty environments. That's why a bit of overlap in zoom coverage is no bad thing – if a lens is dropped I can still carry on. I've carried a back-up body on every trip for over 20 years and never needed it, but you can bet the moment I stopped doing so I would.

It's rush hour in rural Laos and the school run is well underway as the sun appears in the murky sky. Lao children don't get driven to school in 4x4s. Every single one of them cycles and there's a constant stream of them passing us. The weak sun is softly backlighting the scene with warm light. As a landscape it's hopeless, but with the cyclists reflected in the water salvation has come.

AFTER The amount of kit I carry on a trip depends on what sort of a trip is it and how we're going to be getting around. But the major factor is Wendy. On a solo trip I'm limited in what I can take and difficult compromises have to be made. Now that I am only using one Canon DSLR camera system, life is simpler. I used to travel carrying a large panoramic film camera with lenses and a 35mm system plus hundreds of rolls of film. How, I can't recall. But if Wendy is with me, two Lowepro bags as carry-on will hold all I need: laptop, two bodies, eight lenses plus all the filters, cables, chargers etc. Of course she can't take any of her stuff but that's reasonable, isn't it? Photographer's partners are a unique breed.

Cyclists at dawn, rush hour in the countryside
Near Vang Vieng, Laos
Canon EOS-1Ds MKIII, 24–70mm lens, 0.9 ND grad filter,
ISO 250, 1/50 sec at f/8

BEFORE There's a night market in Luang Prabang full of coloured textiles for sale. This is extremely dangerous territory. Textiles are Wendy's 'thing', and there's a danger of our weight allowance for the flight back being massively exceeded as she acquires yet another load of vibrant scarfs, wraps and shawls. This area is famous for its silk weaving and she is in heaven. She did a weaving course yesterday and has now persuaded me to come along and see the skilled craftsmen and women at work. Well OK, it may be a good photo opportunity.

DURING Rows of looms in an open-walled hut greet my eyes. At each loom sits a weaver surrounded by strands of coloured silk. Promising, but there are problems; lighting for one. Gruesome strip lighting is overhead with open shade filtering in from the side. And the clothing is very distracting. I naively imagined rows of attractive locals in colourful traditional dress sat at the looms, but instead there's a motley collection of striped and garish sweatshirts. Skirting around the inconvenient ugly clutter of reality to create something of simple beauty is what being a professional photographer is all about.

The strip lighting has to be switched off – it is the least flattering light source imaginable. Thankfully they acquiesce. I pick one likely looking loom and mentally start to piece together the shoot. Where's the main light source? I consider using flash bounced off the handy collapsible reflector I've brought along. But no, it'll just kill the atmosphere. So the available light will have to do. At least it's neutral and diffuse. I'm thinking tight-in, graphic images of details using the strong lines of the strands and loom is the way to go, with hands giving some idea of the level of expertise involved. Hands can be just as expressive as faces.

I get to work, crouching beneath the loom looking up through the strands, then perching on a stool looking down, investigating all the angles. I settle on the 85mm lens again and used wide open at f/1.2 the

out of focus effect shooting through the backlit silk is making me squeak. Shooting through the silk is confusing the autofocus so I switch to manual, rocking backwards and forwards slightly to fine-tune the focus.

AFTER This is a simple image that needed very little work done on it in post-production. I try and do as much of the processing as possible at the RAW conversion stage before outputting as a 16-bit TIFF for further fine-tuning and dust busting in Photoshop. Levels and Curves controls are my main stomping ground in this world. I'm not a Photoshop guru; I do what I need but distrust 'overcooked' images. Most of my effort goes into optimizing the contrast in selective parts of the image. With this picture, the RAW image's brightness and contrast were tweaked in Capture One and that was virtually it.

Silk weaving
Luang Prabang, Laos
Canon EOS-1Ds MKIII,
85mm lens, ISO 400, 1/1300sec
at f/1.2

LAOS 8/9 – WAT MONK

BEFORE There are so many monks about I'm in danger of getting monked out. One was next to me in an Internet café this morning, getting the latest on WhatWat.com no doubt. You have to wonder what they do all day apart from look colourful. Whenever I wander into a temple they do seem eager to practise their English.

DURING Here I am again, another wat, another monk shot. It's difficult not to keep shooting more. This guy looks bored out of his skull just lounging about in a sleepy temple in the village of Ban Xieng Lech. I'm carrying just two lenses this morning, the 85mm and the 24mm. I could go tight but opt to go wide to use the strong lines of the wat and the ornate setting with all the gold and red. There's harmony in this shot, there should be really considering the subject matter, but also with the complementary colours and the balance of the composition.

AFTER Sometimes deliberately limiting myself to a couple or even just one lens is an interesting exercise. Zooms give unparalleled flexibility in perspective and cropping options, but that can be a distraction, resulting in a lot of dithering at either end of the zoom range. Choosing an appropriate focal length and then just getting on with the business of making the strongest possible composition is often the best way to go.

A monk at a wat
Ban Xieng Lech, near Luang Prabang, Laos
Canon EOS-1Ds MKIII, 24mm lens, ISO 100, 1/100sec at f/1.4

LAOS 9/9 – YET MORE MONKS

BEFORE One more dawn monk session then we head south, back towards Vientianne. We've not covered as much territory as I'd have thought we would; getting around Laos is not easy or quick. But then this trip hasn't been about seeing the sights – the haze has scuppered that. It's been about the situations we've got into and what I've made of these impromptu opportunities.

DURING I'm back on the streets of Luang Prabang for another crack at the orange dawn parade. This time I'm not crouching in deference on a mat, I'm roving and determined to do some more slightly fudgy pictures of monks on the move. I'm on the other side of the road panning with the 70–200mm. I want just enough motion blur to suggest movement while keeping the monks reasonably sharp. A shutter speed of 0.3sec does the job with the white wall and temple above as the perfect backdrop. I keep exposing variations to get the arrangements of the ambling monks just right.

AFTER It has been a strange trip, I've hardly used my tripod, but once I made that mental adjustment about reframing my objectives and changed my approach, the photography became a real joy. If I look back at the work I was doing ten years ago and compare it to this Laotian shoot I can see just how much I've evolved. Back then faced with this smog I think I would have just given it up as a bad job, changed our itinerary and moved on elsewhere. But being flexible and striving to extract the most from seemingly adverse conditions has made me a better and more varied photographer.

Monks walking through the streets at dawn to collect gifts of food
Luang Prabang, Laos
Canon EOS-1Ds MKIII, 70–200mm lens, ISO 400, 0.3sec at f/14

Provence
6.Location

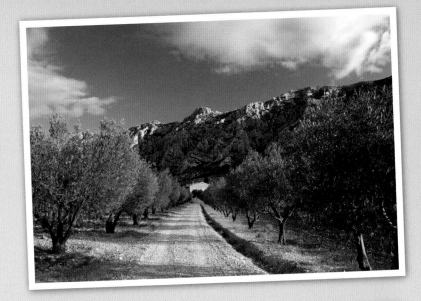

If you have to suffer for your art, I'm failing miserably; there's not much suffering going on here. Provence is at its most sublime and dawn photo shoots are followed by the boulangerie run, meandering through colourful markets and randonnées through vineyards. I'm standing in a field of swaying sunflowers, ruminating on the topic of inspiration. The flowers are at their prime, big splashes of yellow in my foreground. To the north lies Mont Sainte-Victoire, a long ridge of a mountain, all gnarled rock and aromatic scrub. To the west is Aix en Provence and a short way back the way I've come this morning is our campsite where Wendy slumbers on amongst the pines at Puyloubier, our base camp for the week.

Inspiration is the mother of all invention and the lifeblood of all artists. An idea is the trigger that produces a great picture. But where does that idea come from? For me it's usually one moment of blinding inspiration. What generates that inspiration can be anything from a fleeting view to a painter's canvas. When it comes, life is a joy fed by waves of creative energy. When it doesn't the pictures just won't come together, no matter how hard I try. Without inspiration my images start looking very tired very quickly. I wish I could manufacture those moments of revelation to order but I can't. Sometimes I can be somewhere stunning and yet the ideas and pictures elude me. It's the photographer's version of writer's block – I am tormented by the beauty of my surroundings, which I fail to translate into images with impact. Luckily these phases rarely last and I am now much better at anticipating and dealing with these trials than I was when I started, but inspiration remains the key.

Luckily it's not necessary to rely on totally random revelations from the heavens; inspiration can be kick started. Provence has provided the stimulus and subjects for generations of artists. I'm slightly suspicious that many of them came here principally because it's a nice place to be, but nevertheless I can't deny that with all the colours of the lavender and sunflowers, villages perchés, the clarity of the light and the sparkling Mediterranean Sea they did have a point. Cézanne was captivated by Mont Sainte-Victoire and painted it endlessly. Van Gogh was obsessed with the vibrant colours of the Provençal paysage. And Picasso, well, I'm not sure what planet he was on but he ended up here too. I'll freely admit I feed off their and other painters' vision. I couldn't point to any one picture of mine that has been influenced by the twisted shapes and vibrant colours of Van Gogh's landscapes but his work has definitely contributed to my visual database.

Like those illustrious artists, what has brought us to Provence several summers in a row is the search for inspiration. And the weather, food, wine and ambience haven't got anything to do with it, OK?

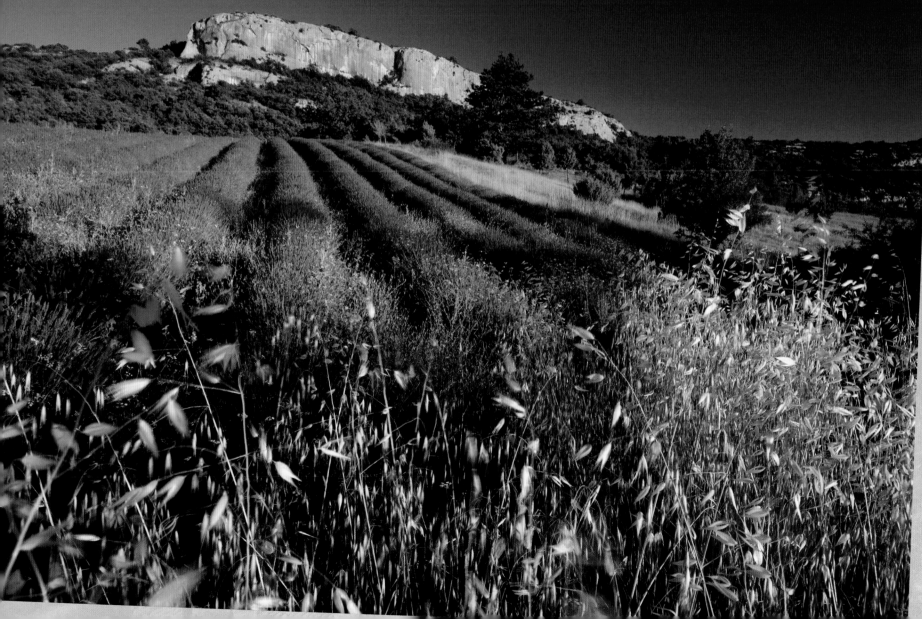

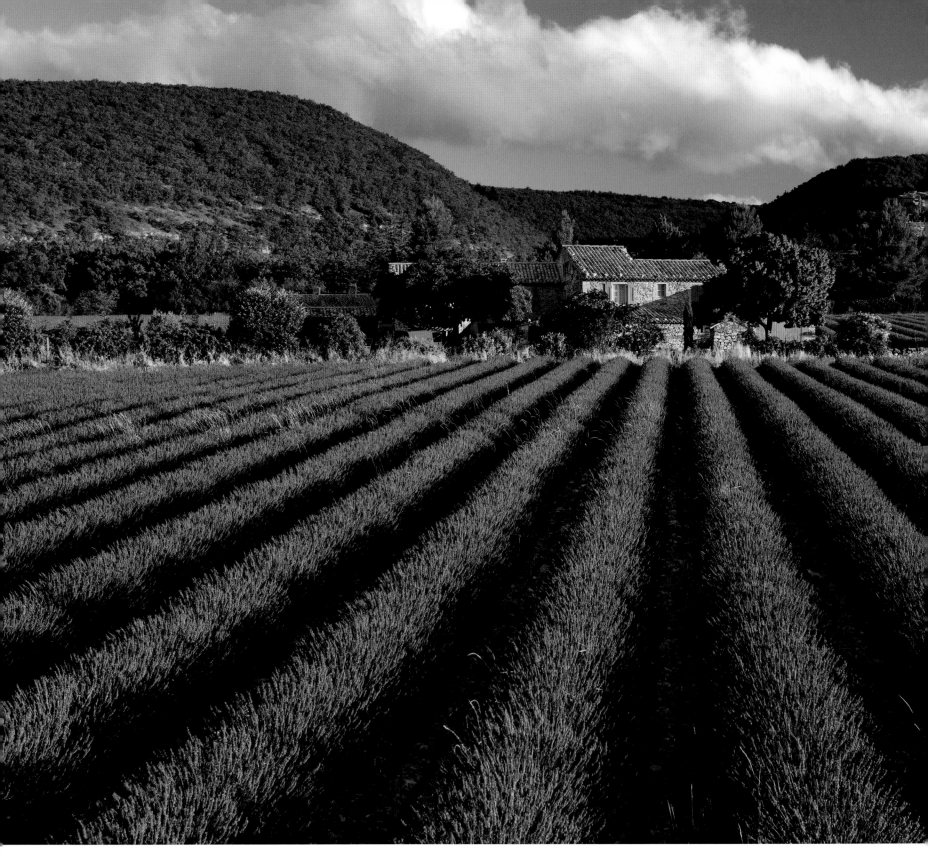

PROVENCE 1/10 – LAVENDER FIELD

BEFORE I defy any photographer to come to Provence in July and not shoot lavender fields. Maybe it's a cliché, but those geometric lines of purple running across the landscape were surely planted for the sole benefit of visiting photographers. Combined with the azure skies, the full-throttle colours and bold lines are a godsend for photographers in search of vibrant compositions.

As we cruised south past Lyon, my photographic wish list for this trip took shape and right at the top was the perfect lavender picture. We were coming at exactly the right time of year. The elements I required were a pristine field of lavender attractively situated in the quintessential Provençal paysage, and a typical village or farmhouse would certainly not go amiss. Finding all that was the mission, a task I didn't underestimate the scale of. This was to be principally an exercise in location finding and a shot planned and executed with almost military precision.

First priority: establish base camp in an area that looks promising – a peaceful campsite under the pine trees in the hills of the Vaucluse. Locate nearest boulangerie for the morning and stock up on vital supplies: Cote du Rhone, saucisson, cassoulet, IGN maps, olive oil, fromage de chevre, camping gas etc. Second priority: start scouting locations – drive, walk, look. Mark maps with options for dawn and dusk. Third priority: find the Perfect Location. This is the hard bit. It's tempting to think scenes like the one required

are ten a centime but it's not the case. Lavender fields vary greatly – many are downright tatty, unkempt and full of weeds. Finding a pristine example with all the other elements on the checklist would not be easy.

On the third day of scouting I found my spot. Not only was the lavender perfect, I also had a farmhouse in the middle distance and a quaint village beyond. The aspect of the view was north west, so at this time of year with the sun rising to the north east I would hopefully have perfect side lighting first thing in the morning.

DURING The light at sunrise is sparkling, clear and crisp. There's no haze, and there's even a token fluffy white cloud floating over the village. I shoot from in amongst the lavender first; all is peace and quiet. Later, in the heat of the day, this will be a busy place, buzzing with insects. There's a breeze blowing and it's almost cool, but not quite. I get up on the platform on the roof of the Land Rover and immediately know this is the place to be. The converging lines of the lavender leading into the frame are far stronger from up here. A polarizer saturates the colours and the work of the last few days slots into place.

AFTER This was a textbook example of how an image should come together, from conception to execution. If only the making of all pictures were as smooth as this.

A lavender field with the village of Banon beyond
The Vaucluse, Provence, France
Canon EOS-1Ds MKIII, 24-70mm lens, polarizing filter, ISO 320, 1/100sec at f/6.3

PROVENCE 2/10 – MARKET DAY

BEFORE I have spent a lot of time wandering around markets from Avignon to Kuala Lumpur. They are great places for impromptu pictures of people buying and selling, not to mention the colourful produce and slices of life on show. In the past I have got so carried away with shooting the rows of shiny sardines on display in the market at Palermo that my editor sent me a message reading simply 'no more dead fish'. Photography aside, just to sit in a café nursing un pression while people-watching on market day is one of the joys of being in France.

DURING The garlic hanging in the market in the Place aux Herbes is so much more succulent then the weedy bulbs available at home. We'll inevitably be stinking the car out carrying these and various seriously ripe cheeses north in a few weeks' time. The colours and shapes of the dried chillies with the garlic in front of the out-of-focus fountain is a simple little shot that captures the essence of the market.

AFTER For all that I love piecing together the big epic shoots, sometimes an innocuous detail can say as much as any sweeping panorama. From any trip I like to come back with a range of images that collectively paint a picture of the destination, from landscapes to portraits to market scenes and details. I try and think about what a place means to me, in this case the south of France, and then strive to express that photographically. It's the old photojournalist's aim of producing a photo essay – ten pictures or so that tell a story and when viewed together are stronger than they are in isolation.

Garlic and chillies for sale in the market
*Place aux Herbes, Uzès, Languedoc-Roussillon, France
Canon EOS-1Ds MKII, 85mm lens, ISO 200, 1/200sec at f/4*

PROVENCE 3/10 – AROMATHERAPY

BEFORE I shot this lavender field last night but don't really believe it worked very well. Everything was right, the light, the location, the lavender, but it just didn't come together. That is the reality of most shoots. Even when the conditions are favourable I estimate only one in three sessions produces the quality goods. That's just the way it is. Great pictures don't fall from the skies and if it were easy everybody would be doing it. Oh, they are? Well, there goes my theory.

DURING I'm back the next morning. If a location is good it's worth sticking with it. Last night I went wide, this morning I'm going in tight. If in doubt, reduce a composition to the simplest form possible, and that's my plan today. With the morning light creeping down the hillside I'm setting up on the opposite hill with a 400mm lens beaming in on the perfect geometry of the purple ranks marching up the slope. The regularity of the pattern is broken by splashes of green weeds. It's simple, bold and graphic. A polarizer helps to concentrate the colour. Even with no wind I'm mindful of the problems of using ultra-long lenses on tripods. Everything is locked tight and the mirror locked up, but with a 0.8sec exposure anything could happen. In these situations a good tripod is worth its carbon fibre weight in gold.

AFTER A tripod should be sturdy, robust and capable of going up to head height without having to resort to using the wobbly centre column, and flexible enough to get down low in amongst the undergrowth. It also needs to be portable. The stability Vs weight compromise is a difficult one to resolve, but a flimsy, feeble set of legs is virtually useless and you can always spot a pro by their tripod. Tripods have a hard life being bounced around in the back of 4x4s, so mine need replacing every couple of years. I think I currently have five different models for various situations.

Rows of lavender in a field
Near St-Saturnin-les-Apt, the Vaucluse, Provence, France
Canon EOS-1Ds MKIII, 400mm lens, polarizing filter, ISO 50,
0.8sec at f/20

PROVENCE 4/10 – DAWN OVER MOUNT VENTOUX

BEFORE Below lies the village of Crestet and the verdant paysage with the bulk of Mont Ventoux beyond. Hues of pink and violet are spreading through the dawn skies as the rays from the still-slumbering sun bounce off the bottom of the clouds and down on to the landscape. I have set up with the camera looking east, straight at the bulk of the mountain with the sun rising behind it. If I wait for the sun to clear the peak I'll have light illuminating the landscape but I'll be shooting straight into it. That can work well, particularly if there are shafts of light from behind cloud playing on the landscape but none shining straight into the lens. Equally it can be an impossible situation, with high contrast and gruesome flare prompting an early croissant run.

DURING With all this in mind I'm endeavouring to make a shot in the dawn light before the sun makes an appearance. With no direct light on the village and landscape the contrast between the bright sky and the dark landscape is just too much for a graduated filter to handle, so I resort to exposure merging. One frame for the sky and one, a full 5 stops brighter, for the foreground should suffice. The colour in the sky is outrageously vibrant; some will believe I've been tampering with reality here, winding up the colour with the saturation slider. It is galling to be accused of such crimes when all I'm doing is recording the majesty of a dawn sky.

AFTER Following the shoot I head back to the campsite near Vaison-la-Romaine, stopping at the boulangerie on the way. As we sit in the morning warmth with our café et croissants, I back up the morning's shoot. Living like this, out of the back of a vehicle, for a month or so I'm always aware of the state of my batteries – for the cameras, back-up drive and laptop. Camera batteries will last around ten days in this climate, others less. Any opportunity to top up power is taken. So I sneak over and furtively plug my laptop into the power supply for a Dutch caravan. Pictures exposed, petit déjeuner in the sun and I'm all backed up with fully charged batteries – it's the definition of happiness.

Dawn over Mont Ventoux from the village of Crestet
The Dentelles de Montmirail, near Vaison-la-Romaine, Provence, France
Canon EOS-1Ds MKIII, 16-35mm lens, ISO 100, two merged exposures

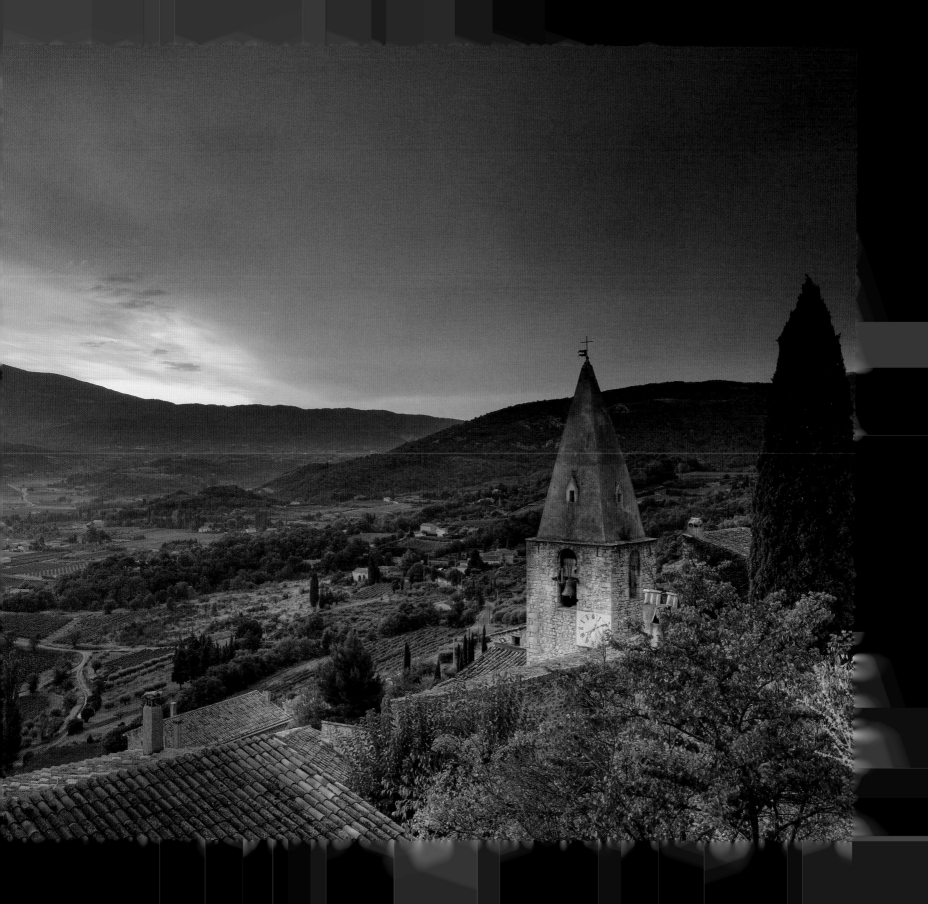

Blinded by the Light

Provence is a big area, from the Italian border through the Alpes-Maritimes to Haut-Provence, the Vaucluse, Gorge du Verdon, Dentelles, Bouches du Rhone, Camargue and the Rhone Valley it covers a lot of varied landscapes from high snow-capped mountains to marshlands and coast. It's got it all: villages perchés, Papal palaces, Roman amphitheatres, vineyards, markets, sunflowers and lavender. Walk across a hillside above yet another dramatic gorge and the aromas of Provence rise up – lavender, thyme, rosemary and camomile. Stroll into a village and the sound of clashing plates and the smell of garlic permeates the narrow streets. From behind closed shutters the waft of a beef daube emanates. Inevitably everything will be closed. All of France stops for lunch. And that village, no matter how small and remote, will have a boulangerie – you can rely on that with absolute certainty. Fresh bread once a day is the right of every French man and woman, enshrined in the values of the Revolution: Liberté, Egalité, Fraternité, et une baguette, s'il vous plait.

I'm sitting under the plane trees that line every Place de la Revolution in France, outside the café, trying unsuccessfully to catch the waiter's eye. Some old boys are playing pétanque with much shrugging of shoulders and Gallic resignation. At the bar others are chatting, I try and listen in but despite the fact that French is the one tongue I have a smattering of I can't understand a word. Wendy is off shopping, where I cannot tell; there doesn't seem to be anywhere to do so, but that won't deter her. Doubtless she'll turn up soon with a brass knocker, some rustic pottery and other essentials I don't know how we ever existed without.

It's a long drive here, made even longer this year by the blocking of the autoroutes by demonstrating French truckers. But now we're here it's an absolute joy. Life on the campsite has settled into a predictable rhythm – boules in amongst the tents, languid conversations questioning whether we could or should live here, sun, cheese and wine. All the nations of Europe are present, all proudly reinforcing national stereotypes, all rubbing along together famously. This cosy tented community should be the model for how the EU could actually work.

This evening I shall stand on top of the Land Rover looking down on a Cote du Rhone Villages vineyard as the sun dips. Then we'll have a picnic on the tailgate: pain, saucisson, fromage, tomates … these annual Provençal pilgrimages refresh the soul. Just where else would we rather be right now?

Sunflowers and vegetables on a market stall

Aix-en-Provence, Provence, France
Canon EOS-1Ds MKIII, 24-70mm, ISO 200, 1/85sec at f/5

PROVENCE 5/10 – PLACE DE LA MADELEINE

BEFORE French markets just look so good; the stall holders take a real pride in their produce and the way it's presented. On Saturdays in Aix-en-Provence it seems the whole of the centre is a market. Aix, like it's Provençal sister city Avignon, is just one of those places that make you want to relax, hang out, and watch the world go by from a pavement café. It feels more like a town then a city, one square after another, all equally beautiful. Aix makes me think that in many ways, the French have got it right.

DURING But it's a dangerous place to be, for me anyway. This is prime Wendy territory and she is wandering la vieille ville with a credit card, a will and a gleam in her eye. I shudder to think what the consequences may be. Meanwhile I'm meandering through the market. Travel photography is all about making the most of every situation, planned or impromptu, and developing an unstoppable momentum to the picture making. Momentum is everything, when it's with me the trip slides past in a euphoric blur with one photo session after another. Of course that momentum exists only in my head. Key to nurturing and sustaining it is shouldering the camera and just doing the job, never walking by a photographic possibility. So here in the Place de la Madeleine with Wendy on the rampage I spend a pleasurable few minutes working the market stall arrangement of sunflowers and colourful vegetables. The trees and diffuse square beyond make for a quintessential Provençal market setting.

AFTER By the time I've finished a row of tourists are standing beside me squinting into the back of their compacts, arms outstretched, copying my idea. The owner of the stall and I take it as a compliment.

BEFORE Menton is a beautiful Provençal town by the sparkling Med, ringed by protective mountains, with a slightly Italian feel. Wandering through the old town I came across the Parvis St-Michel, a square with a stunning view over the Bay of Garavan. I stood and pondered how I could make something of it. The combination of the baroque architecture of the Eglise St-Michel, the attractive square, the shuttered windows and the coast beyond was irresistible. First thoughts were that the lighting was a nightmare; looking due east I'd either be shooting straight into the sun in the morning or lose it behind the buildings in the late afternoon. A dusk shot was a possibility, but I couldn't see any evidence of the square being it. I decided my best option was early in the morning, just as the sun was appearing over the hills. And to add a je ne sais quoi I'd need my very own supermodel.

DURING We're back at dawn. Producing this picture will be a problematic technical exercise, both behind the camera and in post-production. It is crucial to think through the whole process, from shutter to mouse, before the camera is touched. The problem is contrast – how am I going to expose for the backlit sky with the rising sun and the square? I can't use a filter, as the line of the grad would darken the whole top half of the frame, buildings included, and I'm using a 14mm extreme wide-angle lens with a bulbous front element. There's no question about it, It's a job for exposure merging.

We're in luck – the sky is a mosaic that reflects the square's Italianate paving. Wendy is ambling from corner to corner as I do a few test exposures to determine the right amount of blur. As the sun peaks over the hills I start to expose sets of five exposures using auto bracketing from +2 to -3 stops. The first warm rays light up the stone of the church beautifully. This 14mm lens is fully corrected – unlike a 15mm fisheye there's no distortion – so vertical and horizontal lines at the edges of the frame remain straight and the geometry of the square's architecture is faithfully recorded.

The prime time for the image is just as the sun first shines into the square as it rises over the mountain and is quickly over. I think it worked, but I won't really know for sure until I start work on it in Photoshop.

AFTER In the end I only needed four frames. Manually merging them was time consuming – the hardest part was getting the join between the sky and the buildings to look natural. Lots of work with Layers and the Eraser tool did the trick. In the end I'm very pleased; it's a good example of how a shot can come together from conception to execution if all the steps are thought through in advance. The big question: is it cheating? I don't think so – I'm using a multi-exposure technique to deal with extreme contrast – but you may care to differ …

A woman walking through Parvis St-Michel at dawn
*The Old Town, Menton, Cote d'Azur, Provence, France
Canon EOS-1Ds MKIII, 14mm lens, ISO 100, four
merged exposures*

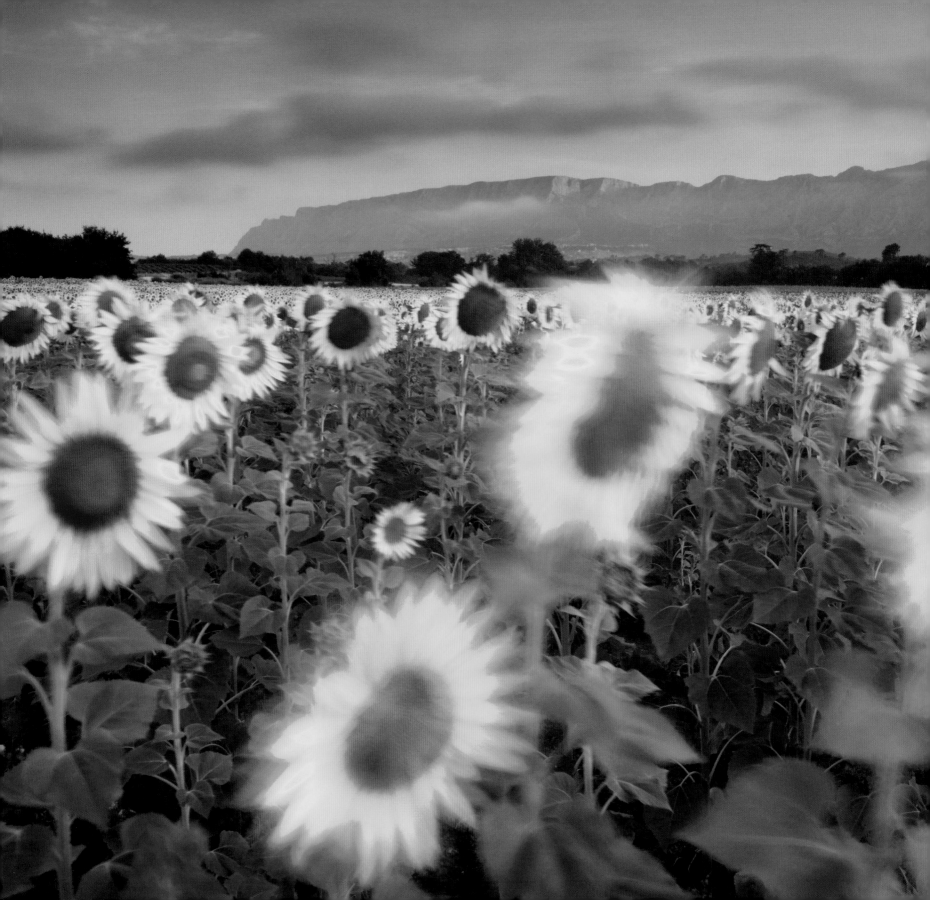

PROVENCE 7/10 – WAFTING SUNFLOWERS

BEFORE We'd been forced to switch campsites by the all-too-close proximity of some, well, let's just say 'regrettable' neighbours. The bywords that we associate with the French camping experience – space and tranquillity – had been taken away all too easily by yobs with satellite dishes. Short of mass murder our only recourse was to flee. Luckily we didn't have to move far, and driving towards our new base a field of perfect sunflowers stood awaiting my return at dawn.

DURING First light paints the landscape. The sunflowers glow in the soft warm illumination as the cloud draped over Mont Sainte-Victoire picks up the pink light of dawn. The faint breeze is swaying the large, mature sunflowers gently; I can either choose to use that movement or freeze it, and on the basis that it rarely pays to fight nature I go for the blur. So I drop the ISO to 50 – I wish I could go lower but the camera manufacturers just seem oblivious to this need. I reach for a 0.9 neutral density filter and dial in the minimum aperture of f/22 to slow the world down a bit more. The resultant exposure of 6.2sec blurs the movement of both the swaying sunflowers and clouds marching across the sky nicely. I know my father won't approve of this picture; he's a scientist and won't see the point of deliberately blurring a picture. Surely everything should be sharp? What am I playing at?

AFTER Getting arty, that's what I'm playing at. Wendy calls this my 'Van Gogh picture', so maybe I have been more influenced by the melancholic Master than I thought. Let's face it, a touch of blur in everyday life is often appealing, and sometimes unavoidable.

Sunflowers blowing in the breeze at dawn with Mont Sainte-Victoire beyond
Near Puyloubier, Bouches-du-Rhone, Provence, France
Canon EOS-1Ds MKIII, 16-35mm lens, 0.9ND filter, ISO 50, 6.2sec at f/22

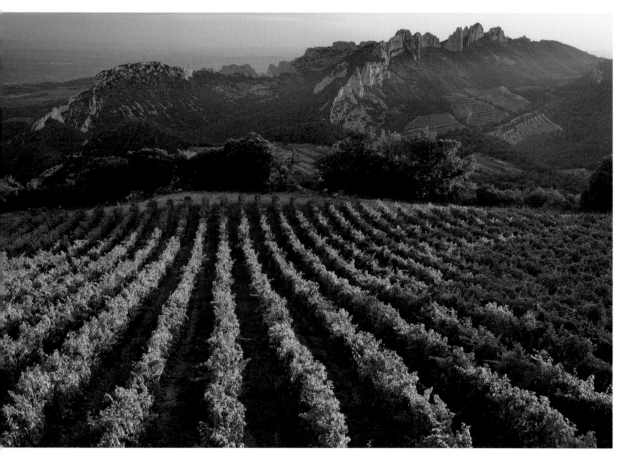

A vineyard in the Dentelles de Montmirail

Near Vaison-la-Romaine, Provence, France
Canon EOS-1Ds MKII, 24-70mm lens, 0.9ND grad filter, ISO 100, 0.5sec at f/11

PROVENCE 8/10 – A VINEYARD

BEFORE The Dentelles are a range of razor-sharp limestone hills that mark the eastern edge of the Rhone valley. This is peak winegrowing terrain – villages set in these craggy hills overlooking the endless rows of vineyards below lend their name to labels on famous bottles: Séguret, Sablet, Vacqueyras and Rasteau. I've shot vineyards from the Barossa Valley to Stellenbosch, Chianti to Colchagua, Marlborough to Saint Emillion, and essentially they all look the same. The rows of vines are always strong compositionally and the twisted wizened trunks and ripening grapes look great close up but unless those elements are situated pictorially in their environment the image could have been made anywhere. So again we're back to location finding, trying to find a picturesque vineyard as part of a landscape, in a setting that just shouts 'Provence'. Alors, on a hot dusty randonnée in the Dentelles we stumbled across this view and were back the same evening, driving up increasingly rough tracks to convert my vision into reality.

DURING We 4x4 owners are pariahs these days – clearly we are solely responsible for climate change. At least though our mount is used for what it was designed for: accessing remote locations well off the asphalt. And there is another feature that makes it a vital tool – the photographic platform on the roof. The key to vineyard photography is to get a bit of elevation. That way the geometric lines of the vines leading into the composition are so much stronger.

It's a beautiful calm evening in Provence. Luckily the Mistral isn't blowing, as that would make working from the exposed roof problematical, but equally there's no cloud in the sky and the Rhone Valley beyond is choked with haze. So I opt to compose including only a token slice of pinky dusk sky. The vineyard and the crags of the Dentelles are the key elements, so I exclude all else.

The light from the dipping sun is increasingly warm, golden and slightly contre jour – side lighting with an edge of backlighting. I wait until the last rays are clipping the tops of the vines and catching the cliffs beyond, click, et voila.

AFTER A 50mm focal length provides the standard perspective on a full-frame camera; an angle of view that conforms closest to our own eyes. The balance between the foreground and background is most natural at this focal length – neither predominates. Going wider would emphasize the rows of vines but the impact of the Dentelles would be lost, going longer would achieve the opposite. A 0.9ND hard grad filter held back the sky.

PROVENCE 9/10 – DAWN PATROL

BEFORE Just down the road is Aubagne, the home of the French Foreign Legion. Camping with us for a few days are our nephews, both recent graduates with, shall we say, currently 'fluid' job prospects. Funnily enough our suggestion of dropping them off in Aubagne for five years of character building in the Legion meets a mixed response. As does our plan for a 5am rise to shoot a lavender field. I'm baffled. What else would they rather do?

DURING With lines of lavender leading towards a vanishing point to the north east, the pink, bottom-lit clouds of dawn seem to radiate out from roughly the same point of convergence as where the sun will soon appear. To emphasize this strong converging composition I go as wide as I can. Again with this 14mm lens, filters are not an option, so it's another job for exposure merging. Just two exposures are necessary here – one for the sky and one for the paysage.

Dawn in a lavender field
Near Sault, the Vaucluse, Provence, France
Canon EOS-1Ds MKIII, 14mm lens, ISO 100, two merged exposures

I take it as read I can utilize super wide-angle lenses nowadays. We used to think of a 24mm optic as super wide when I started out, now focal lengths in the teens are de rigueur. Of course for wide-angle views on the world a full-frame sensor is imperative.

AFTER A full-frame DSLR camera has a sensor size and image area the same as the old 35mm film cameras – 24 x 36mm. However, many DSLRs, and all compact cameras, use a smaller sensor that approximates to the old APS film format, roughly half the square area of a full-frame sensor. This has important repercussions on image quality and lens options. A medium wide-angle lens on a full-frame camera is a standard lens on small APS-frame cameras. The angle of view of a lens is determined by its focal length and the image area. A standard lens – one that equates closest to the perspective we see with our eyes – has a focal length that equals the diagonal dimension of the image area. So a bigger sensor has a wider angle of view for a given focal length.

This is a big issue. It's why landscape photographers, without a shadow of a doubt, need full-frame sensor cameras to be able to exploit all the wide-angle options fully. Conversely it's why wildlife and sports photographers often opt for APS sensor cameras to give their long lenses extra reach. A 400mm lens on an APS sensor camera equates to about a 600mm lens on a full-frame camera, a boost that's handy for photographing stalking cheetahs. Personally though, I've never seen APS-frame cameras as anything other than a cropped down image area. Full frame is the way to go – a big sensor with more pixels, more information and less noise means a higher quality image. Simple as that.

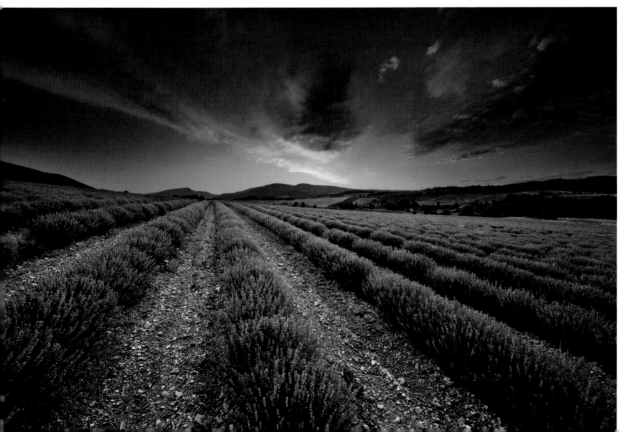

PROVENCE 10/10 –
MISTRAL MOVEMENT

BEFORE One thing that about Provence that drives me to distraction
is the Mistral. That dry northerly wind is the one element that robs the
region of a perfect scorecard. But there's an upside to everything, and
this morning looking over the vineyards back towards Mont Sainte-
Victoire I'm going to use the wind to give me some movement in the
frame. A single shapely tree one third in from the right border is the key
compositional element. You can't beat solitary trees in compositions;
where would we be without them? The farm buildings in the middle
distance are on another intersection of thirds, and with the strong
horizontal lines of the fields and the rocky ridge of the mountain also
fitting roughly along thirds there's a pleasing balance to the picture.

DURING The sun has just made an appearance and its first soft light
is subtly caressing the tree and fields. I've got the 70–200mm lens at
135mm on the camera with a polarizer fitted and the ISO dropped to 50.
At f/16 this enables me to use an exposure of 3.2sec – long enough for
the leaves in the tree and on the vines to blur in the breeze. The slightly
flattened long lens perspective emphasizes the craggy cliffs and twisted
limestone of the mountain beyond, and there are a few wispy clouds in
the sky to boot. C'est parfait.

AFTER I head back to Puyloubier as Wendy is emerging from the tent.
I look like a vagrant when I first scramble out; she looks like she's just
stepped off the catwalk. How does that work? We have to head north
tomorrow. Regrettably, it's time to move on. It's late July and the south
of France is getting busy; the prospect of being here in the school
holidays is unthinkable. We'll be back. Next year it may be Languedoc,
we're not wedded to Provence and I've probably overdosed on lavender
for a while. But the colour, light and ambience are addictive. Provence,
Tuscany and Andalucia are all sunny, cultural, southern European rural
idylls, but they're popular destinations for a reason; it's difficult to resist
their charms. We don't even try. It is etched in stone that every year we
will do at least one roving French trip. Provence has provided endless
inspiration for generations of artists and will undoubtedly continue to
do so. I just wish things were open for a bit longer. How the French
earn a living I'll never know. But maybe they've discovered the secret of
modern life, and we're just a bunch of uptight Anglo-Saxon workaholics.
Could be …

**A tree blowing in the breeze
at dawn with Mont Sainte-
Victoire beyond**
*Near Puyloubier, Bouches-du-
Rhone, Provence, France
Canon EOS-1Ds MKIII,
70–200mm lens, polarizing
filter, ISO 50, 3.2sec at f/16*

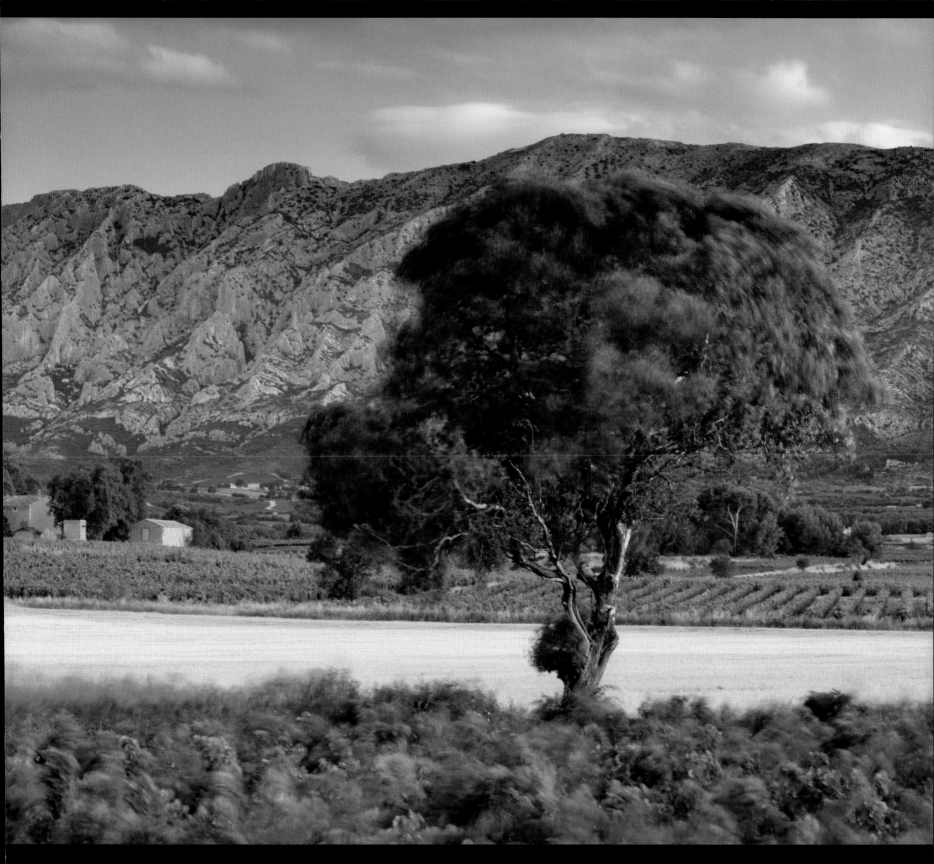

Provence/Location 95

Umbria
7.Relationship

In May we load up the motor with all the photo kit I own plus Wendy's sun hat, a hammock and a barbecue, pass through the tunnel sous la Manche and head south. Boeuf bourguignon in Dijon, another tunnel under Mont Blanc, lasagne in Parma and we're getting close as Firenze passes to port. Perugia, Assisi on the hill to the east, olive groves below Trevi; we're in Umbria now. One more tunnel and we're in the Valnerina – the promised land. Up the twisting narrow valley past fields of poppies and improbably perched hilltop villages, Preci appears clinging to the hillside with the mountains of Monti Sibillini National Park rearing above. We've arrived, again. We've made this journey many times at various points of the year. We keep coming back because we love it here.

Every year there are challenging trips to unknown corners of the planet. I like to keep visiting new places, treading boldly in search of inspiration and adventure. It's just a bit too easy to stick with what you know, and the best trips are always the most adventurous. But now I'll contradict all that by telling you about my love affair with Umbria. The thing about Italy is that there is so much diversity – from the Dolomites to Sicily and Venice to Rome – it's a real-life opera set and photographer's dream. We first came here on honeymoon in 1987 when my shooting at dawn and dusk set the template for our marriage. Incredibly, Wendy is still with me but her one stipulation is that we must visit Italy every year. She has a talent for lunches in sun-dappled squares that needs expressing and who am I to resist?

Our initial sight of Preci was on a roving Italian trip. We'd been to Umbria before but not to the Valnerina. The region scarcely gets a mention in the guidebooks but the snippets I'd read sounded tantalizing. We came, fell in love and ended up staying twice as long as planned. Umbria is the Green Heart of Italy, less well known than Tuscany, more rustic, rugged and with better salsiccia. Here we have the mountains, the villages, the cuisine, the colour, the people … it's beautiful – from Castellucio standing in splendid isolation perched above the sweeping Piano Grande with snow-capped Monte Vettore above, to the fields of spring colour surrounding the village of Campi. Coming back here regularly, getting to know the area and people, making friends and bonding with the region in different seasons has been rewarding and inspirational for us and for my photography. Surges of passion fuel creativity. Umbria stimulates the passion, and the pictures are the result.

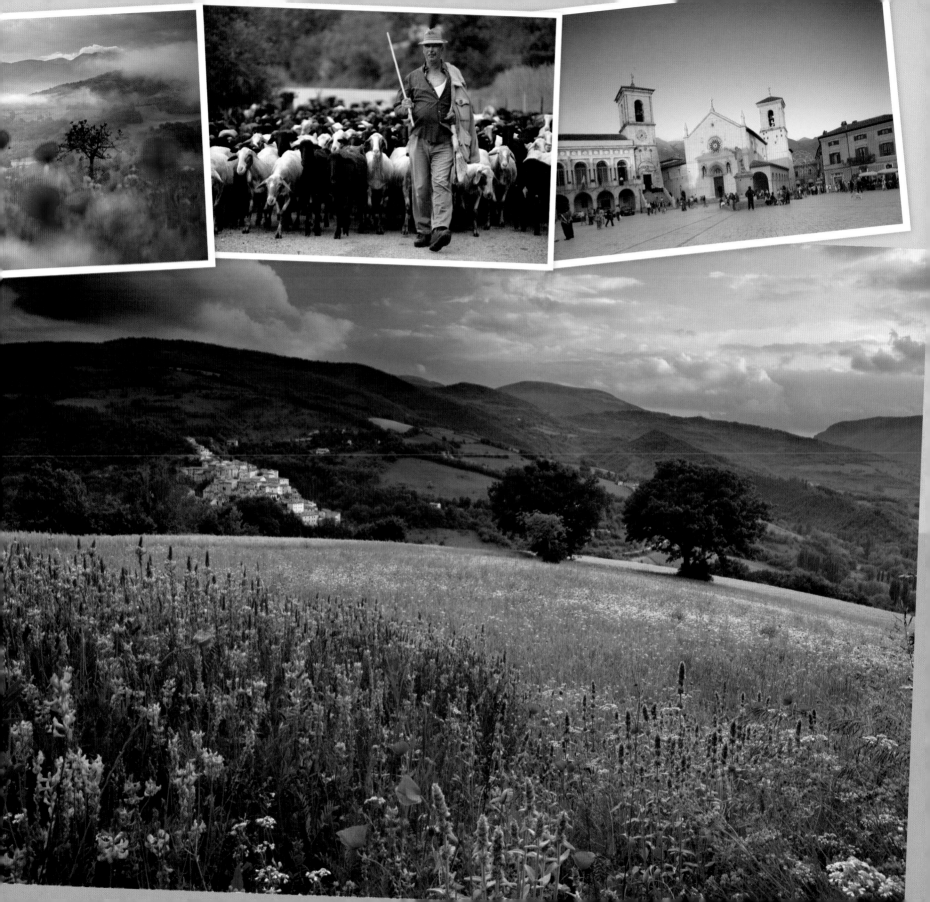

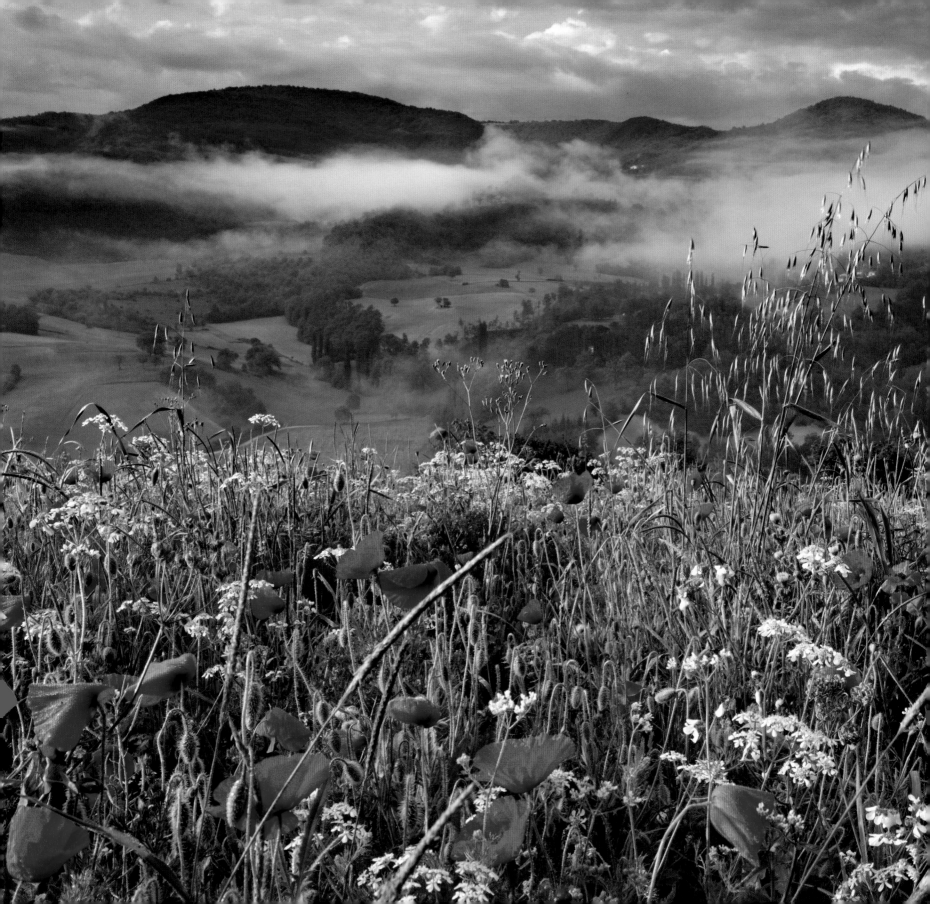

UMBRIA 1/12 – POPPY HEAVEN

BEFORE In May, the fields and hillsides of the Valnerina explode with colour. Patches of purple, pink, yellow and scarlet proliferate, and everywhere you look for a few weeks there are poppies. No photographer can resist them. Bright, bold splashes of primary colours predominate: the lush green of the grass and barley, the deep blue of the sky, and the vibrant red of the poppies.

DURING I'm crouching behind the tripod at dawn in amongst the poppies, covered in dew and pollen, muddy, dishevelled and happy. This valley is a familiar stomping ground, but every year it looks different. This field left fallow for the scarlet poppies to thrive was a ploughed wasteland last year. On this morning's menu I have the magical combination of elements I dream of – colour, mist, light and mood. Landscape photographers crave mist, at least I do; it adds an ethereal quality to a scene as it waxes and wanes. Rain yesterday followed by clear skies overnight hinted at what was to come. I'm no meteorologist but when you follow the weather closely you do start to get the feel for when may mist may occur.

I'm down low using the poppies as bold crimson splashes in my foreground among the greens and whites of the grass. Beyond, on the other side of the valley, traces of mist cling to the hillside and, above, a mottled sky weighs heavily on the landscape. A weak, diffuse light from the sun peaking over Monte Morricone gently sidelights the scene – not strong enough yet to burn off the mist or cause contrast problems.

A 0.6 neutral density graduated filter holds back the exposure in the sky. This is one of those times when I must do it all in one frame, exposure merging is not an option. The stalks of grass gently swaying close to the lens mean any attempt at patching together multiple frames will be doomed, as making a perfect join with the movement will be impossible. I'm using a hard gradation here, as there's a definite line of the hilltops to lay the grad along. I contemplate composing without any sky in, but the clouds have a cool marbled look, so they make the cut.

AFTER I use graduated filters to ensure I'm recording all the information in the sky. If the detail is there I can then fine-tune just how heavy I want the heavens in relationship to the landscape in post-production; dark and brooding or light bright skies – it all depends on the mood. Over filtering a sky can look gruesome, so it's best to use the grad as a contrast control device only. In this digital age it does seem mad to be sticking pieces of hand-dyed optical resin in front of the glass. ND grads aren't exactly hi-tech, but when the world is swaying in front of the lens they are the only solution.

Dawn in a poppy field
The Valnerina Valley, near Preci, Umbria, Italy
Canon EOS-1Ds MK III, 16–35mm lens, 0.6 ND grad filter, ISO 100,
1/10sec at f/22

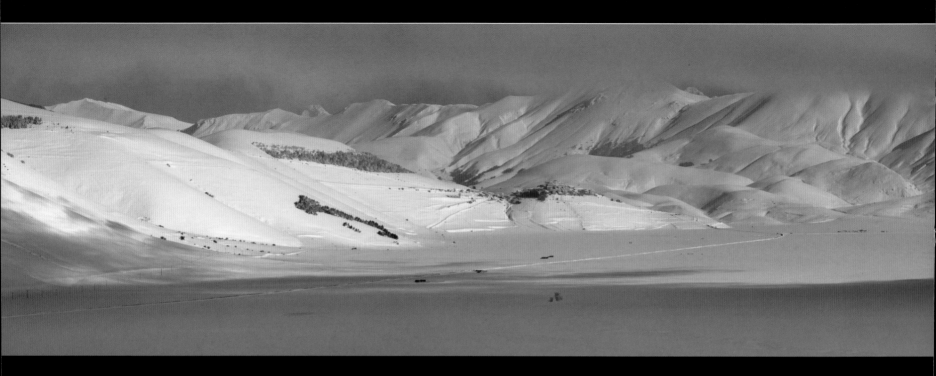

The Piano Grande in winter
Monti Sibillini National Park,
Umbria, Italy
Canon EOS-1Ds MK III,
70–200mm lens, ISO 100,
1/400sec at f/6.3

UMBRIA 2/12 – THE PIANO GRANDE IN WINTER

BEFORE Time has been found for a quick visit to Umbria in winter. All we're likely to experience is dull, moist weather but if you don't take a chance nothing gets exposed. Landing at Perugia, initial signs are promising; it's crisp and clear, and on the hills above Assisi there's snow. On the first morning, we're switchbacking up the road from Norcia in a tiny Lancia, squirming on the ice. As we climb and the snow gets heavier the excitement builds. Over the lip and the familiar vista welcomes us. Covered in pristine snow this is a winter wonderland of unparalleled beauty. We are quite literally gasping, I could never have hoped for such perfect conditions. This is one of those moments you spend your whole life as a photographer waiting for. But the cloud could fill in at any moment, obscuring the view. I need to make the most of this now. No pressure then.

DURING Despite the fact that the moment could pass imminently it pays to pause, look, analyse, think and get back to basics – strong compositions, balanced pictures. No matter how good the situation may be, if these basics aren't addressed it will be a wasted opportunity.

This scene could be Greenland or Antarctica, only the pimple of Castelluccio on its mound suggests we're in Europe. I try to use some icy trees in the foreground, but it rapidly becomes apparent that compositions that work in spring don't work now. With the long lens on I'm concentrating on patches of light on the Piano and Monte Vettore, when I finally realize that this is a perfect opportunity for a stitched panoramic picture.

Precious minutes tick by as I fiddle with the tripod legs, getting the bubble in the centre of the spirit level. Finally all is level and

I do a test exposure of the brightest part of the scene in manual mode. With an optimum exposure set, I take five frames, panning on the tripod, overlapping each frame by about a third. I allow a little extra top and bottom as some image area is lost in the stitching process. I'm struck by the flexibility of working this way; I can go with any width to the panorama I like at any focal length. In my many years shooting with the 6 x 17cm format I was stuck with

merges. This is due to slightly uneven lens coverage; the centre of the frame is a touch brighter than the edges. It's not a problem normally, in fact it's often desirable, but with this panorama it's crucial to correct it to ensure perfect gradations of tone in the sky and snow.

Love Story

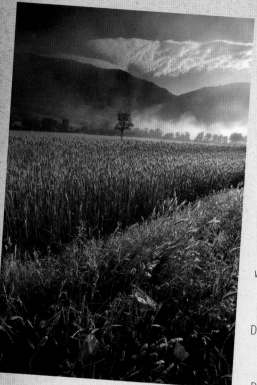

It doesn't matter where or what you are driving in Italy or how fast; there will always be a clapped-out Fiat Vatican glued to your tail, piloted one handed by a maniac with a phone resolutely glued to the ear. They are a nation that should be collectively banned from driving. Even the nuns take corners with two wheels in the air. Yet outside the car they are the most charming, affable and genial people you are likely to meet.

Take Salvatore. He makes sausages, just for private consumption you understand. My photo-mate Jon and I are in his cave; it's cramped and dark and we're struggling with camera, flash and reflector to make a picture of the man surrounded by his hanging sausages. It's an interesting challenge. Afterwards he takes us to his den where we quaff vino rosso out of a five-litre jerry can and gorge on the earthy salsiccia. Salvatore is a man of substance with an Umbrian dialect you could cut with his substantial knife. He is totally bemused as to why we should want to take pictures of him, but is not averse to the attention.

Drive from Salvatore's to Norcia past Preci. The Carabineri are lounging in the shade by the road, cutting a dash - they are surely the best-dressed police force in the world. Dante is out and about, glaring back in response to my laboured buongiorno. Dante passes on the philosophy and also makes sausages; it seems to be mandatory for men of a certain age here. Go past the turning to the abbey at St Eutizio. Here on a quiet day in the 15th century some monks decided to practise eye surgery, as you do, and so Preci became the world centre of expertise for cataract operations. The St Eutizio monks even operated on Elizabeth I's eyes. I bet they dabbled in sausage production too.

At Campi you may meet Santino, a local shepherd who has become a media star. He has posed for our cameras a few times now. He comes off the hill in the late afternoon with his flock and pack of snarling dogs and turns on the charm. Rumour has it he's off for a tour of the sofas as a chat show guest soon.

In Norcia the shops are open, hanging prosciutto, cinghalle and salsiccia adorn the displays. This is the world capital of cured meats; wild boar's heads are everywhere. In the supermarket there's no doubt as to your whereabouts; row upon row of different pastas cram the shelves. In the piazza the passeggio is underway, that delightful habit of Italians to take an evening stroll, to see and be seen. Above the town the last rays of the day catch the mountains still holding traces of snow. As the lights come on in the piazza the restaurants start to open. Waiters hover. What to eat tonight? Truffle pasta? Wild boar stew? Tough choices.

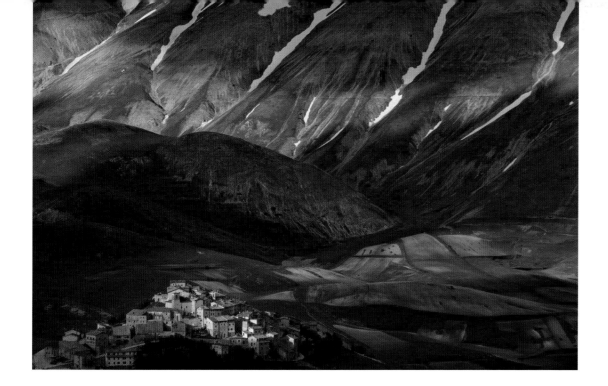

The village of Castelluccio perched above the Piano Grande with the mountains above
Monti Sibillini National Park, Umbria, Italy
Canon EOS-1Ds MK III, 70–200mm lens, polarizing filter, ISO 100, 1/40sec at f/8

UMBRIA 3/12 – VILLAGE OF CASTELLUCCIO

BEFORE Castelluccio is one of those places that look better from afar than up close. Its location on a spur overlooking the Piano Grande dwarfed by the slopes of Monte Vettore is incomparable. It was a picture of this scene that first inspired us to come here. The village itself is pretty scrubby; it's a hard life up here. But the trattoria serves superb agnello scottadino, a dish that, for me, sums up all that is good about Italian cuisine – simple fare relying on loving care and the quality of the produce. And that's not a bad philosophy to apply to photography either.

DURING From a hilltop overlooking Castelluccio I'm wondering whether to go wide to get it all in. There's certainly a lot to include – the Piano Grande, the mountains, the village – but it's all fairly distant. Wide-angle views emphasize the foreground and lessen the impact of distant features. It's an epic scene but with no foreground interest the image doesn't do proper justice to the setting. So what's the alternative? Go long. I reach for my trusty 70–200mm lens.

The late afternoon is painting the landscape with mottled patches of light and shade. By going in tight I achieve the opposite of the wide-angle view, emphasizing the scale of distant features, flattening the perspective and showing the true scale of the mountains rearing above the village. I opt to compose tight so the tops of the mountains are excluded, simplifying the image. You don't need to show it all.

This picture is made by the dappled light. There's the inevitable wait until a heavenly shaft illuminates Castelluccio just before the sun disappears behind the mountains to the west, and that's my moment. With these distant subjects there's no need for any appreciable depth of field so I use an aperture of f/8, right in the lens's mid-range where it performs best. It's a minor point but if you don't need a small aperture don't use one.

AFTER Shooting distant features can be problematic; haze or dust in the atmosphere can cause flat, washed-out pictures. Up here in the sparkling mountain air it's not a problem, but still I use a polarizer to saturate the colours in the scene as the light is coming almost at 90 degrees to the angle of view. The polarizer can also help to slice through haze, up to a point. But what about those skylight and ultra violet filters so beloved by camera shop assistants? Totally useless – I defy anyone to detect any discernible effect they have. Many use them to protect their lenses, but that's what lens caps are for. Why put glass that you don't need in front of your expensive lens?

UMBRIA 4/12 – SPRING COLOUR

BEFORE The colour in the fields around Preci in late spring defies belief. The farmers plant purple and yellow flowers as animal fodder, and these blocks of vibrant colour on the hillside are peppered with random dots of wild scarlet poppies and blue cornflowers.

In the heat of the late afternoon I'm trudging up the steep hill with my tripod on my shoulder and a sweaty back under the weight of the Lowepro. Slogging up hills loaded with equipment is a landscape photographer's lot; long periods of inactivity waiting for the light punctuated with bursts of intense physical effort. I'm thankful for the carbon fibre tripod though – it is a lot lighter than some of the legs I've shouldered. I'm heading for the colour as the bells toll in Preci. It's a beautiful day and I will make a picture this evening come what may.

DURING I'm crouching in a field again, considering the composition. Strong blocks of yellow, purple and green diagonals intersect and lead into the frame. With the nearest purple sainfoin flower just centimetres from the lens I need maximum depth of field. I don't like using the minimum aperture of f/22 unless I have to; diffraction caused by the almost pinhole-sized diaphragm degrades the lens's performance, softening the image slightly. But depth of field considerations outweigh such deliberations every time, so f/22 it is.

The focus point is critical to achieve maximum depth of field; autofocus is useless here, as it would just focus on the nearest object. I need to set the hyperfocal distance manually; that's the closest distance at which a lens can be focused while keeping objects at infinity acceptably sharp – the focus distance with the maximum depth of field for a given combination of focal length and aperture. When the lens is focused at this distance, all objects at distances from half of the hyperfocal distance to infinity will be acceptably sharp. Squatting in amongst the vegetation, sneezing with hay fever, I know that with a focal length of 16mm and an aperture of f/22 if I focus on an object at the hyperfocal distance of 40cm (16in) away everything from 20cm (8in) to infinity, or in this case Preci on the hillside beyond, will be sharp.

How do I know this? I carry a tiny laminated depth of field scale downloaded from the Internet in my bag. You would think this sort of calculation could be incorporated into the camera's firmware, wouldn't you? But no, an old-fashioned chart and tape measure are the order of the day here.

AFTER Even with my trusty depth of field scale, getting the focus point right is tricky and a slightly fuzzy background will kill a picture. The depth of field preview button is fairly useless at minimum aperture, as the viewfinder just goes too dark. Therefore using Live View or doing a test exposure to zoom in and check depth of field is vital.

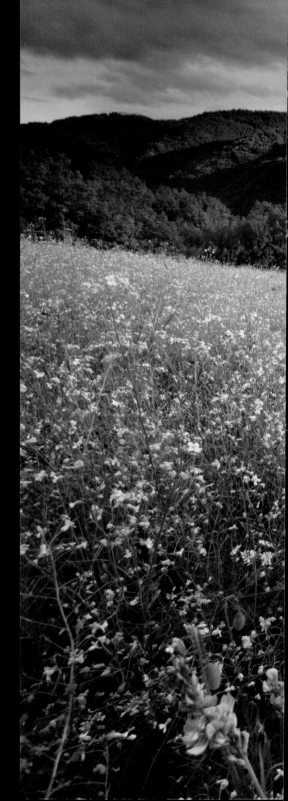

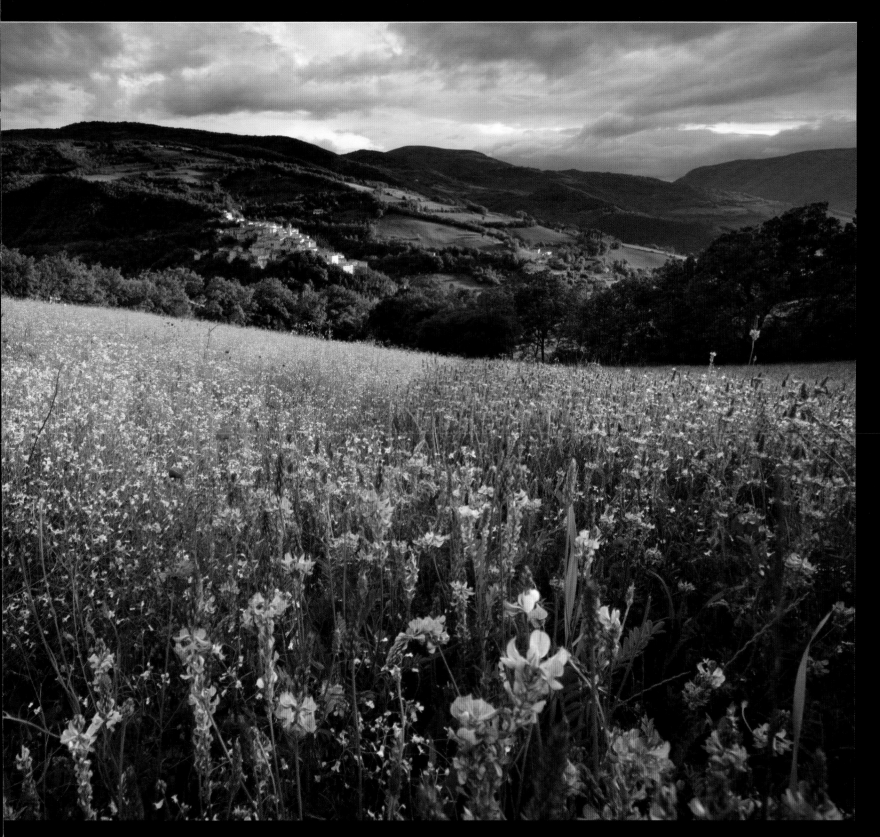

BEFORE We bring our workshop guests up this hill on a photo reconnaissance walk. Viewed in the hard noon light it's not immediately apparent to them why. Quizzical looks and baffled noises tell me they think I've finally lost it. A scrappy foreground and annoying details hijack the eye. Why come here?

DURING The ability to previsualize how a landscape can look at different times of the day is a key skill that comes only with experience. Nowhere looks its best under harsh midday light or flat grey skies, but a photographer needs to analyse the key elements and envisage how the light could illuminate the scene before, during and after dawn and dusk, and at different times of the year. The ingredients that could combine to make a picture here are the village of Castelvecchio nestling below, the rolling green fields and hills beyond and the steep 'V'-shaped cleft of the Valnerina to the right. It's a south-facing view so low side lighting will paint the scene in the early evening in May. Combine that with a cloud-dappled sky full of drama, patches of light and shade, and throw in the magic of infrared and I'm getting excited.

There's a house in the village with a skip and crane where more Brits are doing up a property. Doubtless they'll write a book about their experiences dealing with rustic, quirky craftsman. I can take all that clutter out in Photoshop – if only annoying details in life could be dealt so easily with the magic of the Healing brush. Is that right? Am I tampering with reality? Yes, but in this case I'm not losing sleep over it.

In a landscape so full of colour it seems perverse to work in black and white. But the fresh verdant landscape is in its prime for IR photography. And this infrared phase of my life has really reignited my taste for monochrome.

AFTER Going for a walk is the best way of getting to know a landscape. Cars are probably the worst means of transport for location searching – the temptation to sail on by is too great and too much is missed. Even with a landscape I know well, time spent hiking and looking is never wasted – so much changes from year to year.

The sun drops behind the hills and I head down; vino rosso and risotto tartufo beckon. It's difficult to judge IR images on the camera monitor but I think that session looks promising. The addictive glow of post-shoot satisfaction permeates my soul. Where to head for tomorrow's dawn session? I suppose we should think about moving on soon, but not yet. It's difficult to leave.

The village of Castelvecchio in the Valnerina
Near Preci, Umbria, Italy
Canon EOS-1Ds MK II,
24–70mm lens, ISO 100,
1/125sec at f/8

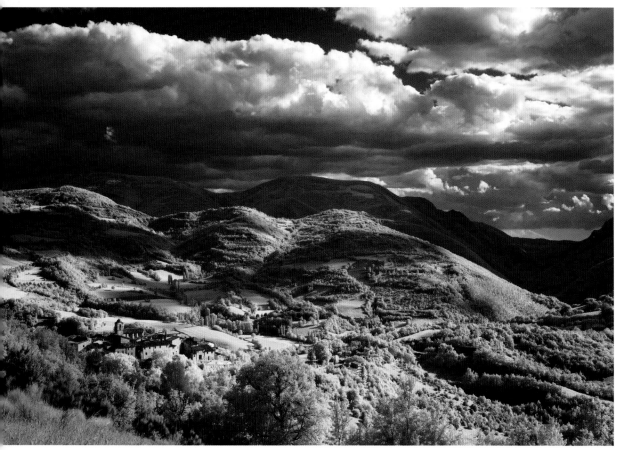

UMBRIA 6/12 – PRECI IN THE SNOW

BEFORE A word of warning for those considering a career as a photographer – it takes over your life. The promise of travel to exotic locations is one thing but if you value your security, family life, regular hours and leisure time it's not the job for you. And as for a normal social life, forget it. All has to be sacrificed on the altar of the next shoot.

I spent last night trying to refuse wine glass top-ups. We were having a good session with friends in Preci, but half my mind was outside. It started snowing heavily yesterday evening and surreptitious peeks out of the window confirmed that it still was. The promise of a fresh snowfall blanketing the Valnerina was enticing. I needed to resist temptation and yet again be the party pooper heading for bed early in readiness for a dawn patrol. Boring, but dawn shoots and sore heads just don't mix.

DURING There's a view looking down the Valnerina to Preci that I have shot many times – in spring, late summer, morning, evening, in mist – it's a classic. If I can make a picture of this view under a blanket of snow I will be eternally happy. As I venture out in the dark before dawn the anticipation mounts. Everything is coated in white and the trees are heavy with fresh snow.

There's no way the little Lancia will cope with this deluge, so I plod up the hill, the snow deadening all sound. The views back to Preci open up and I'm torn between trying to make something of it now in the half light or pressing on to my chosen spot. Panting and sweaty, I finally reach the top. The scene before me is ethereal. Undisturbed snow coats every surface and hangs on every branch – just what I didn't dare to hope for. Snow glazing the landscape is one thing, but for a perfect winter picture it has to be etched in the trees, and with thawing and wind these conditions are hugely temporary. So again I need to make the most of this right now.

I get to work as the mists swirl and occasionally obscure. There's no direct light on the landscape but it's a monochromatic, silvery scene that keeps me absorbed for over an hour. Sometimes the merest hint of colour is a powerful tool. Of course I have no choice in the matter, I have to go with what nature serves up, but a feel for these subtleties is key to making the most of this situation. One shaft from the obscured sun manages to penetrate the cloud and spotlight the hillside. Click.

AFTER A big clump of snow falls from the tree overhead with a heavy thump, just missing the camera. The sun is shining now and melting the snow before my eyes. Time to head back for breakfast. My one criticism of Italian cuisine is that they don't really 'get' breakfasts, but it's a small price to pay …

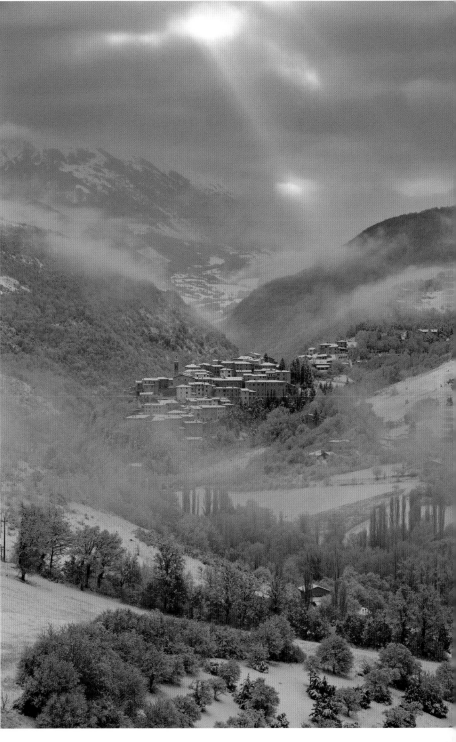

Preci in the snow on a winter morning
The Valnerina, Umbria, Italy
Canon EOS-1Ds MK III, 70–200mm lens, ISO 100, 1/250sec at f/8

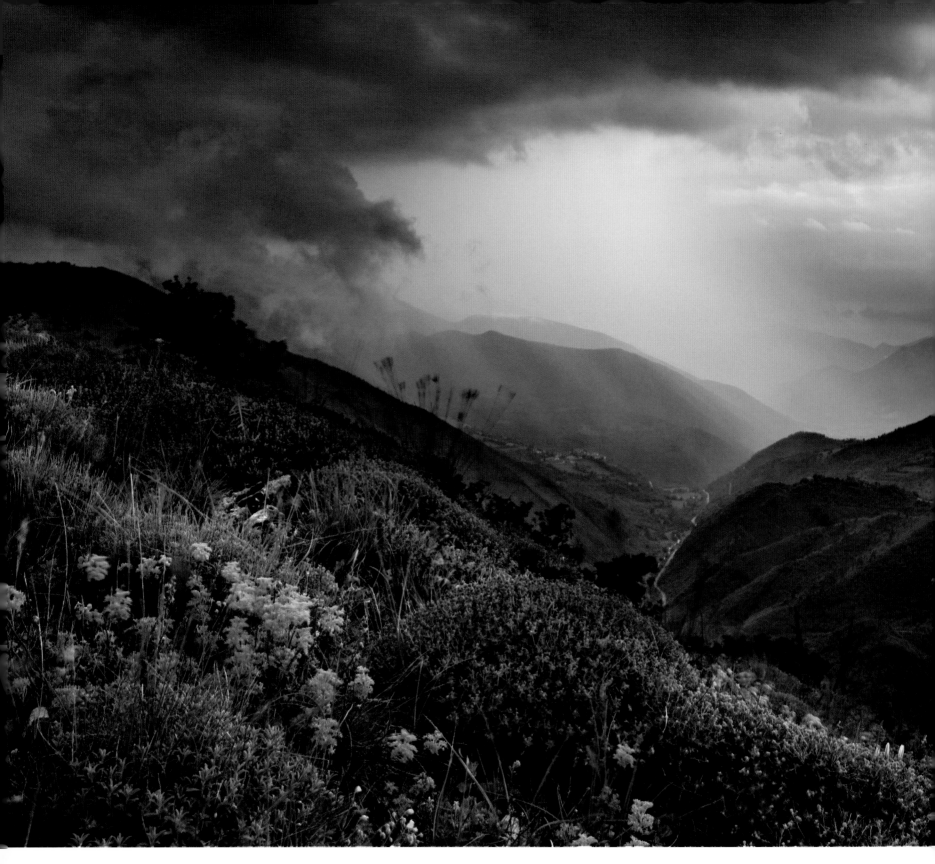

UMBRIA 7/12 – VALNERINA SHOWERS

BEFORE Most mountain regions get their fair share of rain. Umbria doesn't have anything like the number of grey soggy days as Snowdonia but the Green Heart of Italy is green for a reason and that reason is just about to dump on me. I'm on a hilltop overlooking the Valnerina and a sky of pure malevolence is approaching. They say the worst weather can often produce the best pictures, so let's test the theory. I like dramatic images with angry clouds – they're so much more interesting than boring blue skies.

DURING Localized rain showers, backlit shafts of light, a brooding twilight sky; it's all good stuff but there's a problem. Even with a 0.9 neutral density grad filter fitted I can't hold all the detail in the image. From the sombre shaded landscape in the foreground to the brightest area of the heavens, the tonal range is just too great. The other problem is there is no distinct line such as a horizon to lay the grad along – this will have to be a job for exposure merging.

With my 16–35mm lens on I make three exposures using auto bracketing: one for the sky, one for the middle distance and one for the foreground. There's a 4-stop difference between the extremes. I manage to work the situation for a few minutes as the wind builds, then big fat drops of rain start to fall. I could use an umbrella and carry on, but the wind and rain increase as visibility decreases. Game over.

AFTER I merge the three frames in Photoshop manually, laboriously feathering, cutting and pasting. Sometimes it's a job of a few minutes, in this case a bit longer. Why not use that clever High Dynamic Range software to merge them automatically? Because I hate the feel of HDR images, they look artificial and surreal. Doing it this way produces a far more realistic look, I think. If a picture looks like it's been messed with it has failed in my opinion. The trouble is, sometimes I get so absorbed in working on a picture that it's difficult to be objective. Then Wendy will walk past, take one look and deliver the damning verdict: 'that doesn't look right.' I usually rail against the judgement, but she's always right. It may take me a few weeks to accept but eventually I grudgingly admit the truth and hit the Delete button. Having another pair of eyes you trust to look at your work objectively is always useful, no matter how occasionally painful.

A spring storm in the Valnerina
Near Meggiano, Umbria, Italy
Canon EOS-1Ds MK III, 16–35mm lens, ISO 100,
three merged exposures

Umbria/Relationship

UMBRIA 8/12 – WILDFLOWERS

BEFORE Lurching up a track on the Forca Canapine, we become aware of a dim shape racing up the hill towards us. I halt the car and a wild boar races through the headlight beams at full pelt. It's an impressive sight; I certainly wouldn't want to get on the wrong side of him. Onwards and upwards. The slopes up here are quite literally a carpet of wildflower colour and I aim to get down low to tilt and shift this morning.

DURING Among such a profusion of colour it's difficult to know where to start, but after a bit of pacing I select my chosen plants and start setting up. With the tripod's centre column inverted, the camera is hanging between the splayed legs virtually on the ground and less than 10cm (4in) from the blue and yellow blooms that are the key element of this shot.

With a 24mm lens on, I want everything sharp, from the flowers just millimetres from the lens to the mountain beyond. But even at f/22 there's just not going to be enough depth of field. The hyperfocal distance for this focal length/aperture combination is 87.3cm (343/8in), so if I want the distant hills sharp, the nearest plants to appear sharp will be 43.6cm (171/8in) from the front lens element. Sorry to be so pedantically accurate but this is crucial stuff. So I have the choice of those flowers just 10cm (4in) distant or the background appearing crisp but not both.

But I have an ace up my sleeve – my 24mm is a tilt-and-shift lens. Basically, it's capable of contorting itself into strange shapes by shifting up and down, right and left, and tilting backwards and forwards. Why? Shift movements are handy for correcting converging verticals, but this morning I'm tilting in an effort to maximize depth of field. I could talk to you about Scheimpflug's Principle about intersecting lens, film and subject planes but I can hear you nodding off from here. In a nutshell, in a situation like this, by tilting the lens forwards almost infinite depth of field can be achieved. By looking through the eyepiece I first focus on the flowers then adjust the tilt so that all appears sharp then fine-tune the focus. Often there's not even the need to stop right down.

AFTER There's no doubt that tilt-and-shift, or perspective-control lenses to give them their proper title, are incredibly handy for architectural, travel and landscape work – I certainly wouldn't be without mine – but they're expensive, are only available in a few focal lengths and are relatively bulky. However, the promise of infinite depth of field is just too appealing to pass by, so I'd recommend cashing in your internal organs, auctioning your parents on eBay, pawning your lady's jewellery, flogging your bloke's car and selling off the kids for medical experiments to get one. You know it makes sense.

Wildflowers growing at the Forca Canapine
Monti Sibillini National Park, Umbria, Italy
Canon EOS-1Ds MK II, 24mm tilt-and-shift lens, ISO 250, 1/6sec at f/22

UMBRIA 9/12 – INVADING FORCES

BEFORE It has been a while since the Dutch invaded anyone but today a patch of Umbria became Little Holland. An invasion force of 20 caravans launched a lightning strike up the Valnerina and seized the high ground at Il Collaccio's. The column led by a Convoy Captain (complete with cap) are digging in now, laboriously positioning their white Windjammers and setting up the deck chairs. Piero the pizza chef will be busy tonight. I was photographing him earlier as he twirled his dough to make a perfect base; he is a master of his craft and the very picture of an Italian chef. Except he's from Montenegro. Hah, life is rarely as ordered as we think.

DURING I've left the Dutch enclave of Fort Clog and am taking a wander with my infrared camera. We've been away a month now and have another few weeks in France ahead on the way back. This is my favourite phase of a trip; much of the work has been done, pictures are in the can and the sense of achievement engenders a glow of satisfaction and a more laid-back approach. That is often a good thing – when I'm most relaxed creativity often flows, but if that relaxed attitude morphs into casual torpor I'm in trouble. These are the rhythms of the job I know well now; sometimes I need to fight it and spark myself up, while other times it pays to go with the flow. So much of being a photographer is concerned with what's going on in the head.

What's going on in my camera is another infrared picture of late afternoon shafts of light in the valley, with one timely beam illuminating a lonely tree. I just love the clarity of infrared; the complete absence of haze opens up all sorts of opportunities.

AFTER Another session, another card filled. I'm getting a bit worried about my memory. I've brought 24 4MB cards and 18 are now full. As each card fills I back up to a portable hard drive but that's almost stuffed to capacity. Still, I can always use the laptop to back up as well. Whatever you do, you need a system. If my precious RAW files aren't copied to at least two separate drives I'm distinctly nervous. Both in the field and back at base, the system for backing up needs to be consistent, logical and second nature. It's the most boring subject in the world, but so crucial. I have never yet lost a digital image, RAW or processed … touch wood.

The Valnerina Valley
Near Preci, Umbria, Italy
Canon EOS-1Ds MK II, 24–70mm lens, ISO 100, 1/125sec at f/8

UMBRIA 10/12 –
MIST OBSESSION

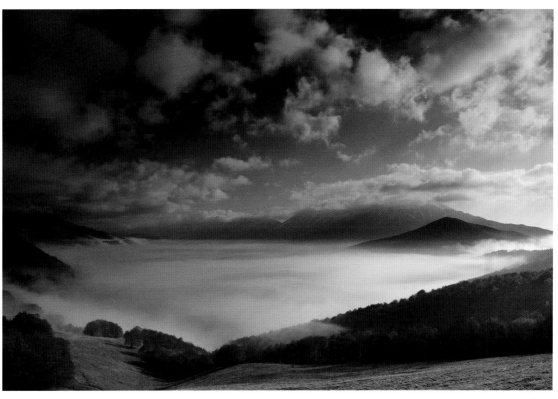

BEFORE Nothing prepares you for the first view of the Piano Grande. It is a sight the like of which I've not seen before – a huge karstic basin that was once a glacial lake, flat as a pancake. If it were in South America it would be called an altiplano. It is surrounded on all sides by the peaks of the Monti Sibillini National Park. To think that this wild scene is in central Italy, less than 100 miles as the crow flies from Rome, is incredible.

DURING Do I have a mist obsession? Possibly. But the promise of a shoot with mist lying on the Piano Grande gets me up at 3.30am again. In Umbria in May, the conditions and weather are good, and day after day my dawn patrols start at this unearthly hour. Coupled with the late end to the day it's punishing.

We arrive in the cool light of pre-dawn; there's mist! Too much actually – standing on the lip looking down into the Piano we're enveloped in it. I know the scene is in front of us but for now we can't see it. That's OK though, countless dawn vigils have taught me mist has a habit of rising before settling and sometimes parting momentarily to reveal stunning vistas, so I need to be ready.

I open up the bag, get the camera on the tripod and fit the 24–70mm lens, spirit level, cable release, wide-angle adaptor ring, filter holder and 0.6 ND grad. I turn the camera on and check it's set at ISO 100. Too often I've started shooting with an inappropriately high ISO still set from the previous session. Always reset the camera to your defaults after use.

An hour passes and I'm still pacing in the murk. Wendy has gone walkabout. Will this be another futile vigil? A call from the hill above: Wendy's in clear air so there's hope. Like a curtain call, the clouds part and there lies a blanket of mist on the Piano Grande with Monte Vettore beyond. The light from the sun to the north-east is contre jour – side lighting from about 2 o'clock – so I'm shooting slightly into it. This situation can cause flare, where direct but non-image forming light from the sun falls on the front element. Flare is bad news, as it causes loss of guts to a picture and nasty reflections in the lens. It's easy enough to rectify though – I lock off the eyepiece and use my body to shade the lens during the exposure.

AFTER This picture is a classic example of how to work as a landscape photographer. Scout the location, analyse the options in different lighting situations, previsualize the image, plan the shoot then keep returning until it's nailed. It sounds so obvious but the first time you do it, the first time a shot comes together exactly as envisaged, is a Eureka! moment. Life, and your photography, will never be the same again.

Mist lying on the Piano Grande at dawn
Monti Sibillini National Park, Umbria, Italy
Canon EOS-1Ds MK III, 24–70mm lens, 0.6 ND grad filter, ISO 100, 1/125sec at f/11

UMBRIA 11/12 – A ROOM WITH A VIEW

BEFORE In the Val di Spoleto olive groves and vineyards predominate. I had the chance to ruminate on this while gazing out of the window from my hospital ward in Spoleto. Wendy had hidden my shoes – she was worried that in my morphine-induced haze I'd discharge myself early from the Italian nurses' tender care to get back behind the lens even before the plaster of my cast had dried. Another note for budding photographers: if you travel for a living, sooner or later you'll end up in a foreign hospital. When that happens I can recommend Spoleto – the view of golden fields is certainly far better than the vista of the Five Ways roundabout from Yeovil's fracture ward. On our second visit to Umbria I pitched over on the way back from a poppy shooting session and dislocated my elbow. I prefer not to remember the journey to the hospital on a twisting road with my arm hanging off. One contributory factor was the weight of my camera bag – for years it kept putting on weight as I added and carried more and more. It couldn't go on. Abandoning the big panoramic film system has helped; I now work with just the one Canon DSLR system and haven't ended up in any ditches since.

DURING On the hill above Bevagna yesterday I found this olive grove overlooking the Vale below and so I am back to see what I can make of the location in the dawn light. There's a mist lying in the valley and heavy cloud building; it's looking good.

As I contemplate the scene I'm setting up the camera on the tripod, going through the routine. This camera, the 1Ds MKIII, has now become so familiar to me I barely register it. It's probably halfway through its working life – doubtless a successor will be along soon and I'll succumb to an upgrade. In the past, cameras would earn their keep for over a decade, now I reckon on perhaps a three-year lifespan. But it's not necessary to have the very latest of everything; the importance of the actual camera is always overestimated. This one is doing the job – its 21MP sensor produces amazingly crisp and rich results – but anything over 20MP is academic, beyond that the lenses simply can't match the sensor's resolution.

I opt to wait until the sun is hidden behind cloud to avoid any flare problems that could result from the wide-angle of view and contre jour lighting. Olive trees are great to photograph; their twisted, gnarled trunks and silvery reflective leaves are so expressive of all things Mediterranean.

AFTER My arm is still twisted, a permanent reminder that carrying too much equipment is counterproductive. If the light and location are good, one body and a few lenses will suffice. After all, you can only use one camera at a time.

An olive grove overlooking Bevagna and the Val di Spoleto at dawn
Umbria, Italy
Canon EOS-1Ds MK III, 24–70mm lens, ISO 100, 1/4sec at f/11

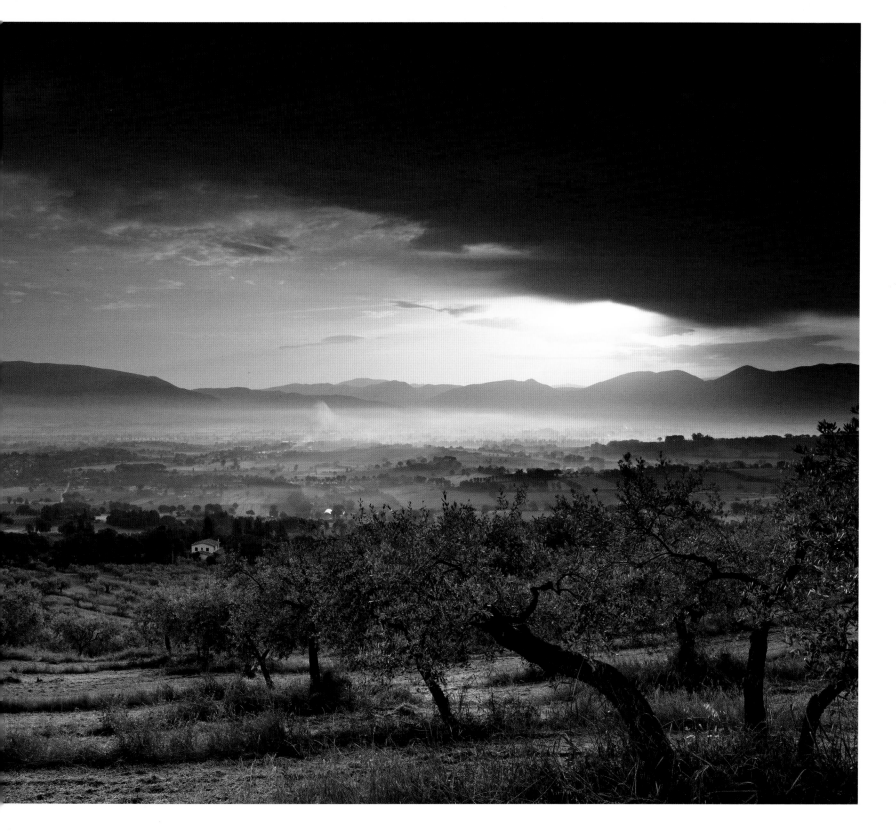

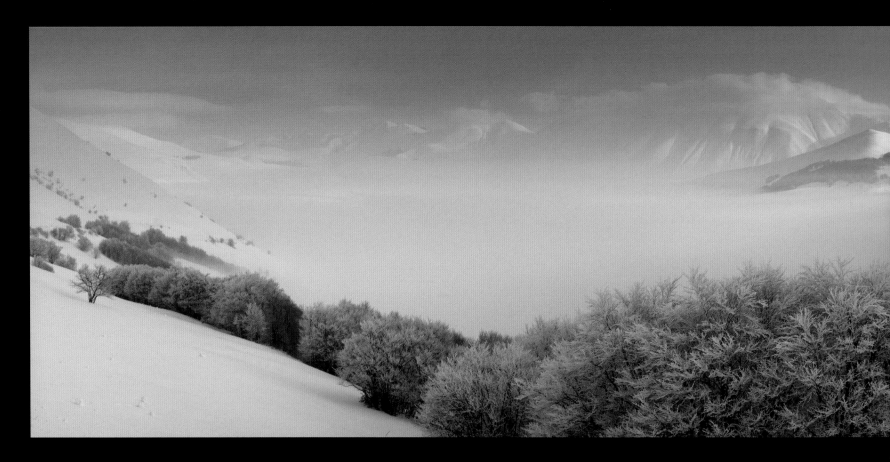

The Piano Grande in winter
*Monti Sibillini National Park,
Umbria, Italy
Canon EOS-1Ds MK III,
24–70mm lens, 0.6 ND grad
filter, ISO 100, 1/85sec at f/11*

UMBRIA 12/12 – WINTER STITCH UP

BEFORE Day two on the Piano Grande in winter and the snow and ice are still pristine but the visibility is poor and, although we've arrived in good time, two hours have been spent waiting, mourning the lack of my furry snow boots as my toes gradually freeze. They are just the job for conditions like this, but are currently in the loft at home, left behind due to the straightjacket of airline restrictions.

 As we're hanging around by the tripod the Corpo Forestale arrive, barely glance at us and move on. After years of being hassled in London by all manner of security types for the heinous crime of taking a picture I'm paranoid about all forms of officialdom. Just how many types of police does Italy have?

DURING I've framed up a shot utilizing the heavily frosted trees in the foreground. Tantalizing wisps of cloud are draped over the landscape but at the moment the Piano Grande and mountains beyond are invisible. I've levelled off the tripod in readiness; another stitched panorama may be a possibility. In an ideal world I'd have a panoramic head on the tripod (by rotating the camera around the lens's nodal point, exact joins are ensured in stitched panoramas) but they are bulky, cumbersome and ponderous to use. I've found that unless there are precise geometrical lines in the composition's foreground detail, I can get away without one. That's not being sloppy; a panoramic head permanently on the tripod would cause problems for normal photography. This

system whereby I can do a panoramic whenever I want with any lens I want and without any specialist gear is working well. Give a photographer more flexibility and opportunities for pictures open up. And if it works, don't fix it.

Wendy shouts down from above again. She's on watch up the hill reporting on a brief parting of the heavens approaching. And then perfection is revealed; a layer of mist sits on the Piano as the mountains beyond catch a glimmer of pale winter sun. It is indescribably beautiful. I make a picture, check the histogram, dial in +2/3 exposure compensation and do another. Any blinkies? No. The 0.6 ND grad is doing the job on the top half of the frame, enabling me to expose for all the detail in the frosted trees. Let's

try for a panorama now. Set exposure manually, quickly check what focal length is appropriate and go for it. Five frames exposed. The clouds are filling in again; that was it. Perfection is fleeting.

AFTER Another session, another picture fuelled by the stimulus of working this beguiling region. These surges of creativity, energized by our passion for Umbria and the Valnerina, are driving my photography forwards. If my photography isn't progressing it's stagnating, but stitched panoramas, digital infrared and winter conditions are all new and exciting things for me. No danger of stagnation here yet – it's just pure photographic fun, and in just a few months we'll be back. Ciao.

Canada
8.Roots

We can see the Rocky Mountains rearing up on the western skyline as soon as we leave Calgary Airport, relentlessly pulling us into the jaws of the Bow Valley. We're not exactly resisting – the allure of the Canadian Rockies never diminishes. It's a big country with big hair, big mountains, big glaciers, big lakes, big trains, big beds, big breakfasts and big bears. A familiar stomping ground? Sort of – we've been many times but I could spend a lifetime photographing this vast wilderness and not get anywhere near exhausting its potential.

For a landscape photographer this is the Promised Land. My enthusiasm for this country is tinged with nostalgia; I grew up partly in Canada. Granted that was a long time ago, the Leafs even won hockey's Stanley Cup back then, and a long way from here, but I'll always carry a trace of maple syrup in my blood.

This trip is a journey back to my roots both geographically and photographically. For the best part of the next month I am going to indulge in unrestrained uninterrupted landscape photography in one of the most epic settings in the world. No distractions; this is Wendy and me in our element. Landscape photography was my first photographic love and it will be my last. I thrive on the new challenges of travel portraiture and wildlife, but there comes a time when I have to come back to the core activity that got me hooked on photography in the first place. And there's no better place to do that than here.

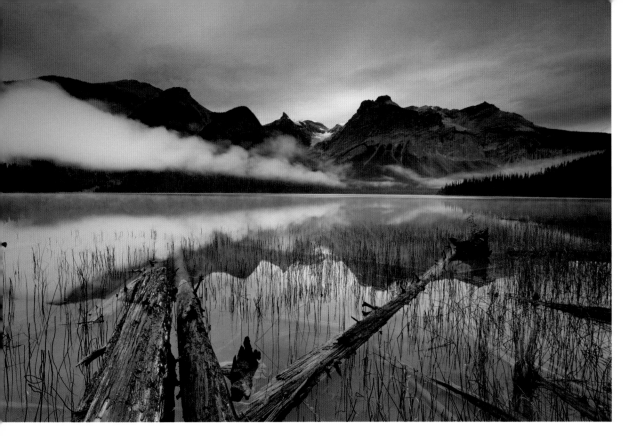

Emerald Lake at dawn with the peaks of the President Range beyond
Yoho National Park, British Columbia, Canada
Canon EOS-1Ds MKIII, 16–35mm lens, 0.6ND grad filter, ISO 100, 0.5sec at f/11

CANADA 1/13 –
EMERALD LAKE AT DAWN

BEFORE We pass over the continental divide through the Kicking Horse Pass and into Yoho National Park – great names. Don't they alone just make you want to come here? Emerald Lake is incomparably situated with its creamy jade glacial waters surrounded by the towering peaks of the President Range. We're here for four days and I'm going to be shooting in the immediate vicinity every dawn and dusk. Increasingly I like to work this way. Maybe I'm getting on a bit, maybe I should be whizzing all over western Canada trying to do it all NOW, but experience has taught me if you travel less you see more and photographically that's always worthwhile.

DURING The combination of the previous day's rain and a big overnight drop in temperature has delivered a thick layer of mist lying on the lake at dawn. I set up in the cool light before sunrise. Two crossed pieces of driftwood give the composition some bold lead-in lines. How wide to go? I'm using a 16–35mm lens and frame up with a 0.6ND hard graduated filter on to balance the reflections. If I go super wide the foreground looks amazing

but the scale of the President peaks beyond diminishes. Composition is all about balancing shapes. What's right and wrong? It's impossible to say but with the strong lines of the logs, the mountains, the tree-clad headland, the mist and the reflections, a natural arrangement jumps out at me. Move slightly, assess, improve, analyse.

Once the shot is framed up I wait. Will strong directional light from the rising sun break through? No, not this morning, but the scene is wonderfully muted, subtle and moody. This is what I've been waiting for; on the final morning of being here, it has all come together. Zoom in, focus on the twig at the hyperfocal distance (see page 104), zoom out, do a test exposure. I decide here and now that this image is going up big – a print over 1m (40in) wide is on the cards. Crisp and sharp detail from fore to aft, rich, deep shadow information, pure evenness of tone with subtle gradations of colour; when you get it right with a 21MP camera the results in print are phenomenal. But to get the very best from a full-frame DSLR with a quality lens bolted on everything has to be right – tripod stability, focus point, exposure and processing, not to mention the aesthetics.

AFTER There is a decisive moment for all pictures when all the elements combine harmoniously. With landscapes it's often difficult to know when that is. Here the dawn sky picked up a hint of twilight colour and that was my moment. I could have been all over the place working a multitude of different spots over these four days, but that approach just doesn't work for me, I end up with memory cards full of mediocrity. When I've found a magic spot I work it to the maximum.

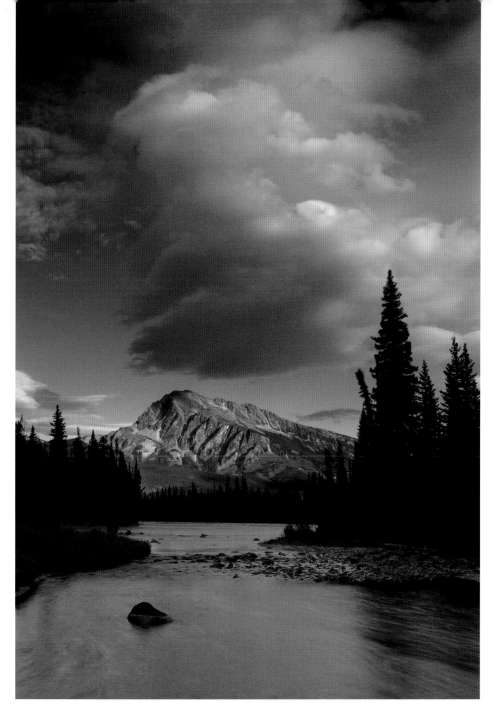

The Athabasca River at the Meeting of the Waters with Mount Hardisty beyond
Jasper National Park, Alberta, Canada
Canon EOS-1Ds MKIII, 24–70mm lens, 0.9ND filter, ISO 50, 2sec at f/16

CANADA 2/13 – THE ATHABASCA RIVER

BEFORE Walking down Banff High Street, I'm feeling slightly intimidated. Seemingly every shop window is displaying books, cards, calendars and prints of the Canadian Rockies in perfect conditions. Morraine, Louise and Maligne Lakes – all the classics.

Does the world really need more pictures of this stunningly beautiful region? The simple answer is no.

This huge area of interconnecting National Parks spanning Alberta and British Columbia is one of my favourite places in the world. There are the 'Big Four' National Parks – Banff, Jasper, Yoho and Kootenay – plus the no lesser Provincial Parks – Mount Assiniboine, Mount Robson, Glacier, and so on. It is a photographic playground of almost endless scope. Yet an annoyingly persistent germ of self-doubt refuses to let up and I'm still pondering my purpose. It has all been done before, so what's the point of shooting yet more of this photo-saturated landscape?

Experience is a great thing, not just behind the lens but also dealing with the mental challenges as they arise. This is just fatigue talking. I'll bet all photographers go through this. I just have to ignore what others have done and do what I do. Simple – now get on with it, Noton.

DURING We're scouting along the western bank of the Athabasca River south of Jasper looking for locations. After several sessions by lakesides I feel the need for big vistas by the surging river but it's proving difficult to find the right foreground. At times, as we stop on the roadside to check out another possibility, we cause a roadblock as passing motorists stop to peer, convinced we've spotted something special. Find your own views!

I'm standing in the river at dusk, as you do. The last light is playing on Mount Hardisty, but what make the scene are the towering layers of cloud pressing down on the landscape. Using a 0.9 neutral density filter and an ISO of 50 to slow the flow of the water a touch I expose for 2sec. I'm not entirely happy with the composition and foreground but the sky makes the shot.

AFTER Better put the caption in before I forget where we were that evening. As the image is processed this crucial information is entered into the image metadata so that wherever the picture ends up and however it's reproduced, the location, description, author, copyright and technical details will be available. The sooner that crucial stuff is done the better; I need my stamp on my precious pictures. Keywords are added later. It's just another job to be done, but with this information embedded any imaging database can read and find this picture. And if you can't find an image when you need it, what's the point of making it?

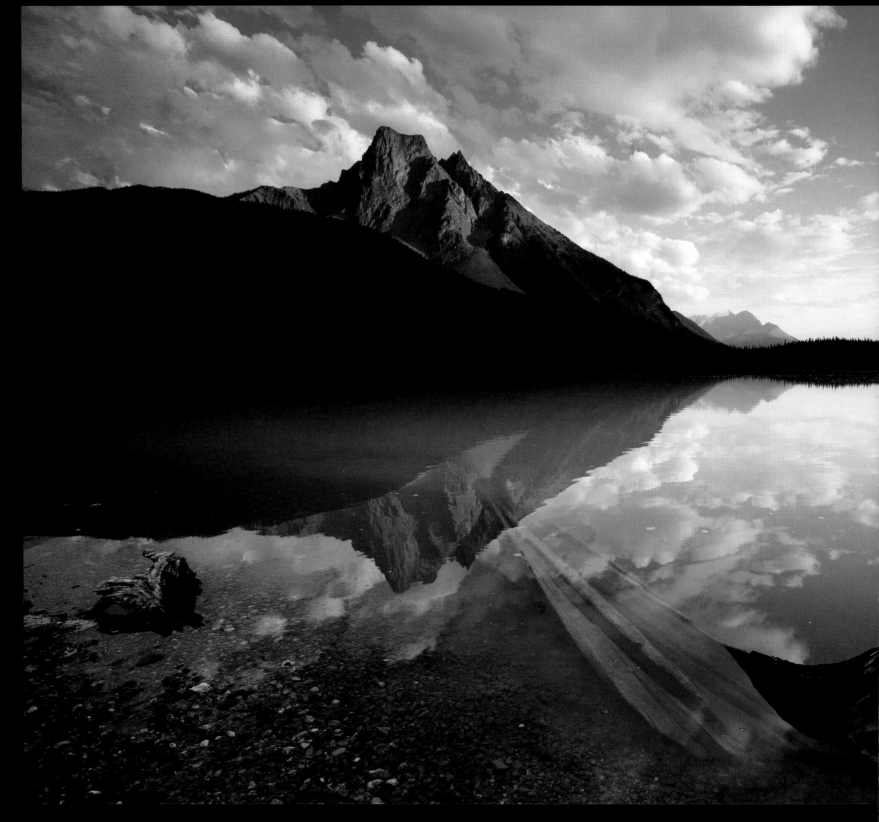

CANADA 3/13 – EMERALD LAKE AT DUSK

BEFORE In the evening we're skirting around the lake again to a location I spotted at the head of the valley. An artfully sculpted piece of driftwood lies on the shore, leading the eye into the frame with the perfect peak of Mount Burgess beyond looking like a proper mountain – triangular and imposing. No interference with nature is required, it is in a perfect spot, positioned just so. But if this shot is to work I need flawless reflections, and right now, one hour before dusk, a strong breeze is scudding across the glacial waters spoiling the show. Patience is a necessary virtue for any landscape photographer. We sit, wait, chat, look. Perhaps the title of this book should be Still Waiting for the Light …

DURING Often, as the sun drops to the western horizon, the world settles, the wind drops and lakes become mirrors. I've seen it happen countless times and this is what I'm hoping will transpire this evening. Sometimes I've just got to squat down and let the shot come to me. It does. I expose a vertical composition as the waters reflect the last rays texturing the rocky crags of Mount Burgess. There's just enough cloud around to make for an interesting sky. I've got the 24–70mm lens on with a polarizer fitted and as the sun drops I switch to a horizontal composition. Don't you just love it when a previsualized image comes together just as you hoped?

AFTER This picture took a bit of work at the post-production stage to bring out the best of all the tones in the scene, from the brightest clouds and reflections to the detail on the crags of the mountain and in the driftwood. I made two separate conversions of the same RAW file, one for the highlights and one for the shadows – one bright and one dark. I then combined these in Photoshop using my tried-and-tested technique of selecting and feathering appropriate areas of the lighter image and laying those selections on top of the darker image as layers. All the information was there in the one RAW file – I just needed to bring it out. This is where attention to detail at the shutter release stage, behind the camera, really pays off – checking the histogram to assess the exposure. Shooting perfect reflections on Rocky Mountain lakes is addictive. I know as the trip develops it could get repetitive and I'll have to vary my repertoire, but for now I can't help myself. It just has to be done.

Emerald Lake at dusk with Mount Burgess reflected beyond
Yoho National Park, British Columbia, Canada
Canon EOS-1Ds MKIII, 24–70mm lens, polarizing filter, ISO 50,
1/10sec at f/13

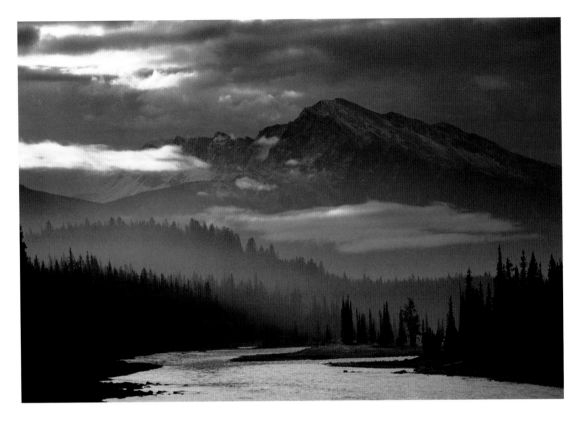

The Athabasca River and Mount Hardisty at dawn
Jasper National Park, Alberta, Canada
Canon EOS-1Ds MKIII, 70–200mm lens, ISO 160, 1/250sec at f/7.1

CANADA 4/13 – MOMENTARY SHAFT

BEFORE Life has settled into a pleasing rhythm here in Jasper: dawn shoot, breakfast, back up, hike, and the late afternoon shoot followed by evenings in our log cabin. The days are conveniently short so something approaching a normal life is possible with evening repose and dinner– how radical! By day we rove the around the park, packing in the photo sessions and the boot mileage. Gradually, after too much time spent in front of computers back in the real world, we're getting our mountain legs back. If only this could carry on indefinitely. We last came to Jasper 15 years ago and looking back I'm wondering what I was playing at. Photographically I failed spectacularly to make the most of this wild and wonderful area. It just shows how my photography has moved on. Back then I was fixated on the famous Maligne Lake view, now I'm seeing all sorts of possibilities I was oblivious to previously.

DURING Driving back after a frigid morning by the Athabasca River, I catch a glimpse in the rear-view mirror as a momentary shaft of light permeates the heavy skies. We pull into a lay-by and I'm rummaging in the boot, sorry, trunk, before you can say reticulation. Out with the camera, on with the 70–200mm lens, ISO up to 160, Image Stabilization on, shoot. Try and get the horizon level. The long lens flattens up the perspective emphasizing the grandeur of the mountains in relation to the trees. All I need is a grizzly splashing through the river. It could be cut and pasted in – I guess there are some who would stoop so low. I can see how it would be tempting, but the trouble is when viewers realize they've been duped all pictures would be tarred with the same brush and discounted as fake. We live by the sword, or the Clone tool. Such duplicity doesn't bear thinking about; this scene is Canada personified, it would be a travesty to mess with Mother Nature.

AFTER With such a momentary opportunity I had just seconds to make the shot – no time for filters or tripod. I was worried about the highlights in the sky burning out, but using the highlight recovery function in the RAW convertor I managed to salvage almost all of them. First instincts when such fleeting moments occur are to get something exposed. That first rapid response should be well considered, with no sloppy technique, but it's important not to be fiddling about with camera settings when the heavens part. Familiarity with your equipment is vital in these situations. Once that first shot is achieved, fine-tuning of exposure and composition can take place. The success of whole trips can turn on the response to such ephemeral moments.

CANADA 5/13 – PYRAMID LAKE

BEFORE It doesn't matter how stunning a view is, finding the right spot to make the most of it is never straightforward. Get the boots on and walk, look, think, move around, crouch, climb, look again, previsualize. Where will the light be coming from at dawn and dusk? How long will it take for the sun to clear that ridge? Do I want the subtle twilight on this scene, or the first direct rays of the rising sun, or the last warm light of day? This is what the game is all about – this is the work. Location finding is everything; the photography is the easy bit. On the first afternoon in Jasper around Pyramid Lake we go, weighing up options, logging locations and ideas. I now have a plan and the world can spin without me while I revel in photography with no distractions.

DURING Another dawn, another lake, another mountain, more driftwood – am I working to a formula here? No reflections this morning though and precious little happening in the sky either. Initially I'm tempted to pack it in and move on, it doesn't look promising, but where else would I go? Back to bed? It's enticing, but too often I've retreated too early only to be tormented with gorgeous light painting the landscape. Best to stay on and try to work the location. So I bolt on the 16–35mm lens with 0.9ND grad and straight 0.9ND filters to slow things down. The first kiss of light is touching the top of Pyramid Mountain, glowing red as the merest wisp of cloud drifts into the frame. I expose as the rays creep down the perfectly shaped peak. With the ISO down at 50, a 21sec exposure is possible, blurring the motion of the water and clouds. For a situation that looked hopeless on arrival, I'm pleased to have made something of it.

AFTER Just along the shore is a group of shapely rocks – a well-known viewpoint where countless pictures of Pyramid Lake have been taken from. During the hour or so I've spent crouching here by my low tripod, a few other photographers have come, spent a few minutes exposing at The Spot, and gone. Established viewpoints are alluring for photographers, but merely replicating what's been shot before is a pointless exercise that does nothing for your creative integrity or development. Making an image that is unique – a product of your individual vision – is so much more rewarding than locating the tripod legs in the holes left by previous photographers. In a world that is so well covered it is hard to come up with new slants on familiar subjects, but that's the challenge. No one said it was easy.

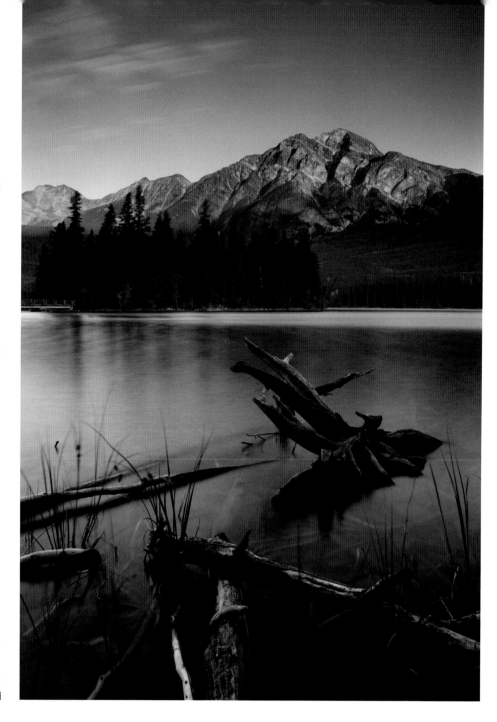

Pyramid Lake and Mountain at dawn
Jasper National Park, Alberta, Canada
Canon EOS-1Ds MKIII, 16–35mm lens, 0.9ND grad and 0.9ND filters, ISO 50, 21sec at f/20

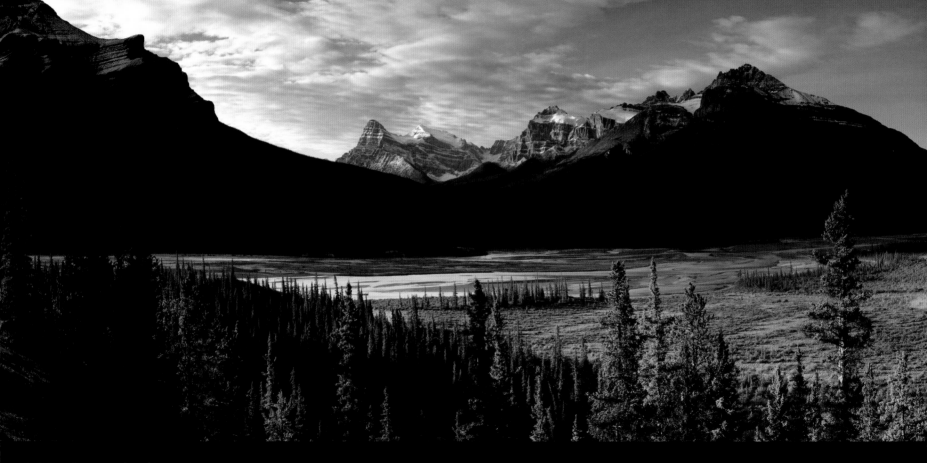

It should have been a tough decision, but in the end, it wasn't. I'll admit I enjoy owning the best photographic equipment, but I enjoy using it for what it was designed for even more. Cameras are only tools. Being professional I can justify having the best, but only if they earn their keep. If any tool is sat gathering dust, it has to go. It's the end of an era.

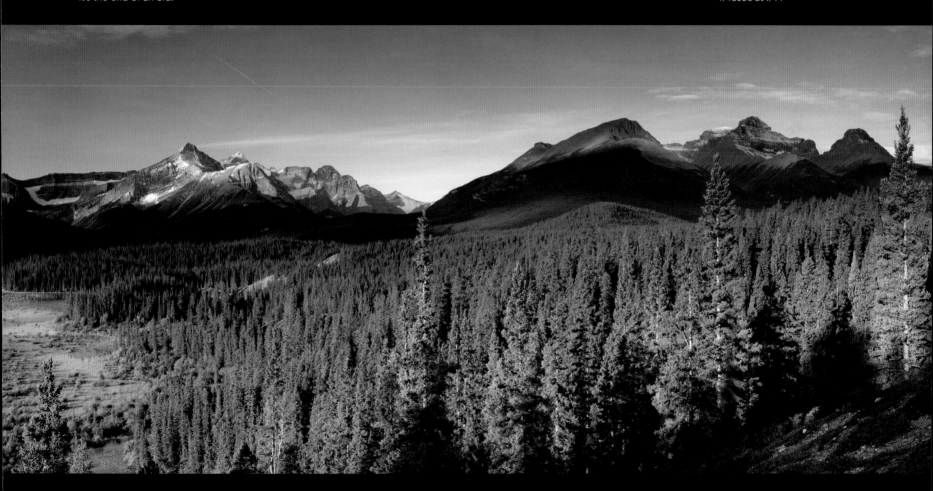

Misty Water-Coloured Memories

Being a landscape photographer means a life covered in cobwebs. It's the prize for being the first along the trail in the darkness before dawn, stumbling over roots by torchlight, wondering about the strange rustling noises in the woods. I once came head to head with a startled moose in the half-light, we both glared at each other wondering what the other was doing out and about at such an hour. I suppose I was on his patch. It does feel so good to be back on the dawn patrol in Canada though. This morning there are no clouds or mist and the scene before me, though beautiful, is lacking in balls. As the sun's rays creep down the mountains I expose, but I know this is just a start, it will get better. A wind gets up and the reflections are a memory; time for pancakes, maple syrup and all the stuff that makes for a Classic Canadian Cardiac Breakfast.

Next day, switch-backing up the trail to Yoho Lake, we're singing Abba - Waterloo to be precise. Wendy switches to Mamma Mia, I move on to yodelling. It was an interesting combo that had to be heard. Let's just say I'm better at photography than anything musical. But head-to-head encounters with surprised bears are not recommended; it's best if they hear you coming, hence our cacophony. Mind you, any grizzly that heard my singing clearly opted for early hibernation, as we've not yet had that meeting. What we have had is long mountain hikes, epic vistas, canoeing on glassy waters and gorgeous light painting landscapes that leave us speechless with their grandeur. Plus watching the Leafs lose to the Canadiens on Hockey Night, trains that are so long they take 15 minutes to rumble past, the Royal Canadian Mounted Police on mountain bikes, chipmunks, Hudson's Bay stores, the Trans-Canada Highway, caribou steaks, Tim Horton's coffee, trees, more trees, the Parks Canada pass hanging from the rear-view mirror, snow shoes and the names; all those evocative names that take me back to history lessons in Kitchener: Huron, Iroquois, Cree … but above all, the space, the vast, almost limitless feeling of space. This is a big, wild, beautiful country. Oh yes, it is so good to be back.

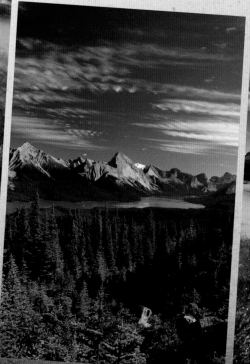
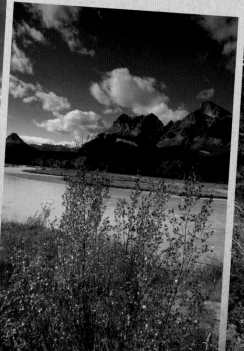

atmospheric particles, haven't just disappeared; they have been scattered and are bouncing around the atmosphere as non-directional ambient light, making the sky look blue and illuminating my shaded foreground, reflecting off the glacial river making the waters look even colder than they are. So I have two light sources here, both with very different colour characteristics – warm direct sunlight and cool ambient light.

Colour characteristics of light are measured as a colour temperature (CT) and just to confuse you, a light source with a high CT of say 10,000K, like the ambient light on the water in this shot, is cool and blue, while a light source with a low CT of say 2,000K, such as candlelight, is warm. Neutral daylight is 5,200K. Cool is warm and warm is cool, OK? Think of a gas flame – the hottest part is the blue bit.

Now you may think this is all technobabble, but understanding light is fundamentally important for a photographer. My mental image processor is doing a sort of Auto White Balance on this scene. The wide disparity in colour temperature between these two light sources isn't immediately apparent to the eye, but the camera's sensor, set to Daylight White Balance, will see and record these differences. Understanding and predicting these shifts in the CT is crucial; a photographer never stops learning about the endless subtleties of natural light. This image is made by the contrast between the warm and cool lighting, and that didn't happen by accident.

AFTER Quite apart from the colour temperature in the shade, the air temperature was equally cool. It was inevitable – I bought the down jacket. It now resides in my camera bag, ready to insulate on demand. Having the right gear for the environment is just as important as the lenses; I now don't know how I lived without my goose feathers.

The Athabasca River with Mount Fryatt and Mount Edith Cavell

Jasper National Park, Alberta, Canada
Canon EOS-1Ds MKIII, 16-35mm lens, ISO 50, 1.6sec at f/16

CANADA 7/13 – WARM IS COOL

BEFORE I'm cold. It's the usual story; the camera is all set up, the shot framed, all is ready except a bank of cloud sits on the eastern horizon, obscuring the rising sun. Everywhere else in the sky there are gaps, but the sun this morning is having a lie in. Summer has slid into autumn, which in turn is showing decidedly wintry tendencies and I'm contemplating those down jackets for sale in Jasper's outdoors shops.

DURING After at least an hour of shuffling, mumbling and gazing at the sky, one blast of early morning sunlight bathes the far bank of the Athabasca River. That low-angled light has had to slice obliquely through the atmosphere and on its journey particles in the atmosphere have scattered the shorter wavelengths at the blue end of the visible spectrum. What's left are the longer wavelengths at the orange end of the spectrum, and that's why low morning and evening light is warm and luscious, and a setting sun looks red. That warm direct light is now making the trees on the far bank glow golden.

Meanwhile the blue rays, interrupted on their journey by

CANADA 8/13 – MINIMAL COLOUR

BEFORE Western Canada doesn't experience the blaze of autumnal colour that the east of the country does, but the golden-leaved aspen trees in their fall finery are striking in amongst the sea of conifers. The almost metallic white sheen of their bark is equally appealing. Combine those subtle tones with the first snowfall of the approaching winter and it makes for enticing conditions the like of which I'd never experienced before. I was in photographer's heaven.

DURING I'm getting all graphic with the repetitive shapes of the aspen trees against the muted colours of autumn, all coated with a dusting of fresh snow. Colour is often most powerful when it's bold, saturated and in your face, but sometimes a muted, minimal, understated approach is equally potent in a restrained, subtle way. I'm using the long lens to isolate detail and go for simple tight compositions. Should I stop down and go for an extensive depth of field, or open up and drop the more distant trees out of focus? I go for the latter. I fine-tune the cropping and composition by zooming in a bit tighter.

This 70–200mm lens is such a flexible tool for this sort of thing. I used to use prime lenses only; I didn't trust zooms to give me the optimum crispness I demanded. But then sometime in the early '90s, in the hills near Chiang Mai, I realized I was spending a huge proportion of my life bending over my camera bag getting backache swapping filter rings from one lens to the other. By then lens technology had advanced such that the quality differential between the best zooms and prime lenses was almost imperceptible. Of course, that was in the film era. Now the evolution of 20+MP sensors has put the spotlight back on this debate. There is no doubt that if optical quality is your sole criteria then prime lenses are the way to go. But the difference in many cases is so minimal in my view that it isn't worth losing sleep over.

Zooms are so useful, offering focal lengths and cropping flexibility unachievable with even the most comprehensive array of prime lenses. They also save time and, compared to carrying multiple optics, weight. The time issue isn't mere laziness creeping in; when gorgeous light beams are painting the landscape in momentary visions of wonder, the difference between a few seconds of zooming and recomposing and a hasty, fumbling lens change can represent the fine line between a masterpiece on a memory card with subsequent glowing euphoria and a desolate evening of remorse.

AFTER I think I've spent a few minutes squinting through the eyepiece but in fact two hours of utter absorption have passed. It's sobering just how engrossing photography is; not a pastime that combines well with family or friends with a different agenda. Wendy is well used to these interminable hours of contemplation. She is a rare breed.

Autumn colours of the aspen trees in the snow
Near Muleshoe, Bow Valley Parkway, Banff National Park, Alberta, Canada
Canon EOS-1Ds MKIII, 70–200mm lens, ISO 200, 1/400sec at f/2.8

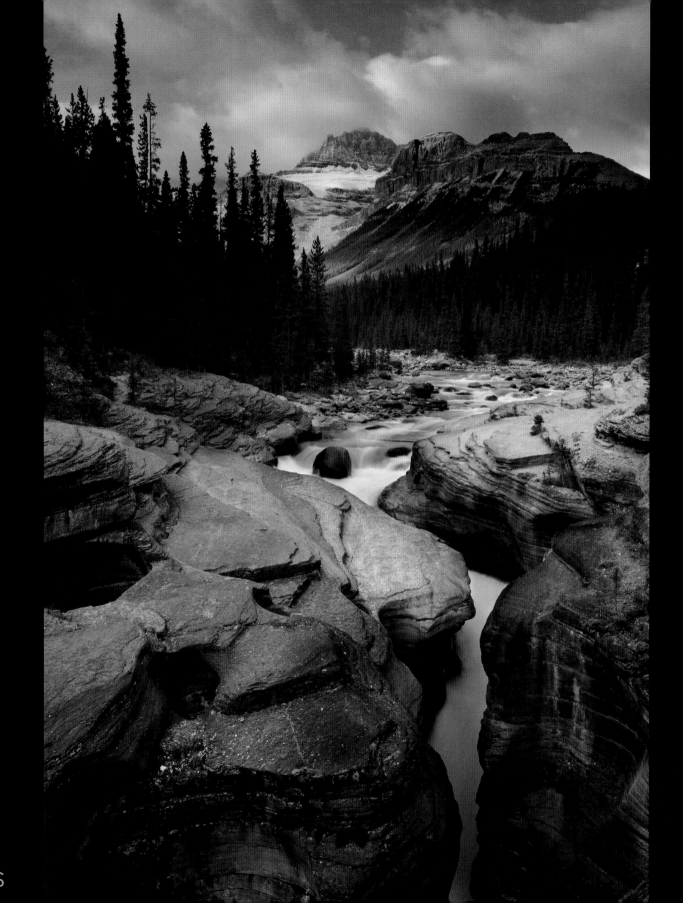

BEFORE The glacially fed waters from Peyto Lake rush through the bottleneck of Mistaya Canyon with a constant roar. Over the millennia the erosive powers of the churning river have cut a narrow, deep, twisting cleft, leaving the rock curved and textured as only nature's creativity could. We've been here for two hours or more. We arrived in darkness. I hoped for ghostly twilight on the snow-clad peaks, but it was not to be. The next event could have been the first pink rays on the mountains, but cloud to the east prevented that. But we've stuck it out and with weak dappled light just managing to break through now there's a possibility of a shot.

DURING The insipid low-contrast light has its advantages, as I need to expose for the shaded canyon yet hold the detail in the sky and distant peaks. The composition precludes use of a hard ND grad, but a 0.6 soft grad subtly holds back the exposure on the top half of the frame without showing the telltale grad line. A 2sec exposure enables me to record a touch of movement in the water. The wonderful contortions of the twisted rock make the picture.

With limbs stiff with the cold, we're finally packing up when I see a figure approaching with the familiar shape of a tripod over the shoulder. It had to happen. A month here and I've managed not to lock antlers with another photographer yet, but it was inevitable at some stage. To the uninitiated this is a fascinating behavioural study. Two photographers working the same patch usually circle each other warily, sniffing the air, eyeballs rolling, tripods poised, pawing the ground and posturing. Actual physical aggression is rare, but not unknown. More likely there will be a prolonged stand off as, like two competing rhinos, they snort and manoeuvre for the best vantage point.

Photographers as a species are a strange lot; too much time spent on lonely hilltops often produces beings with haunted looks and dubious social skills. My encounters in the field with others of my craft have resulted in some truly bizarre incidents; a few have become friends, others have refused to acknowledge my presence. This morning, as he's coming and we're going, no blood is drawn and we even manage polite greetings. But the ritual eyeing-up of the kit does occur and his body language leaves me in no doubt that, as he's using a large 10 x 8in camera, I am a lesser being. I decline to point out that he's too late and has missed the best light.

AFTER Back in the motel I quickly do a rough process of the RAW image on the laptop; I need to know whether the long cold vigil was worth it. I'm delighted – it seems to have worked. My 'friend' with the cumbersome, impractical wooden camera is still probably setting up. Hah!

Mistaya Canyon at dawn
Near Saskatchewan Crossing, Banff National Park, Alberta, Canada
Canon EOS-1Ds MKIII, 24-70mm lens, 0.6ND grad filter,
ISO 50, 2sec at f/16

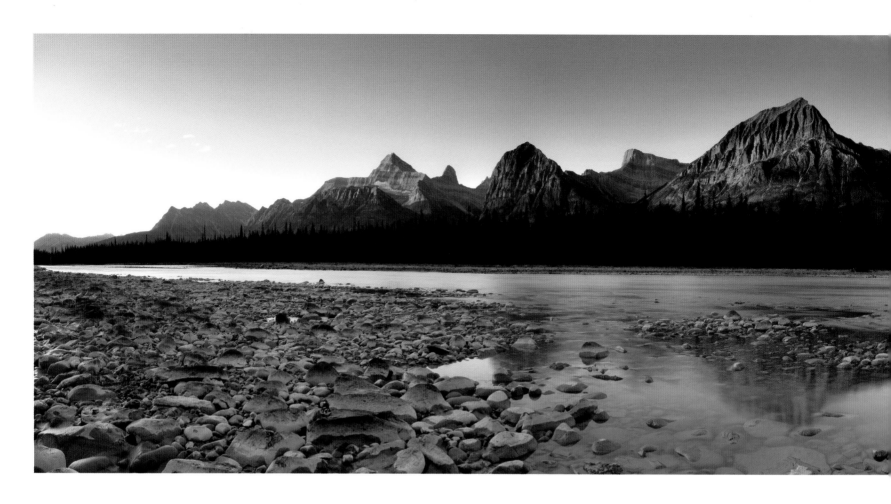

The Athabasca River with Mount Fryatt and Brussels Peak at dawn
Jasper National Park, Alberta, Canada
Canon EOS-1Ds MKIII, 16-35mm lens, 0.6ND grad filter, ISO 50, 5.2sec at f/16

CANADA 10/13 – THE BIG PICTURE

BEFORE What is the attraction of panoramic pictures? Ultimately it's just a shape. I've never bonded with square images, but letterbox proportions do seem to suit landscapes. I guess it replicates the experience of standing in a landscape and sweeping the eyes around the view. Twenty years ago I hired a 6 x 17cm panoramic film camera and took it to Venice. Ten days shooting in that artist's paradise on that format launched a whole decade and more of inspiration. To say I bonded with the panoramic format would be an understatement. Back then, exposing big wide pieces of film was my calling. That era has now passed, and of late I've had a rest from panoramas, as the 2 x 3 aspect ratio of a full-frame DSLR is a very natural shape for a picture. When I first started shooting panoramic I tried to do everything with it, but in truth few locations and vistas really suited the format. But now, with image stitching, my appetite for the letterbox view is back, and

sometimes I find myself contemplating a vista that just cries out for the panoramic approach.

DURING How wide to go with panoramas? There are no limits – a complete 360 degrees is possible, although I think images like that are usually done more for a novelty factor then for pictorial appeal. Here on the banks of the Athabasca River I'm going for a full 180-degree sweep using six overlapping frames all shot at a focal length of 24mm. With a 0.6ND grad filter on I'm assessing the exposure, which for such a wide angle is tricky – I have to use the same exposure for all six frames. The brightest parts of the scene are at the extremes – to the left where I'm shooting into the light and to the right where the light is full frontal. If I expose to hang on to the highlights in those parts, the central frames will be very dark. In the end it's a compromise, I can't hang on to all of

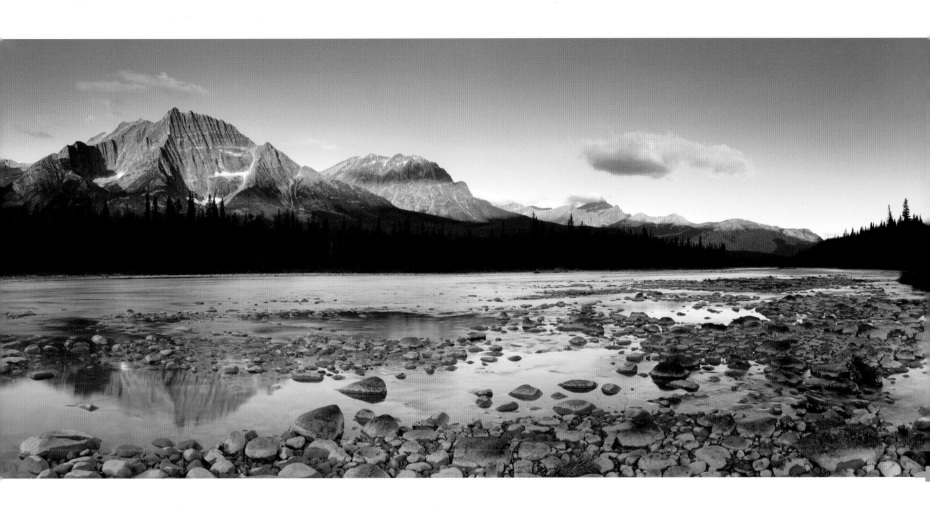

the highlights. The high-contrast lighting and the almost cloudless sky will make getting a seamless join between frames crucial; any disparity will show up horribly. But getting to grips with all this is exciting and I'm loving the challenge.

AFTER Photography should be fun, if it's not there's something wrong. Trying new techniques and approaches is key to refreshing the creative juices. A lot of time and thought went into this picture; days of location searching, reconnoitring every view up and down the river for miles, numerous returns and much loitering with intent. The processing and stitching took less than an hour, still significant when hundreds of images await my attention but compared to the job of processing and scanning a transparency, no big deal. And the buzz of seeing the end product pop up on my screen as smoke belches from the weary computer is just plain magic.

CANADA 11/13 – ONE DASH OF GOLD

BEFORE The Valley of the Ten Peaks is one of Canada's most famous views. Any day now the road up here will be closed for the winter and snowshoes and skis will be the only way to get around. We're lucky to be able to see this epic valley like this, draped in fresh snow with the odd splash of autumn colour showing through.

DURING It's a sombre, overcast view of the pine-clad valley with the ominous peaks rising above. The fresh snow reveals the form of the trees, crags and cliffs like a fingerprint. One dash of yellow in the foreground interrupts the otherwise monochromatic scene.

AFTER What will happen to this picture? Once it's been backed up I may choose to look at it in Capture One this evening on the laptop with a Molson beer in hand, but generally that waits until I'm back at base where I can process and edit on my large calibrated monitor. This is a laborious job; for every hour spent

behind the lens there will be the same hunched in servitude, watching egg timers on the screen. I wish I could farm this out, but it's such a crucial stage that I couldn't possibly delegate the creative decisions made at the time of exposure to anyone else. That's why I choose to concentrate on quality over quantity; otherwise I'd spend the rest of my life chained to the computer.

Once I've done my bit to the RAW image and subsequently the 16-bit TIFF, a Photoshop Action converts the edited image to 8-bit, saves the hi-res TIFF to two separate folders on different machines and makes a low-res JPEG copy for reference and keywording. This is where Sharyn and Wendy step in as dust busters, going over the high-res image area meticulously at 100 per cent to check for imperfections. These are dealt with summarily using the Cloning and Healing brushes. Metadata is checked, keywords added and finally the picture is done. A final low-res copy is made and both hi-res 60MB TIFF and low-res JPEG are saved to our constantly growing library. The master TIFF is kept in three separate locations, any subsequent use for reproduction, website or print can be accessed easily by searching the database using any of the information contained in the metadata – description, location or keyword. The original RAW files are similarly archived and backed up. The low-res files are used for emailing, web use and quick viewing.

It's a system that we've evolved over ten or more years. We're always looking to see how we can improve and streamline this workflow, and doubtless others have different working practices, but it works well. Whatever you do, amateur or professional, and no matter how casual your hobby, there has to be a system. Without one, pictures are lost in random folders, accidentally deleted or consigned to oblivion by hard drive failures. It's boring stuff, but so crucial.

A fresh snowfall in the Valley of the Ten Peaks
*Banff National Park, Alberta, Canada
Canon EOS-1Ds MKIII, 24–70mm lens, ISO 100, 1/160sec at f/9*

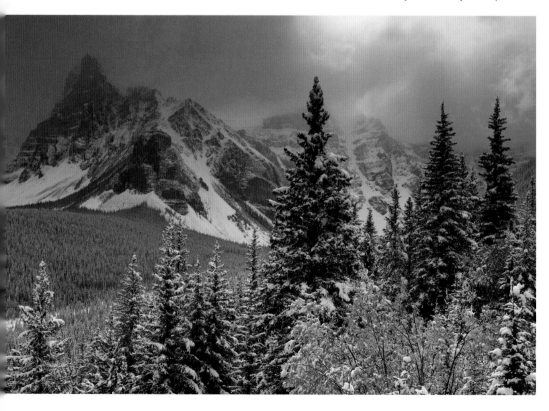

CANADA 12/13 – RUSHING WATERS

BEFORE It's still dark yet the shutter is open. Using the B (bulb) setting, I've locked it open and will just see what pops up on the monitor in a few minutes. I can hardly see through the lens to compose, but it's always worth getting to a location early to work the light as it evolves.

The air temperature is well below zero and, with our proximity to the rushing glacial waters, the chill is palpable. It's another frigid dawn session, but in our down jackets with base layers underneath we're toasty. Being equipped and attired for photography is an interesting task. At times intense physical activity scaling a hill is followed by interminable periods of waiting in exposed positions. As with mountaineering, getting the layering right does the job, but those long periods of inactivity mean having to carry a considerable reserve of insulation for use on windy hilltops. Most camera bags simply don't allow enough cargo space for all this stuff: extra layers, waterproof shell, thermos, water, pork pie etc. Being too cold on a shoot is something you do only once; it's just poor preparation. Hats make all the difference.

DURING It's getting brighter now but the light still has a sky-high colour temperature (see page 129) and so will record as a cool royal blue. With the 16–35mm lens at its widest, I'm as close to the rushing waters as I can be without full immersion, and there's some interesting flowing streaks around the rocks in the foreground. The sky is just starting to pick up some subtle twilight reflecting off the heavy clouds. A 0.9ND filter slows the exposure down to 16sec at f/16 with the ISO dropped to 50. Some will believe this vibrant blue colour is false, the product of some distinctly dodgy wizardry in post-production. But it's real enough, the product of ambient light with a CT around 1,000K. I hardly ever adjust the colour balance of a picture – I just go with what nature provides.

AFTER I'm often asked how I get such vibrant colours in my pictures. I'm sure some suspect that I'm in love with the Saturation slider, but honestly it's not the case. The key to producing clean, crisp, colourful images is in the basics that I've been discussing throughout this book: shooting in the right light to start with and making the perfect exposure in-camera before setting the appropriate black and white points and optimizing contrast and tonal range in post-production. The difference between this approach and just turning up the Saturation slider is like night and day. Oversaturated images induce feelings of nausea rapidly followed by violent vomiting. The colours just don't look real. Yes, I will sometimes dial in a touch, but only a few notches. The Saturation slider is a tool to be used with restraint. A good picture is like a fillet steak – overcook it and you lose all the flavour.

The Athabasca River with Dragon Peak and the Winston Churchill Range at dawn
Jasper National Park, Alberta, Canada
Canon EOS-1Ds MKIII, 16–35mm lens, 0.9ND filter, ISO 50, 16sec at f/16

BEFORE Morraine Lake in Banff National Park, along with Niagara Falls, is possibly Canada's most well-known view; a scene that graces the Canadian 20-dollar bill. In the summer the milky blue of the glacial waters and the verdant green of the trees makes for a classic Rocky Mountain vista. But this afternoon all is fresh, pristine and white. The jagged serrated edge of the ten peaks is mostly lost in the cloud, but the imposing bulk of the mountains are evident. To see this archetypal view in these perfect winter conditions is a real treat, especially as this is our last day here, for now. Full memory cards and the National Hockey League season opener tonight – does life get any better?

DURING I'm shooting straight into the light as momentary blasts of sun permeate the shifting clouds over the peaks. Dappled light plays on the lake, not too hard to cause contrast problems but enough to lift the scene. I've got the super-wide 14mm lens in action to get it all in, something I generally abhor but in this case that soaring cliff on the left adds drama and leads into the frame. Unable to use a filter with this lens, I have to make two exposures for subsequent merging – one for the sky and one for the landscape. With all the brightness of the reflections on the water and the whiter-than-white snow, the highlights need watching. As usual those handy 'blinkies' alert me to blown highlights (see page 31), and the histogram confirms the danger, so I dial in a touch of underexposure. Should I be worried about those 'blinkies' in the brightest part of the sky where the sun shines through? No, get a life – we don't expect to see detail there! The clouds draw in and dusk starts to settle, winter is here. Regretfully, we head back down the Bow Valley Parkway to Banff in the gathering gloom.

AFTER There's a touch of remorse hanging in the air around us, even though we're in such a beautiful place; we don't want this to end. Stripping away all the nonsense in life and just getting back to the essential pleasures of being in a big, wild and wonderful landscape that we both love with no priorities other than hiking, photography and the next meal has refreshed our souls. And it's during these intensive weeks of photography that tangible progress is made with the constant evolution of my craft. I'll get the hang of it one day. Tomorrow: airports, emails, reality. It will never catch on …

A fresh snowfall on the banks of Morraine Lake
Valley of the Ten Peaks, Banff National Park, Alberta, Canada Canon EOS-1Ds MKIII, 14mm lens, ISO 100, 1/125sec at f/11

Dorset
8.Familiarity

There's much to be said for working your own back yard. Local knowledge is so handy, and during day-to-day life you build up a database of what happens when, meaning you know exactly what time of year the combination of light and mist at dawn works in that field with the shapely trees just down the road. Being able to go back to the same location time and again through the changing seasons until the image comes together entirely to satisfaction is such a boon. I doubt I'm alone in thinking some of my best pictures were shot less than an hour from home.

I have the good fortune to live in an extremely attractive part of England on the Somerset/Dorset border with the Jurassic Coast – a UNESCO World Heritage Site – nearby. I've been photographing this coast and county all my photographic life and have every intention of continuing. I've lost cameras at Portland Bill, lenses at Lyme Regis and have a hip flask engraved with the iconic Cerne Giant fashioned from one of my pictures. But working my own locale brings its own problems – reality keeps getting in the way.

When we're away on a photographic mission life becomes very simple. The framework of each day is dominated by photographic needs; where to be and when for the light, location searches and moving on all slot into place. Eating, sleeping and everything else has to fit in around the Holy Grail of the Photographic Timetable. Getting away on these trips is usually a huge relief, as the other clutter of life is left behind. Not so when shooting in Wessex – photography sessions have to fit in between meetings, editing, copy deadlines, talks, workshops, dinner dates, family commitments, the gym, dentist, kitchen renovations and everyday life. Diaries fill up and finding a slot for a session by the tripod on the Cob at Lyme Regis becomes difficult. When we're away I fondle my cameras each and every day; at home weeks can go by without any meaningful photo activity. I feel like I'm an ex-photographer shackled to the computer, and that's when flights have to be booked.

But with so much on offer on the coast and in the verdant rolling hinterland, neglecting Dorset is madness. We always photograph best what we have a real feeling for, and I have a deep connection with this region; it's my home, where my maternal ancestors have been for centuries. I'm just going to have to create some gaps in life to trudge the leafy lanes and cliff tops of England's green and pleasant land.

DORSET 1/13 – KIMMERIDGE BAY

BEFORE I am a complete digital convert – I love the flexibility, control and quality I can achieve – but there is one major thing I miss about exposing large-format film: long exposures. Using movement is an essential technique in a photographer's repertoire. Trees blowing, grass swaying, water lapping, people bustling, clouds scudding and leaves rustling; a bit of motion blur can transform an image.

Clearly a photographer needs to be able to use exposures ranging from several minutes to thousandths of a second, but with modern DSLRs with default ISO settings of 100 or 200, it's often difficult to slow exposures down enough to recognize discernible movement. You can put neutral density (ND) filters in front of the lens and stop down to f/22, but this still only buys you a few seconds. But my life has now changed. I have just acquired a 10-stop ND filter to really prolong exposures; it's so dense I can't see a thing through it, but it's so useful.

DURING I'm at Kimmeridge Bay on a November afternoon watching the ebbing tide, scouting along the rocks for my perfect foreground shapes. The sun is dropping behind a layer of cloud marching in from the west. I frame up my shot, take an exposure reading in manual mode then mentally calculate an extra 10 stops of exposure; 6min at f/11. I fit the 10xND, position a 0.9ND grad by eye in front of the lens to hold back the sky, set the camera to B (bulb)

setting, then lock open the shutter and pace for six minutes. This is just like the old days; mentally calculating exposures with filter factors and applying running adjustments during the exposure as the light changes.

As the exposure drags on I wander about a bit, chat to people on the beach and wait. Eventually I release the lock and check the histogram – too dense. Open up again, go for a walk and stroll back to the camera ten minutes later. I look at the image glowing on the monitor in the gathering gloom – it's like magic.

AFTER With really long exposures getting an accurate exposure reading is difficult, as the exposure is usually changing as I take the shot. If at dusk I take a reading that with the 10xND indicates a 6min exposure, by the time the shutter has been open half that time the gathering darkness may have dropped the exposure by another 50 per cent. Decades of large-format long exposures have given me useful experience dealing with this quandary. Halfway through an exposure I take another exposure reading. As the camera is inert with an open shutter I use my old hand-held spot meter. I then prolong or curtail the exposure accordingly. It's not an exact science, but consider the fact that the difference between a 6min and an 8min exposure is not much at all, about 1/3 stop only. Exposures of this length show clouds streaking through the sky and ethereal seas of mercury.

Kimmeridge Bay at dusk
Jurassic Coast, Dorset, UK
Canon EOS-1Ds MKIII, 16–35mm lens, 10xND and 0.9ND grad filters, ISO 100, 10min at f/11

Autumn colours
Near Cerne Abbas, Dorset, UK
Canon EOS-1Ds MKIII,
70–200mm lens, polarizing
filter, ISO 100, 1/12sec at f/8

DORSET 2/13 – AUTUMN COLOURS

BEFORE Getting the boots muddy is just the best way of clearing the mind and is also brilliant and pleasurable exercise. I should really spend more time out wandering, because there's no better way of finding new photographic locations, which is an endless quest. I park the car at Minterne and walk along the hilltops above the Giant to Cerne Abbas, then come back up the other side of the valley through Up Cerne. It's a hike that encompasses all that makes the rural Dorset landscape special: chalk ridges and green valleys, stately homes, a quaint village, some mysterious history and a country estate. Walking this circuit refreshes the soul.

DURING I'm on the hill above Minterne Magna looking down the valley towards Cerne Abbas. The light is just creeping over the ridge giving strong side lighting and revealing the textures of the valley. I've got the 70–200mm lens on the tripod, collar mounted, mirror lock activated and a polarizing filter fitted. As I'm

shooting at virtually 90 degrees to the angle of the light, the polarizer has maximum effect. This is confirmed as I rotate the filter on the lens and the colours pop into saturation – a quick way to assess its effect. Polarizers do introduce contrast into a scene; this can be a good thing but in hard light it's often too much. If in doubt I do one shot with the polarizer and one without.

Check the tripod – no matter how sturdy the legs are they're only as good as the ground they're on. Tripod feet on spongy moss or grass will spell unsharp pictures. Check all is locked off. Long lens exposures on tripods are tricky; everything needs to be right to get a crisp image. First press of the remote and the mirror locks up, second press and the shutter fires. I always use mirror lock up when using any focal length longer then 50mm.

AFTER A tripod is the most important piece of kit you can buy. It doesn't matter how good your camera or lenses are, if they're supported on cheap, wobbly legs that waft in the breeze your pictures will be unspeakably soft. Portability against stability is the trade off that needs to be addressed. There's no question that a sturdy tripod that goes up to head height is required but it has to be carried so some compromise has to be made. I have a range of tripods for different uses but carbon fibre has become the norm; the weight saving is significant without any sacrifice of rigidity. The tripod's own weight does contribute to stability, though. By hanging my camera bag from the centre column I can give the whole rig extra ballast. The trouble is, in a breeze when the tripod is most tested, the bag sways in the wind, so I use a bungee that allows the bag to rest just touching the ground. The weight and elasticity then act as a damper.

DORSET 3/13 – INVISIBLE LIGHT

BEFORE Take one perfectly good camera, modify it so it's not receptive to visible light, then go out into the field and endeavour to make stunning landscapes using light you can't actually see. Welcome to the world of infrared (IR) photography.

IR photography is nothing new but its potential has expanded massively with the ability to shoot digitally. The digital technique is more fun and offers increased flexibility and control than its film predecessor, but it's not easy; it requires a whole new way of looking and thinking. A classic infrared monochrome landscape has a definable look with white clouds against black skies and seemingly luminescent foliage.

Think of white light being refracted through a prism, displaying the visible spectrum: violet, indigo, blue, green, yellow, orange and red. Photographic film and now digital sensors by and large replicate the sensitivity of the human eye, but beyond the visible spectrum there is light that we can't see: ultraviolet (UV) at one end, and infrared at the other.

Minute particles in our atmosphere reflect the shorter wavelengths at the blue end of the spectrum, which is why the sky looks blue. The UV light so dispersed causes haze, a landscape photographer's curse, but the longer wavelengths at the IR end are not reflected, giving IR landscapes a clarity devoid of haze for even distant views. In spring and early summer, photosynthesis causes leaves to reflect infrared light, so foliage looks almost white. But this is just the start – learning how different subjects reflect and transmit IR light is a whole new photographic world.

DURING On a day of sunshine and showers in May I'm crouching in among the gravestones at Longburton Church, composing the leafy trees against the dramatic black skies and towering cumulonimbus. The direction and angle of the light is still key, but there's a big change from my normal way of working in landscape mode at dawn and dusk. The fact is, IR photography doesn't really work with subtle low-contrast lighting; strong, bright sunlight is needed so I'm here late in the morning. It feels wrong, but the red images appearing on the monitor indicate otherwise.

St James' Church
Longburton, Dorset, UK
Canon EOS-1Ds MKII,
24-70mm lens, ISO 100,
1/100sec at f/14

AFTER There are lots of theories about how best to convert a colour image to monochrome; essentially it comes down to the options of using the Channel Mixer or simply Desaturating. In this case virtually all the information is in the red channel so there's no point in using the Channel Mixer; a simple Desaturation of all the IR images in one batch is a good way to begin assessing the shots. Even when all the images are shot in strong bright light the first impression is of a flat set of pictures. It's easier to put contrast in than it is to take it out, so I do some tweaking of Curves and adjusting of black and white points in the RAW converter (see page 152). In Photoshop I then selectively tweak areas of the image to introduce local contrast.

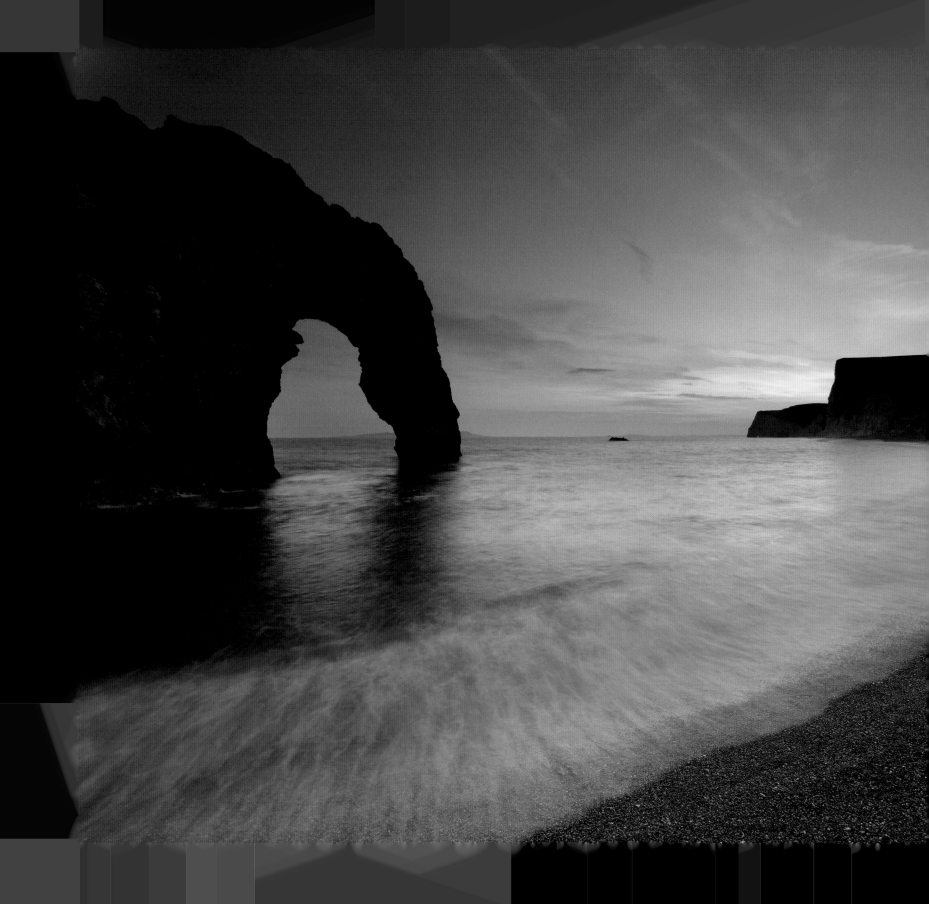

DORSET 4/13 – DURDLE DOOR

BEFORE I'm chained to the computer, tormented by the glorious day outside. I just have to flee – anywhere – and expose. Too long without the imaging drug and I get decidedly twitchy. So I cast off my shackles and head for the coast with my new camera, the EOS-1Ds MKIII. One of the great advantages of using a camera with a full-frame sensor is the ability to use extreme wide-angle lenses, and so another recent acquisition is a 14mm f/2.8 L II – an extreme wide-angle that's fully corrected. I've already got a 15mm fisheye lens, but the curving of horizons and verticals often isn't desirable.

I'm heading for Durdle Door, one of Britain's most famous coastal features that I've photographed more often than Rocky has had comebacks. So why do it again? Clearly, replicating what I've shot before is not an option but the extreme wide-angle coverage now available has given me an idea for a new take on this classic location. It's worth a shot, and I have to break free from the tyranny of the computer.

DURING As the sun dips behind the cliffs, a beautiful twilight suffuses through the sky. I use an exposure just long enough to get some movement in the water while retaining some sea texture. The familiar outline of a Lowepro-clad figure touting a tripod along the beach reminds me just how popular this spot is.

AFTER The following day I processed the Durdle Door image and looked at it on the screen at 100 per cent. Just how big could I print this? Only one way to find out. I made a print file to produce a 120 x 80cm (47 x 31in) print, the biggest my lab can do. This would be interesting.

You can look at pictures on screen forever, but the result that matters most is a big print on the wall. Most pictures we take never get reproduced larger than A4 (29.7 x 21cm / 11 3/4 x 8 1/2in), but we all aspire to producing giant prints. By the time the big tube arrived back I was dying to see the results. I was sure that this huge print would be taking things too far, with loss of detail, artefacts and 'gritty' colour gradients when viewed up close. But no, I was amazed, it looks fantastic. The quality shines through – crisp and detailed with luscious smoothness of tone. If I'd seen this print hanging in a gallery I would've sworn it was shot on 5 x 4in film. Forget all that stuff about viewing distance, photographers look at prints with their noses pressed to the print surface, trying to see softness or noise. This print is as sharp as Excalibur. The level of detail a full-frame 20+ MP camera is capable of recording (if your optics and technique are up to it) is quite extraordinary. It seems now I have something approaching the Holy Grail of photographic systems – large-format quality with 35mm flexibility, something we all hanker for.

Durdle Door at dusk
Jurassic Coast, Dorset, UK
Canon EOS-1Ds MKIII, 14mm lens, ISO 50,
2sec at f/16

Return of the Native

Standing on the cliff top at Bats Head we are met by an impressive panorama - over two thousand years of history in one vista. To the west are the mounds of the Iron Age hill fort of Maiden Castle. On the northern horizon are the lands around Sherborne, the capital of King Alfred's Kingdom. Over my left shoulder is the Norman castle of Corfe, an impressive landmark despite being reduced to rubble in 1645 during the English Civil War. To my right, Weymouth, a sheltered bay in the lee of Portland, has long been a harbour for cross-channel commerce. Here in the 13th century a ship unloaded a cargo of Black Death from Genoa and one-quarter of England's population was wiped out. Later, in the 17th century, Huguenots fleeing religious persecution in France settled here, amongst them one family, les Tizards. There goes the neighbourhood muttered the locals.

Across the bay I can see the lighthouse at Portland Bill, from which the Spanish Armada was visible as it passed by in 1588. Beyond is Chesil Beach and Moonfleet; a favoured landing point for smugglers. On the hilltop above Chesil stands Hardy's Monument, commemorating the captain of HMS Victory, Nelson's flagship at the Battle of Trafalgar. A bike ride along the bridleways from there brings you to Tolpuddle, where the first stirrings of discontent by abused farm hands in 1820 sent them into exile Down Under and launched the Labour Movement. Meanwhile a seaside visit from a Regent in 1850 made bathing and Weymouth fashionable.

In 1860 The Times reported a search for two Tizard brothers feared lost, swept out to sea off Weymouth in a rowing boat during a storm. They showed up at Lulworth Cove a few days later, bedraggled and thirsty but alive. Then in 1916 one William Albert Tizard from Weymouth lied about his age, joined the Somerset Light Infantry and went off to France. He returned, only to find himself in uniform again 22 years later in 1940 patrolling the cliff tops in the Home Guard. Four years later his daughter, Susan Tizard, my mother, was cycling to school past American soldiers camped on the beach, waiting to embark on the D-Day landings.

Over to the east I can hear the rattling of automatic fire on the ranges beyond Lulworth. The Armoured Corps from Bovingdon are gearing up for their next visit to Afghanistan. Beyond them at Sandbanks lies the most expensive property in Britain. Over at Bincombe, they're building a new road - the Olympics are coming to Dorset. Tourists are on the beaches and hang gliders are launching themselves off at Ringstead. Over at Portland Bill my nephew is probably doing a long exposure of the waves. Somehow he's got the notion that he can earn a living travelling the world taking pictures. It's pie in the sky stuff if you ask me.

Wendy and I breathe in the view. We shoulder our rucksacks to plod on down to Scratchy Bottom; we've got a picnic to devour and the frigid seas of the English Channel to brave. For us, this is the best walk in the world.

DORSET 5/13 – AVENUE OF TREES

BEFORE Beavering away in the office I'm aware of the beautiful day outside. Pangs of guilt assail me; I should be out there, being a photographer. Where to head? If in doubt just put the boots on and walk out the door. So that's what I do.

DURING I'm analysing the arrangement of the shapes within the frame and considering the options; should I move back and use a medium to long lens to compress the perspective? That would emphasize the row of trees leading into the frame. Or I could move forward and go wide to feature the tree in the foreground at the expense of the distant interest. I decide to go with the wide-angle zoom at 18mm. I sweep my eye from corner to corner of the frame; is there anything in there doesn't deserve to be? How can I make this shot better? I move right just a touch, forward a step, fine-tuning the composition. There's something soft and smelly under my foot now. Never mind, I'll have to suffer for my art. This is the spot.

AFTER Composition isn't something that can be taught, as there is no right or wrong and it's largely intuitive. The classic, golden rule of thirds is a good starting point, but it's only a guideline to ignore at will. Bold and simple compositions with a pleasing arrangement of strong shapes within the frame will always win over cluttered pictures. This image is made by the impact of the row of trees against the black sky, and the positioning of the lead tree on a vertical third is critical.

Decisions and musings on perspective are best done before raising the camera to the eye. It's good discipline to analyse and compose by eye rather than zoom. Through the lens everything can look fabulous and it's easy to end up blasting away at both ends and in between the zoom range without really considering the best way to frame the scene.

Avenue of trees
Venn Farm, Milborne Port, Somerset, UK
Canon EOS-1Ds MKII, 16–35mm lens, ISO 100, 1/125sec at f/9

DORSET 6/13 – BLUEBELLS

BEFORE There's a brief window of opportunity in late April when the bluebells are at their prime. Go for a walk in the woods then and you're strolling though a sea of violet. It's late afternoon and I'm in the office trying to clear the editing and processing backlog but the bluebells are calling. This is the dilemma of working from base, there's always something to pull me away from where I should be: behind the lens. I need to decide now whether to set the alarm for the hour before dawn. If the weather's not promising I can't afford to spend time on a futile quest. I'm getting mixed signals from the Met Office, but I'm going to go for it.

DURING It's 5.30am and I'm driving south. I know the woods I'm heading for well, so I have a clear idea of the picture I'm after. When photographing bluebell woods two things are critical: lighting and the quality of the woodland – it needs to have 'proud' trees, not be full of scrubby growth and clutter. Direct sunlight is hopeless in woodlands as the contrast goes sky high. Flat diffuse lighting such as on a dull grey day is an option, but is not very exciting. This morning my chosen spot is a hill sloping to the east, so the aspect is perfect to catch the first soft rays of sun backlighting the scene.
 I arrive and set up. The 16–35mm lens goes on with a 0.6ND soft grad to hold back the top of the frame, but as the scene is backlit a few highlights in the sky will inevitably burn out. An hour of intense photography passes as the sun rises and the light arcs through the trees. The backlit bluebell sea picks up the warm tones beautifully. I knew exactly where to set up, the shot I wanted and the light I would get – local knowledge delivered the goods.

AFTER Graduated filters come in two options: hard or soft, referring to the severity of the gradation. A soft grad will have a smooth transition from clear to dark, whereas a hard grad will have a more abrupt change. Which to use when is a confusingly inexact science. With a definite line such as a horizon to lay the grad along the choice is clear, a hard grad is the way to go. With a less well-defined composition a soft could be the answer. With a wide-angle lens at minimum aperture I tend to reach for a soft, while with longer lenses at wider apertures I often go for a hard, but that's only a guideline. The actual composition is far more of a factor. Rather then holding back the sky I've used a soft 0.6ND grad here to balance the exposure top and bottom. It is a very subtle effect, but if I can get the image perfect in-camera why not? It cuts down a little on the tasks ahead.

Bluebells in the woods
*Batcombe, Dorset, UK
Canon EOS 5D MKII,
16–35mm lens, 0.6ND grad
filter, ISO 100, 1sec at f/22*

A country lane
Near Purse Caundle,
Dorset, UK
Canon EOS-1Ds MKII,
16–35mm lens, ISO 100,
1/250sec at f/9

DORSET 7/13 –
A COUNTRY LANE

BEFORE In the film era shooting infrared was a haphazard affair.
The film had to be loaded in total darkness. I daren't think what
the chambermaid at my Paris hotel thought when she disturbed
me fumbling under the duvet with a Nikon and a roll of 35mm IR
film behind closed shutters in the middle of the day. Exposure was
a matter of guesswork – 1/125sec at f/11 and bracket like mad.
Ditto focusing; I had to offset the focus point manually a bit and
hope that the small aperture would save my skin. It worked but the
film was horrendously soft and grainy. That, I suppose, was all part
of the look, but now it has all changed.

I've had my 'old' Canon EOS-1Ds MKII converted for infrared. It's
a one-way process; this camera can now be used only for IR work. I
take a picture and all I get on the monitor is a red image but I can
shoot, meter and focus as normal.

Digital sensors are actually sensitive to infrared light. This is
undesirable for normal photography (it causes nasty fringing) so

the manufacturers build in a filter to block IR
rays. To make a camera sensitive to infrared
only, the IR filter is removed and replaced
with one to cut out the visible spectrum. The
focusing plane also needs to be offset to deal
with the longer wavelengths. Simple, but not
a job I'd attempt with tweezers on the kitchen
table, so the camera is sent off for professional
conversion. This summer, down the leafy lanes
of Wessex, I am pushing the boundaries of my
infrared vision.

DURING On a country lane near Purse Caundle,
I'm squinting through the eyepiece on the roof
of my Land Rover. Exposure-wise things are
so much easier than the days of guessing and bracketing. I use
AE evaluative metering and check the histogram after every shot.
Beware; it is very easy to clip the highlights in the red channel.
It's not easy to assess the image on the monitor though. A Mono
Picture Style setting on the converted camera would help, but I
don't have that, so I'm looking at a pretty flat red image displayed
on the now seemingly tiny 1Ds MKII monitor.

AFTER That dull flat image can be changed into a sparkling image
with punchy contrast relatively easily at the RAW conversion
or Photoshop stage by adjusting the black and white points in
the Levels histogram. By adjusting the sliders accordingly, the
brightest tone in the image will be a pure white with the merest
hint of detail, rather than the dirty grey of the unprocessed image.
Similarly by sliding in the black point to the toe of the histogram
the darkest tone in the picture will be a pure black rather than a
muddy charcoal. This optimizing of the tonal range is one of the
most fundamental things you can do to improve the contrast and
impact of an image.

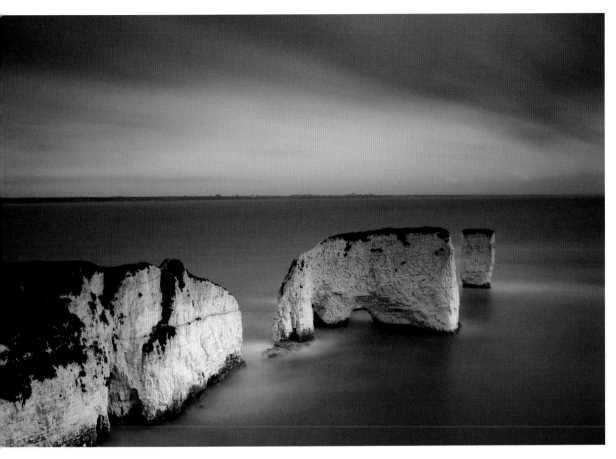

Old Harry and his Wife
*Studland, Jurassic Coast,
Dorset, UK
Canon EOS-1Ds MK III,
24-70mm lens, ISO 50,
5min at f/11*

DORSET 8/13 – OLD HARRY

BEFORE The chalk of Purbeck has been breached by the seas between Studland and the Needles, just visible now to the east of the Isle of Wight. The white sea-stacks of Old Harry and his Wife stand sentinel at the entrance to the sheltered waters of Poole Harbour. On a tranquil dawn in November I'm standing on the edge of the sheer cliffs, shuffling by the tripod, glancing at my watch, mumbling to myself, dying for a coffee and looking forward to breakfast.

DURING I've got the 10-stop ND filter (see page 143) fitted and am halfway through my first five-minute exposure. The clouds are picking up traces of pink from the sun still below the eastern horizon. They'll be streaking through the frame nicely. After five minutes of pacing and muttering I release the shutter lock and check the histogram. The monitor shows a display bunched to the left; it's a touch underexposed. There's no clipping of the shadows, but with this relatively low-contrast scene I have the scope to

expose for longer. Why bother? Because by giving the most exposure possible without clipping the highlights I record the maximum amount of information, and that makes me happy. I open the shutter and resume my solitary pacing. With dawn steadily breaking six minutes should do it. And a Full English Breakfast is definitely on the cards after this dawn patrol.

AFTER Increasing the exposure shifts the 'camel's back' of the histogram display to the right. The advantage of doing this is that the maximum tonal and colour detail is recorded and the signal-to-noise ratio is highest. There's a limit to just how much overexposure can be dialled in of course, with a high-contrast scene there's usually no such scope. But with a low-contrast scene such as this I can afford to give +2/3 overexposure before I start to clip the highlights in the white cliffs. This is called exposing to the right (as opposed to dressing to the left) and although the resulting frame may look pale, overexposed and washed-out on the camera monitor, the amount of information recorded by the sensor will aid in post-production to produce a picture with lusciously smooth and rich colour gradations and detail deep into the shadows. A camera's sensor is not a linear device so the right half of the histogram contains far more information than the left. Those apparently overexposed images, when processed with the brightness brought back to the desired density, will have richer tones and less noise than a frame exposed to the left.

All of this takes a leap of faith away from perceiving the glowing image on the camera's monitor as the be all and end all. It's just a reference, a visual aid to be viewed with caution. The RAW file is like a negative, an intermediate stage that has the sole function of recording information, and the more information the better.

DORSET 9/13 –
HORSES GRAZING

BEFORE I'm spending late spring and early summer gazing at clouds and trees. These are the two elements that really make an infrared landscape and I'm looking at the world around me in an entirely new way as I gradually get a feel for how Dorset looks in IR. Every ramble we do I'm taking the infrared body with the 24–70mm lens and noting good fulsome trees for a possible return. I'm enjoying my photography more than ever these days and getting my teeth into novel ventures like this certainly helps. Self-initiated projects can revitalize a waning photographic 'mojo' and give life behind the lens purpose.

DURING On a June afternoon I flee the office and head for Minterne Magna. I love the village names around here – Rhyme Intrinseca, Piddletrenthide, Sixpennyhandley, Whitchurch Canincornum. On a recent walk I spotted some likely looking oak and beech trees so here I am again clutching a Canon. The sky is full of drama seen in infrared and I'm enjoying shooting the trees against the bold black and mottled heavens. There are some horses grazing nearby. Their inquisitiveness gets the better of them and they come over, right into my full-frame composition. Their sleek black shapes against the bright vegetation make stark bold silhouettes. Two graze in my foreground and I manoeuvre around to make a composition. It's good, but when a third wanders into the frame the balance is complete and the shutter fires.

AFTER I check the histogram on the camera monitor. It's vital to understand what an exposure histogram shows. On the camera back and all through the various phases of post-production, the Levels histogram is the first and last reference point for assessing brightness, tonal range and contrast. The histogram shows the brightness range in a picture, from pure black on the left to clean white on the right.

The actual shape of the display is determined by the subject matter. A polar bear in a snowstorm will record with lots of whitish tones represented by a peak bunched to the right of the display. A black bear at night will show the reverse, with a display orientated to the left. And an average scene, if there is such a thing, on a sunny day will show a complete range of tones from left to right with a peak in the middle. What concerns us are the right and left extremes of the histogram representing highlights and shadows. Overexpose an image and spikes on the right margin of the histogram represent clipping of the highlights – bright areas in the scene with no detail. This is bad. Ditto the reverse; underexpose and clipped shadows on the left indicate blocked-in, featureless areas.

Understanding the histogram and using it to check exposures before dialling in over or underexposure compensation to protect those fragile highlights and shadows is the way to make perfectly exposed images.

Horses grazing
Minterne Magna, Dorset, UK
Canon EOS-1Ds MKII, 24–70mm lens, ISO 200, 1/160sec at f/13

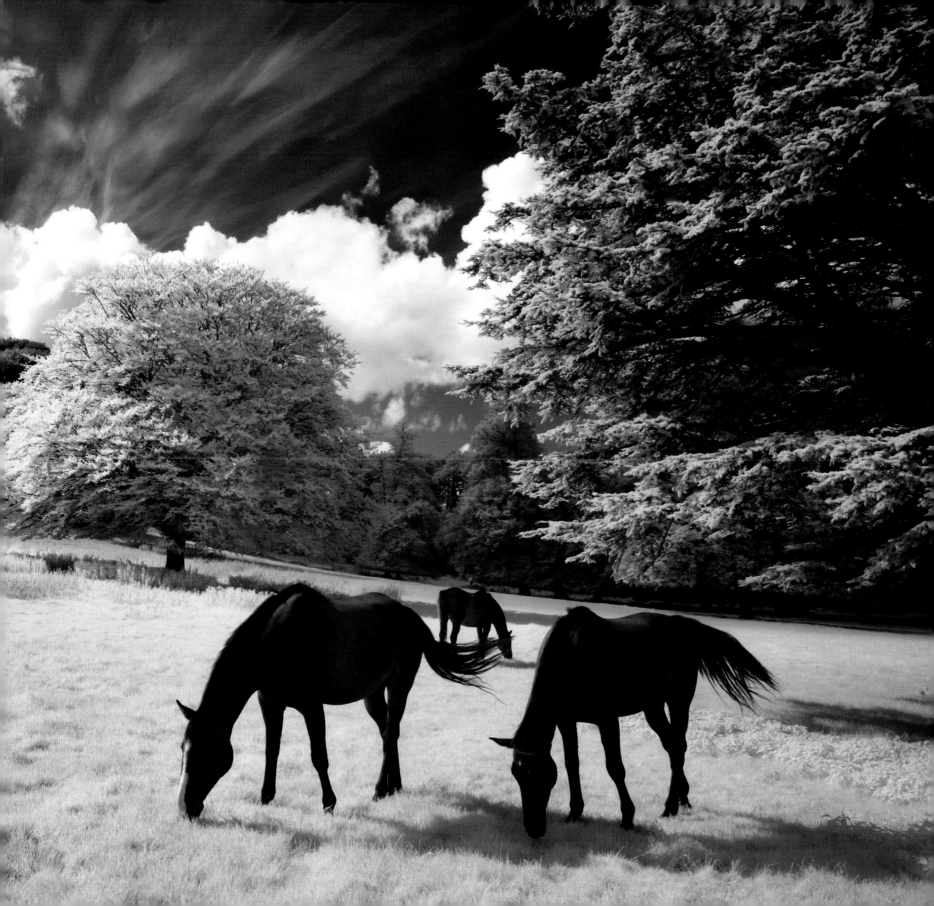

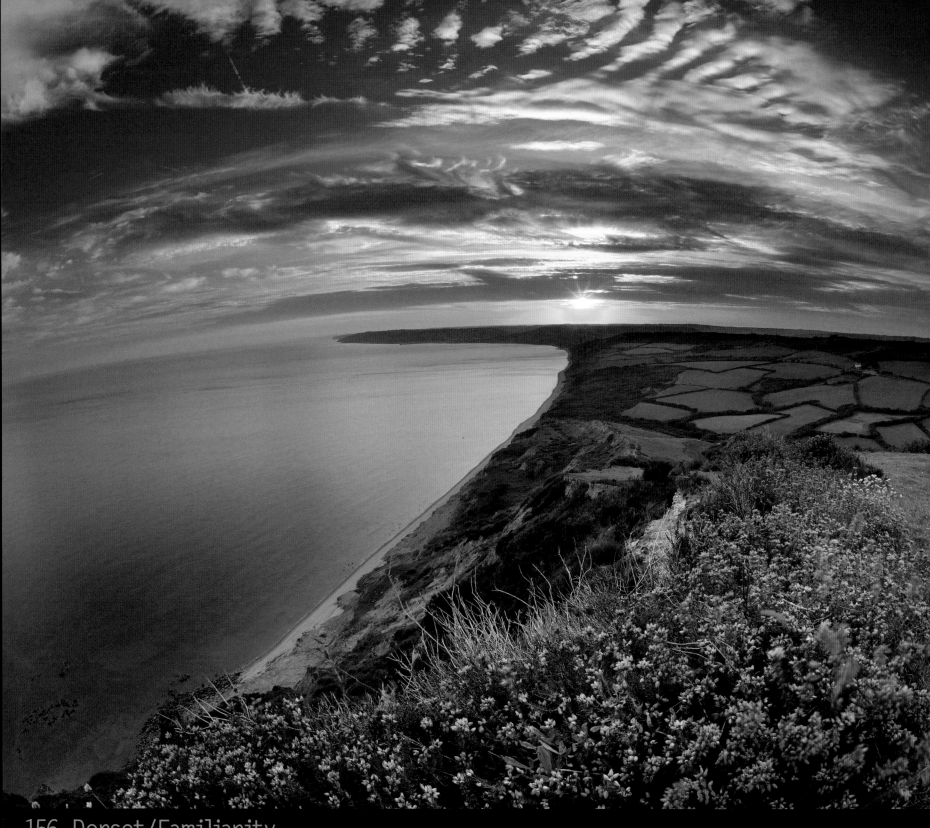

DORSET 10/13 – JURASSIC DUSK

BEFORE In late summer on the Dorset cliffs, clumps of purple bell heather pepper the landscape with colour. Offset by the lush green fields inland and the deep blue sea it makes for an enticing combination. Shooting the south-facing coast at this time of year, however, is problematic. In mid September, the sun rises due east and sets due west, so any view along the coast early or late in the day when the light is most alluring will be looking either straight into the light or illuminated directly from behind. Neither is ideal. Side lighting is my 'default setting' for most situations; it gives texture and form to the landscape. In winter the light here is so appealing; with the sun rising in the south-east and setting to the south-west, oblique lighting bathes the cliffs at dawn and dusk. But the heather appears for only a few weeks so I'm just going to have to deal with it.

DURING I arrive early and have an hour to wait before the sun is on the horizon. I select my clump of heather and now need to get low enough to use the splash of purple as a strong foreground feature. I've opted to shoot in the evening straight into the light, and to really emphasize the foreground I'm going very wide using a 15mm fisheye lens with a 180-degree angle of view.

I remove the centre column and splay the legs to get the tripod just centimetres from the heather. If I needed to get even lower

I could always reverse the column and hang the camera upside down between the legs, but that would deprive me of the view of the fields below.

The element that will make this image is the sky. I need dramatic clouds, both for visual effect and to hide the setting sun behind slightly. Shooting straight into the light is fraught with problems. I wait until the sun is right on the horizon and partially masked, otherwise the flare and contrast is just too great.

The other problem I have is how to balance the exposure between the sky and the landscape. I need to hold all the detail in the sky while still exposing for the foreground. With a lens this wide filters are out so there's only one way: exposure blending. As the sun pops out beneath a cloud I expose using auto bracketing. Three exposures spanning 4 stops do the trick.

AFTER I blend the exposures together manually in Photoshop – land, sea, sky – by taking feathered selections of each element and dropping them into place as layers. The alternative is HDR, that automated process using specialist software, but I can't stand the artificial look of that technique. Is this cheating? Well, I'm just trying to record what's there using multiple exposures to control the contrast. I think that's acceptable but I'll grant it's a fine line – take post-production too far and the resultant 'overcooked' pictures lose their integrity.

Sunset over the Jurassic Coast from the Golden Cap
Dorset, UK
Canon EOS-1Ds MK II,
15mm lens, ISO 100, three merged exposures

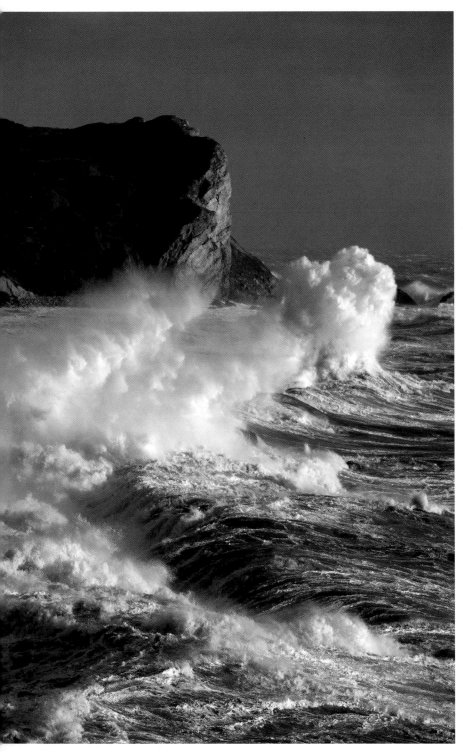

Stormy seas
Man O' War Bay, Jurassic Coast, Dorset, UK
Canon EOS-1Ds MK III, 70–200mm lens, ISO 200, 1/2000sec at f/6.3

DORSET 11/13 – STORMY SEAS

BEFORE By the light of our head torches we marched, a troop of 12 with Goretex hoods drawn tight around pinched faces, tripods over our shoulders. The worst storm of the year was battering the south coast and we were walking straight into the gale in the darkness before dawn. We trudged on before being blasted to a standstill by screaming winds and stinging rain. We could hardly stand; the prospect of fiddling with filter rings in these conditions was preposterous. I looked back at the huddled group and the bizarre thought crossed my mind that these people were paying us for this pleasure.

It was Day Two of our Jurassic Coast photography workshop and 100mph winds served up raging seas the like of which I've never seen here. However, the most adverse conditions can sometimes produce the most dramatic photographs and with shafts of late autumn light on the white chalk cliffs and the pounding surf, the coastline looked its moody best.

DURING Crouching in the lee of Durdle Door it's just possible to avoid being blown away and shoot the huge waves curling in along Man O War Bay. With the 70–200mm lens, I'm working hand-held using a fast shutter speed to both freeze the movement and hopefully enable me to make a sharp image despite the wind. Photographing waves is fascinating. Is it best to expose just as they crash on the rocks, as they roll in, or when the spray is frothing to maximum effect? There's no straight answer, so a couple of hours is spent watching, analysing and exposing. Every few minutes a lens cloth is needed to wipe off the front element. I'm shooting with the nagging thought that most of what I'm exposing will be soft. Fast shutter speeds should deal with the wind but the spray on the lens will surely compromise many frames. But this is what seascapes are all about.

AFTER A fair few of the frames were soft due to shooting through a thick layer of salt, but enough weren't and a few had that magic combination of curling waves, surging seas and pounding surf. Looking at the best image several months later I decided to convert it to monochrome, the drama of the image was all shape and form and the colour of the slightly brownish churning seas added nothing. This time I used the Black & White converter in Photoshop to juggle the levels of the colour channels. For this I find it useful to think in terms of how I used to use filters when shooting black-and-white film. A red filter darkened the blue sky, upped the contrast and added impact so for this seascape I dropped the blue levels and increased red and yellow. How do you decide which channels to boost and which to drop? Look at the image and analyse. Think. Experiment. Like most things in photography it's not a black art, and you can't beat trial and error.

DORSET 12/13 – MORE STORMY SEAS

BEFORE With such a good location and dramatic conditions it was worth sticking with it and making the most of the unfolding drama that began early that morning (see page 153). The crisp light of the afternoon softened as the sun settled into the sea mist. The direct rays from the weakening sun became warmer as they sliced through more of the atmosphere. At the same time the ambient indirect light bouncing around the heavens became cooler. This is 'happy hour', when light goes through some magical transformations.

DURING As the light softens, I resolve to try using a slower shutter speed to convey some of the movement in the scene. This is an ambitious plan; with the strong wind I have no great hopes of being able to keep the camera steady but it is worth a try. This is where a good sturdy tripod comes in. However, short of setting the camera in stone, high winds are going to cause problems no matter how rigid the tripod, especially using long lenses. With the tripod low and everything tight and double-checked, I try to shield the camera with my body, waiting for the waves to roll in. How slow should I go?

 At speeds above 1/250sec the motion of water is frozen. At 1/60sec movement starts to become apparent. At 1/8sec the breaking waves start to paint enticing shapes. At 1sec wonderful swirls, layers of tone and traces of mist paint the seas yet the form and texture of the waves is still visible. Go slower, to say 10sec, and the misty effect increases, individual waves are invisible and the turmoil becomes more ethereal. Go beyond 30sec and the raging waves become a tranquil sea of mercury. Today I want to convey the turbulence, so an exposure around 1sec is the way to go. I drop the ISO to 50 and with the fading light an exposure of 1.3sec at f/16 is possible without the necessity of a neutral density filter.

AFTER The shifts in the colour temperature of the light that happen at this time of day aren't immediately apparent to the naked eye; our mental image processor does a sort of Auto White Balance and corrects the shifts. But with the camera set to Daylight White Balance the coolish light, which in fact has a very high CT (see page 129), appears blue on the monitor and when opened up in processing. Of course, as I'm shooting RAW the camera White Balance setting is largely irrelevant as that can be controlled subsequently. I very rarely alter the colour balance of an image; I tend to go with what nature provides. If the light is warm and golden that's the way I want it to appear, and if the ambient light has a cool feel who am I to meddle with it? The last thing I want is for the camera to try neutralizing that feel, even if it's only affecting the monitor display. That's why my White Balance setting remains resolutely on Daylight.

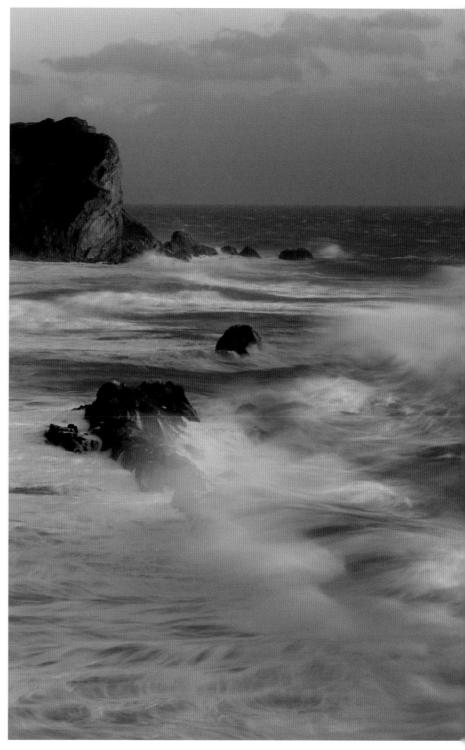

More stormy seas
Man O' War Bay, Jurassic Coast, Dorset, UK
Canon EOS-1Ds MK III, 70–200mm lens, ISO 50, 1.3sec at f/16

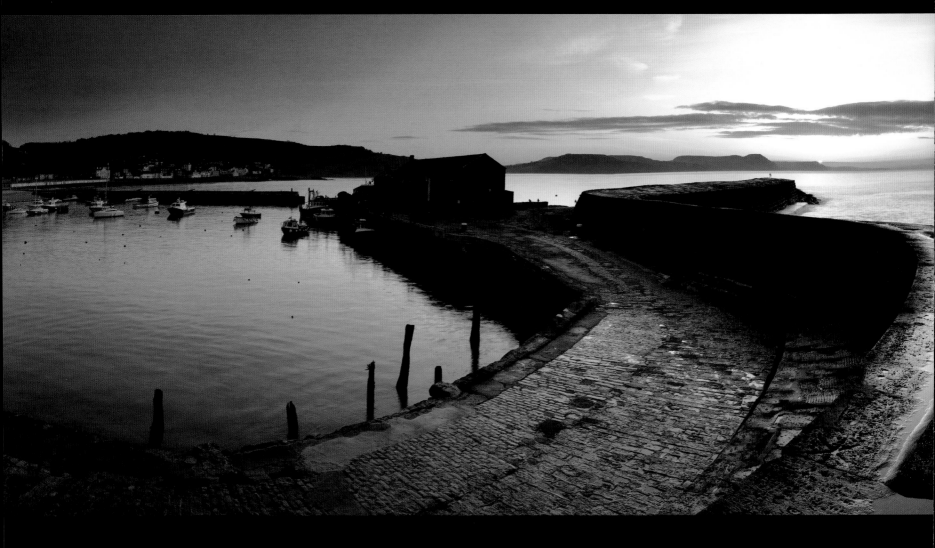

The Cob at dawn
Lyme Regis, Dorset, UK
Canon EOS-1Ds MK III, 24mm
tilt and shift lens, ISO 100,
3.2sec at f/11

DORSET 13/13 –
THE COB AT DAWN

BEFORE I'm driving to Lyme Regis yet again, down the narrow country lanes south of Crewkerne through villages still slumbering, as any right-minded person would be at 4.30am. I could do with a bit more sleep quite frankly. We've just got home from Bolivia and all manner of that reality stuff needs dealing with; the pace of life is just a bit too frantic for one, still jet-lagged, photographer. But the conditions this morning seem promising for the picture I have in mind and it has become a bit of an obsession.

This is my fourth attempt. A panorama of the Cob at dawn with the sun rising over the coast beyond is the brief, but a few too many variables have been messing me around so far. I need a low tide and a relatively calm morning – waves breaking over the Cob would result in a soggy camera – so I've been scrutinizing weather forecasts and tide tables, waiting for the right conditions. However, interpreting weather forecasts for photographic missions is never a cut-and-dry art. Five visits have ensued; the first for the recce, the second was too cloudy and the third too clear. I need cloud with the rising sun just breaking through; a fairly specific set of circumstances to demand of Mother Nature. The last attempt was productive, the shot's almost there but not quite – I know it can be better. This is the beauty of working locally; I can keep coming back again and again in a quest for absolute perfection.

DURING The concept of the picture is evolving with each attempt. The 'S' shape of the Cob leading into the frame makes for a strong composition. I set up the tripod on my now familiar mark, fussing with the legs and squinting at the spirit bubble to get it absolutely level. Quite apart from the vagaries of the light and clouds I'm having a few technical glitches to deal with. The stitched test shots I've done so far are displaying an undulating horizon; not a good look. I thought initially it was lens distortion but no, the stitching software is distorting the image to get a perfect join in the foreground, and that's bending the horizon of each frame. I'll find a solution. I enjoy getting to grips with technical challenges like this.

AFTER I'm heading home for a Full English Breakfast. My head is full of the shoot, replaying the moment, analysing, contemplating the benefits of using drop shift with the 24mm lens and panoramic heads. Clearly I've still a lot to learn about this game of panorama stitching. Did I make the shot this morning? I'm not sure. I'll get stitching later and see. But I will make this image – in this life or the next. I'll just keep coming back until it's nailed. And in the process I'll learn and improve. And score a few breakfasts.

Snowdonia
9.Basics

Are all landscape photographers keen walkers? Surely it must be so. Way before photography dominated my life hiking was My Thing. It started with a soggy outward-bound course in the Lake District; tromping over hills and dales with huge frame rucksacks and camping out by remote tarns seemed like fun. Our family rambles were an acquired pleasure involving following my father's suspect navigation through irate farmers' yards, with snarling dogs snapping at our heels. Then hiking with the Army Cadets on various 'Arduous Training' exercises introduced me to the joy of living off endless tins of Hungarian Goulash in the snows of the Brecon Beacons; what else would any young lad want to do? My idea of fun on leave from the Merchant Navy was backpacking on Skye, with the long tab back down Glen Sligachan in driving rain. So when photography burst into my life, the most natural thing in the world was to combine my two passions. Landscape photography seemed a natural calling and not much has changed since.

On our photography workshops we ask our guests to bring five of their favourite prints. Without fail when a guest has a real passion for a region, an activity or a subject, it always shines through in the pictures. Two guests' portfolios affected me deeply; they were both Hard Men of the Northern Hills, both had serious mileage under their boots, one spent every available minute tramping the Bens and Glens of the Scottish Highlands, the other the hard rock of Snowdonia. Their pictures showed their enthusiasm and reminded me of where I came from photographically. Jetting off to Bali or Bolivia is all well and good, but sometimes I need to get back to basics: get the boots on and just head for the hills.

With all the foreign travel we do, we're often asked where we go for holidays. Travelling for a living means the last thing we want on vacation is an airport check-in, so we hire a cottage in Snowdonia and spend a week hiking. No phone coverage, no Internet, no cameras. Except I'm lying. Faced with the prospect of a week of leisure in the Welsh hills the Lowepro is furtively snuck into the back of the car at the last minute, just in case …

SNOWDONIA 1/4 – ROLLING FARMLAND

BEFORE There's a limit to how much pink decor and lace I can take, so instead of a B&B, this time we've rented a cottage. It's October and the autumn colours are subtly tinting the rolling Welsh countryside. After the long drive here all I want to do is relax, but soft afternoon light is painting the landscape and knowing the fickleness of the weather here this may be the only sun we see. So up the hill behind the cottage I trudge.

DURING The 70–200mm lens at 155mm flattens the perspective of the undulating farmland, a polarizer saturates the colour and the light is dappled. Two things bother me: the wind and that quad bike making a beeline towards me. Here we go again, another altercation with a truculent Farmer Jones. I'm just off a footpath but causing no man or sheep any distress. I set the teeth and stretch the nostrils wide, but it's not necessary, he's affable and curious. Relief. Now what about this wind? I double-check the tripod; is it firmly rooted on spongy moss, squidgy cow dung or hard Welsh rock? Is everything tight, including the quick-release plate on the camera? That's one glitch that can creep up and bite me if not routinely checked. I've done all I can, mirror lock is activated, Image Stabilization and autofocus turned off, so I wait for a gentle period between the gusts, expose then zoom in on the camera monitor to check sharpness. It's sometimes difficult to tell on an unsharpened image but it looks OK.

AFTER Sharpening doesn't make pictures that are soft due to poor camera craft crisp. Images that are unsharp due to camera shake or poor focusing can never be retrieved. For them there's only one option – hit the Delete key. Sharpening is something we have to do with all digital images because pictures made up of square pixels need local micro contrast introduced to create the illusion of crisp edges. All images need this, no matter how many megapixels are crammed in or how sharp the lenses are. How much sharpening is needed is a moot point – an over sharpened image looks truly gruesome. The amount of sharpening required is dependent on the size of reproduction and, confusingly, small prints or thumbnails need more and large pictures less.

The accepted wisdom on this preaches that sharpening should be applied right at the end of the workflow when the repro size has been determined. The trouble for us is that doesn't work in practice – pictures submitted for repro in magazines, books or on websites often end up being published with no sharpening applied at all – everyone along the road assumes it has been done by someone else. So I always apply a touch at the RAW processing stage just to take the softness out, then fine-tune subsequent sharpening for print or web use accordingly.

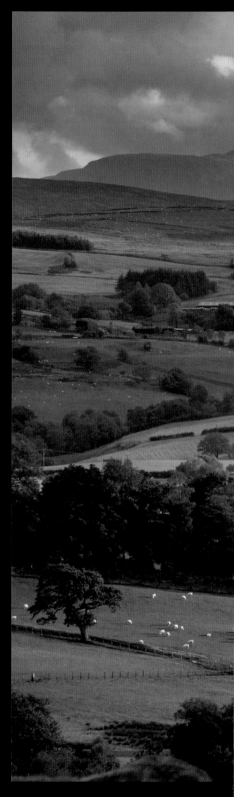

Rolling farmland on the edge of Snowdonia National Park
Near Ysbyty Ifan, County Conway, North Wales, UK
Canon EOS-1Ds MKIII, 70–200mm lens, polarizing filter, ISO 100, 1/8sec at f/8

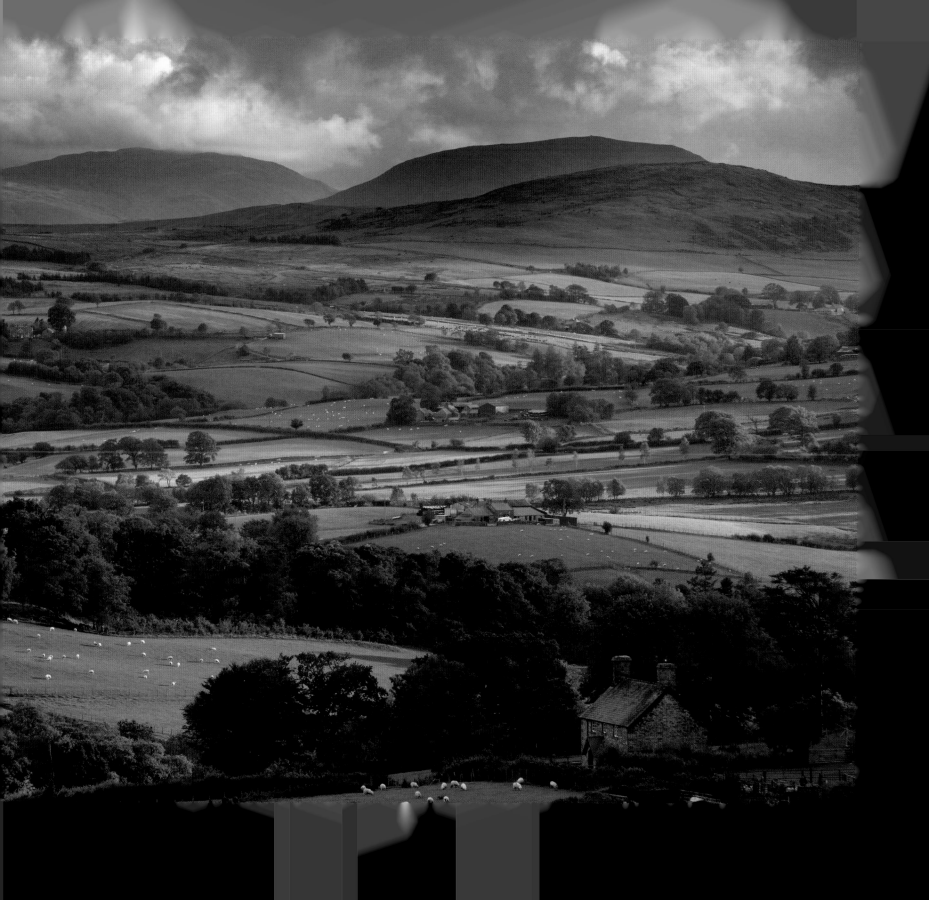

Once More Unto the Breach

It's raining. It's hardly an unusual occurrence here and we know what to do on dark days in March like this; all the outdoor types do. Once more unto the breach, dear friends. The task is clear; we good yeomen need to show the mettle of our pasture. So with noble lustre in our eyes we wander around the gear shops in Betws-y-Coed aimlessly gazing at boots, rucksacks, camping stoves and Goretex clothing we don't need. It's a comforting ritual and we're good at it. There's also the option of self-torment, so I leaf wistfully through the coffee table books on sale showing Snowdonia in absolutely perfect conditions. Then we sit morosely in the pub staring out of the streaming windows - this is what we know to be enjoyment. Let it not be said we're having a winter of discontent.

Next is a damp walk along the river before trying to dry our sodden kit back at the B&B. Here six inches seems to be the defining measurement: six inches of space around the bed to stash all our gear, a six-inch lead on the tiny kettle for the tea and coffee with UHT milk, a six-inch high stack of *Hello!* magazines on the bedside table, and six square inches of space in the shower cubicle crammed in the corner to qualify as en suite. Everything is pink and covered in lace, including the spare loo roll. Breakfast is served between 8.30 and 8.32am, and it is obligatory for all guests to whisper in the dining room. It's the Great British B&B experience - it is so good to know some things in life don't change. After countless such days in the craggier regions of the British Isles we're well versed in what's expected of us.

The next day all that is forgotten. We stiffen the sinews and summon the blood as we trudge relentlessly up the hard rocky slopes of Cadair Idris. Another day, another hill. Below lies a carpet of low cloud, ahead yet another false summit raising our hopes of an early packed lunch. Sweaty backs, crisp air, the promise of a pork pie on the summit and views over the receding ridges of the Cambrian Mountains cleanse the soul. Does life get any better? Tonight, we may even score a Welsh curry.

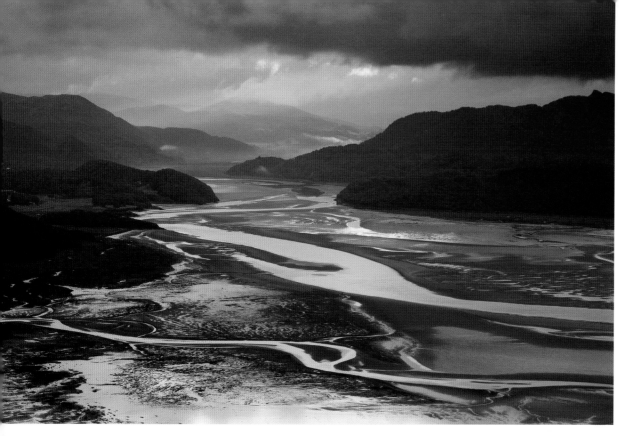

The Mawddach Estuary at dawn

*Snowdonia National Park,
North Wales, UK
Canon EOS-1Ds MKIII,
70–200mm lens, ISO 100,
1/20sec at f/8*

SNOWDONIA 2/4 – THE MAWDDACH ESTUARY

BEFORE There are so many variables that can make or break a picture: the light, weather, regrettable people, wind, the photographer's ability, technical glitches, dead alarm clock batteries, and the moon. I knew this location well – in late summer the hillside here is a blaze of colour with purple bell heather and yellow gorse – but for the picture I had in mind to work I needed dawn to coincide with the low tide.

DURING We walk through the dark woods by torchlight. As we emerge on to the hillside the view below is revealed in the dim light at the crack of dawn. The Mawddach Estuary is a swirl of pools, mud flats and shallow channels leading inland to the shapely undulations of Snowdonia. The colour temperature of the light (see page 129) is sky-high giving a cool blue tinge to the scene. Just the weakest shaft of light from the rising sun struggles ineffectually to permeate the thick cloud overhead. The 70–200mm lens is on again, at 90mm this time. It's such a useful lens, and super sharp. There are lenses with wider zoom ranges; ideally a 16–500mm zoom, optically perfect from wide to tight, small and compact with a super-fast maximum aperture would mean only ever having to carry one optic. Sounds good? Dream on.

AFTER With any zoom lens that tries to do it all there's a trade off between convenience and quality. The wider the range of the zoom, the more compromises the manufacturer has had to make with performance. A zoom that performs well as a medium telephoto is unlikely to deliver the same quality at the wide-angle end and vice versa. Barrel distortion, flare, soft corners – all these 'nasties' creep in when all is not right optically. Of course, this is all relative – there are some very clever people making lenses in Japan. But if you want to get the very best from your expensive camera this is something to ponder.

When choosing lenses many factors need to be considered: weight, size, zoom range, maximum aperture and cost. Optical performance has to be at the heart of all lens decisions. Now, we can all enlarge our images up to 100 per cent and analyse corner sharpness to the nth degree (actually I get the impression there are some in the twilight regions of the World Wide Web who do nothing else) but it can be a bit obsessive; doing so is analogous to standing with our noses pressed against the margins of an exhibition-sized print. No lens, however good, is quite as sharp in the corners as it is in the centre, so a sense of pragmatism is necessary. It is possible to become a bit of an anorak about it all. Ultimately we need to make decisions on what lens suits our needs then just get on with the business of making pictures.

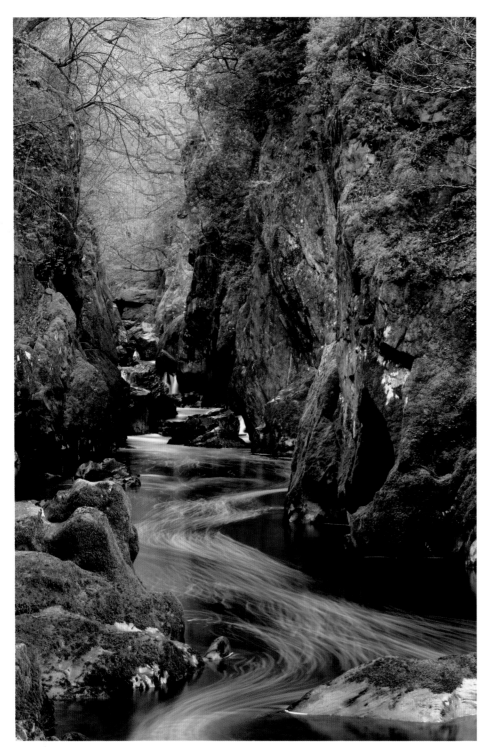

The Fairy Glen, a gorge on the Conwy River
Near Betws-y-Coed, Snowdonia National Park, North Wales, UK
Canon EOS-1Ds MKIII, 70–200mm lens, polarizing filter, ISO 50, 12sec at f/32

SNOWDONIA 3/4 – THE FAIRY GLEN

BEFORE You don't normally have to wait long for a grey day in North Wales. We came through this way on a long ramble on Day One and I resolved to return suitably equipped with the heavy artillery when the light was right. The deep cleft of the Fairy Glen meant that contrast would be a problem; flat, diffuse overhead lighting was necessary. Sure enough, a few days later it is damp and soggy and we're back, exposing and singing in the rain.

DURING Wendy's holding the umbrella over the camera as I expose. This is a holiday darling, honest! The flat light is perfect. A polarizer saturates the greens and oranges of the moss. A slow exposure creates an 'S' shape in the black waters flowing through the gorge. With the 70–200mm lens at 100mm I'm contemplating my depth of field and focusing point. Time was when all the necessary information was etched on the lens barrel as a depth of field scale, but it's now missing from zooms and most modern optics; a retrograde step, surely. It's easy to believe that with auto exposure and autofocus a photographer can just concentrate on the aesthetics and let the camera take care of the rest. That's heresy – a photographer needs to be in control of the technology, not a slave to it, be aware of what the camera is doing and ready to step in, take control, override the automated systems and show it who's boss.

AFTER I'm printing this picture back in the office, for no other reason than I want to. Looking at pictures on the screen is fine but it's good to get back to basics – you can't beat the impact of a big print. I have a Canon 9500 A3+ printer that does the business; the ease of making a print at the click of a mouse is such a luxury compared to the hit-and-miss agony of reversal printing from transparencies, which wasted so much time and money in the past. Colour management are words that strike fear into the hearts of many photographers, and this is also officially *the* most boring topic in the world. Techy geeks make it into a black art of unimaginable complexity, but essentially it doesn't have to be. With my camera, processing software, calibrated monitor and printer all using the same colour profile there are no problems; what I get in print is what I see on the screen and saw in the Fairy Glen. It's as simple as that.

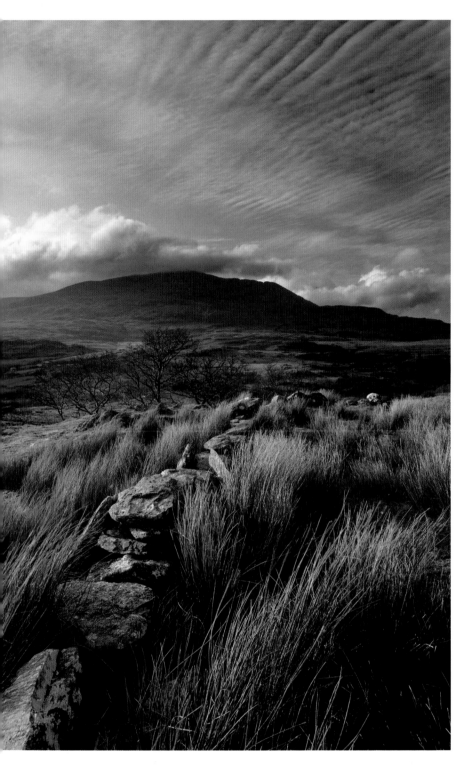

SNOWDONIA 4/4 – OVER THE HILLS AND FAR AWAY

BEFORE I used to think that if I took my camera far and high enough then stunning pictures would ensue. The more ambitious the route the better the pictures would be. But gradually it dawned on me that this approach wasn't working. For mountaineers and hikers the route is everything; the photography is in a supporting role. It took me some years to work out that if photography is the primary reason for being in the hills then I was going about it back to front. The first and foremost need was to be in the right place at the right time for photography, and all the trekking over mountain passes had to be solely for that purpose. The route was irrelevant, finding and getting to the photographic locations for the best light became the be all and end all.

There is no doubt that an appetite for lung-busting ascents, knee-crunching descents, Goretex clothing and muddy boots is an asset for a landscape photographer. The best vantage points are often in remote, exposed, inaccessible places. Trudging up winding paths in the faint light before dawn is as much a part of the game as grappling with expensive lenses. Finding those unique locations in the first place is the hardest part, and to do that you need to march with a mission, looking and logging ideas. There is no other way.

DURING Most of the time on our day hikes I don't even carry a camera. Lately I've taken to carrying one body with a mid-range zoom, but all that seems to result in is lots of pictures of us eating sandwiches on misty summits. For the most part now our hiking is a recreational activity that also serves as a location search. Which means all related expenses are tax deductible, right? Not this time though, as here we are on holiday, where I am definitely not working, doing a route round the back of Moel Siabod. And here is a sheep trap and ruined building in an attractive setting. I'll just nip back early evening with the gear, Wendy. But it's still a holiday, OK?

Lovely light, a rippled sky, a line of stones leading into the frame in amongst the tall grass, the trees and mountain beyond … it encapsulates all that is Snowdonia. Pity I'm not working.

AFTER I plod back down the hill, tripod on the shoulder in the gathering gloom with that buzz that only photographers know. It was exhilarating, just being there was a treat that refreshed the soul, and it's all been enhanced by the knowledge that maybe, just maybe I've made something special, a unique picture, a work of (dare I say it?) art. On my holiday.

A stone wall above the Glyn Lledr with Moel Siabod beyond
Near Dolwyddelan, Snowdonia National Park, North Wales, UK
Canon EOS-1Ds MKIII, 16–35mm, polarizing filter, ISO 100, 1/6sec at f/16

Bolivia
10.Adventure

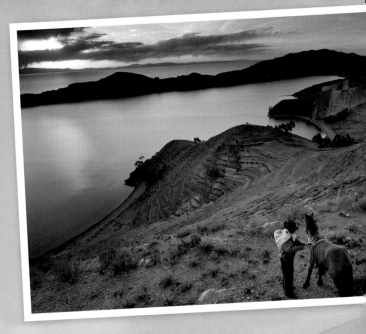

The best trips are always the most courageous, no doubt about it. One sure-fire way to give your photography a boost is to tread boldly way beyond the limits of the comfort zone. Don't think about it too much just go – somewhere epic and challenging, new and exciting. We all need adventure in our lives; whether that is scaling Everest or hiking the southwest coastal path it doesn't matter. Without this buzz, life pales, and so does my photography. As much as we thrive on returning to familiar haunts there have to be several trips every year to new frontiers. Wendy gives me a certain resigned look when I concoct the next plans for trips to the far side of the world. They're always somewhat daunting, but life doesn't come without risk, and confronting these challenges keeps us fresh.

The first thing that appealed to me about photography was its relationship with exploration. I left school in 1977 and joined the Merchant Navy, desperate for adventure. On my first trip to sea we circumnavigated the globe and, transiting the Panama Canal, I felt the pull of the vast intoxicating continent to the south. Subsequent voyages took me to Brazil, Argentina, Uruguay, Chile and Columbia but the restraints of time inherent in being a salty sea dog were starting to frustrate. I was travelling the world but seeing only seedy ports. So, when I resolved to sacrifice my life on the altar of photography it was world travel that was the pull. Of course, it took many years to make it happen – industrial estates in Avonmouth were the initial reality of a jobbing photographer's life – but now the pull of Big Adventures in South America cannot be resisted. We've had amazing trips to Patagonia, the Atacama and the Sacred Valley of the Incas; now it was time for the altiplano, salt pans and volcanic landscapes of Bolivia.

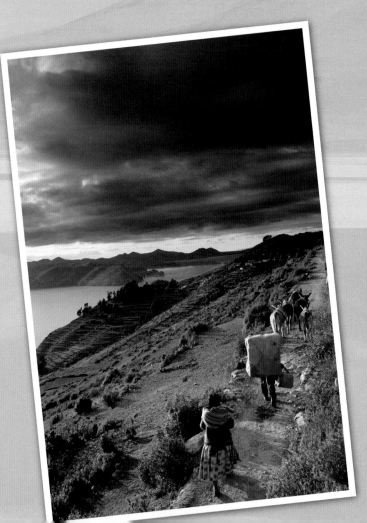

We're in La Paz, acclimatizing and sorting out logistics for the next few weeks. How will we get about in the remote regions of the southwest? Where will we stay? How will we cope with the altitude? Do I have a suitable hat? What shutter speed should I pan with on a strolling llama? It's all part of the experience to be embraced. Bring it on.

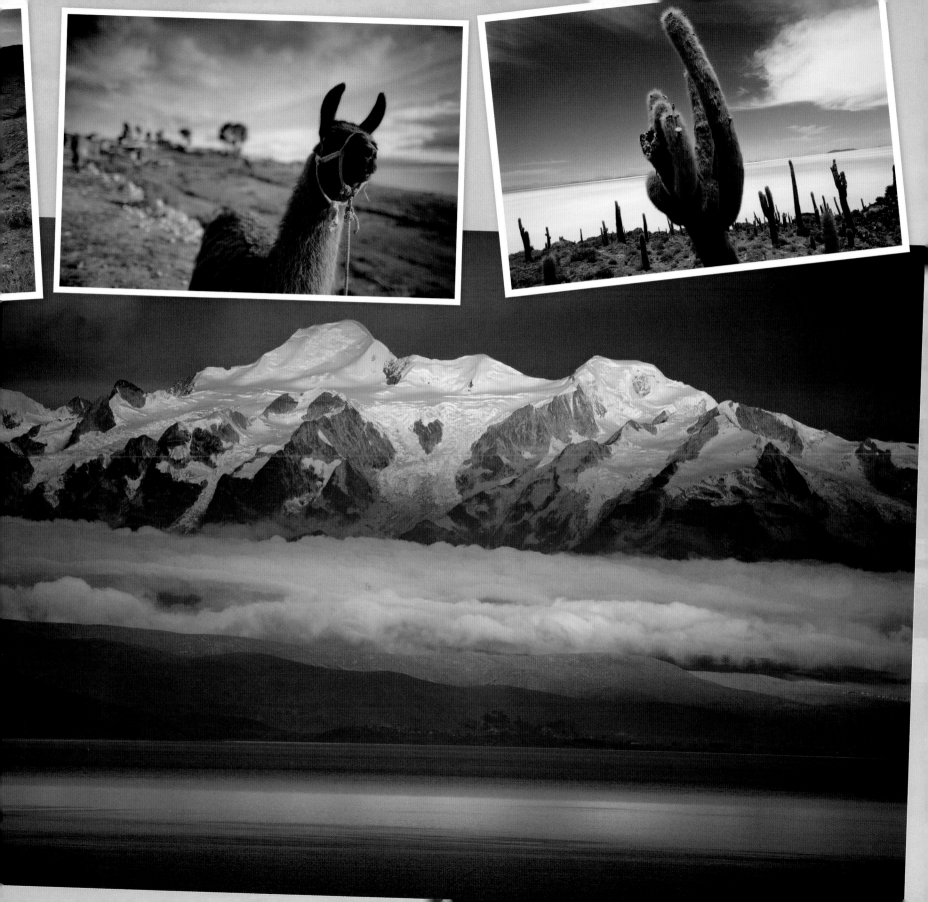

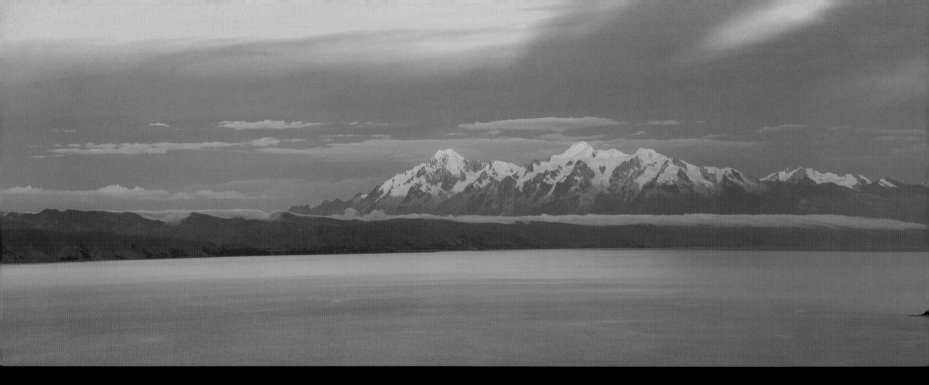

**View of the Isla de la Luna
with the Cordillera Real
beyond**

*Lake Titicaca, Bolivia
Canon EOS-1Ds MKIII,
70–200mm lens, ISO 100,
1/15sec at f/5.6*

BOLIVIA 1/10 –
ISLA DE LA LUNA

BEFORE One thing one you should know – landlocked Bolivia has a Navy. They are sky-high sailors who patrol the waters of Lake Titicaca, that huge body of fresh water perched at over 4000m above sea level in the Andes. Right now Wendy and I are standing on a hilltop on the Isla del Sol looking across the lake to the snow-clad peaks of the Cordillera Real bathed in evening light.

The Isla del Sol is a tranquil place, as the Incas found out. With its terraced hillsides and mules it has the feel of a Greek island … until we try to walk up a hill. It's then we're quickly reminded of how high up we are, and how recently we arrived. On our travels we've been up high on many continents, but we usually trek in and have time to adjust. This time we flew straight into La Paz and so here we are wheezing and puffing up hills. The women in their strange hats and colourful shawls, the stars at night, the big skies, the absence of cars, the relaxed rural pace and the deep blue of the water make this a very special place, and we've got three days here to settle into Bolivia and get the first pictures in the can.

DURING I have a dilemma: whichever way I turn there are stunning vistas. To the west, Peru. To the north are the hills around trusty compact. Her pictures these days are getting worryingly good. And to the east the massive peaks of the Andes. They are a long way from here – at least 100km – but it's amazing how visible they are, a testament to the crystal clarity of the air at this altitude. We know all about that from the harshness of the sun; I must get a better hat. Which way to look? I can only do one picture at a time, so I'll do my best with the view over Titicaca to the Cordillera Real. The other options will just have to wait until tomorrow evening. It is so easy to get distracted by multiple views and end up compromising them all. One good shot from this evening's shoot will do nicely, thank you.

So I get to work on a long lens panorama with the last twilight playing on the distant peaks. The Isla de la Luna lies like a humpback whale in the lake. Streaks of pink arc through the sky. This isn't a bad way to start an adventure.

AFTER Dinner back at the lodge consists of the meal we will get to know so well over the next few weeks: meat or fish, rice, potatoes and boiled vegetables. To my right sits a Bolivian guide, to my left a Peruvian. I ask about relations between the two countries, and

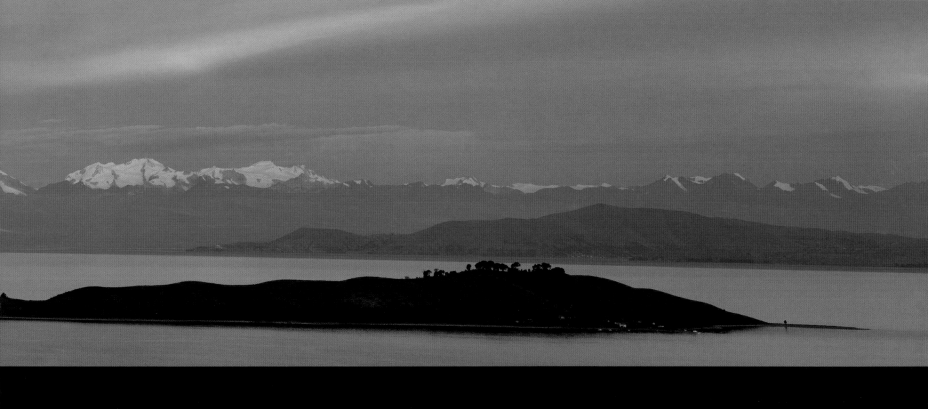

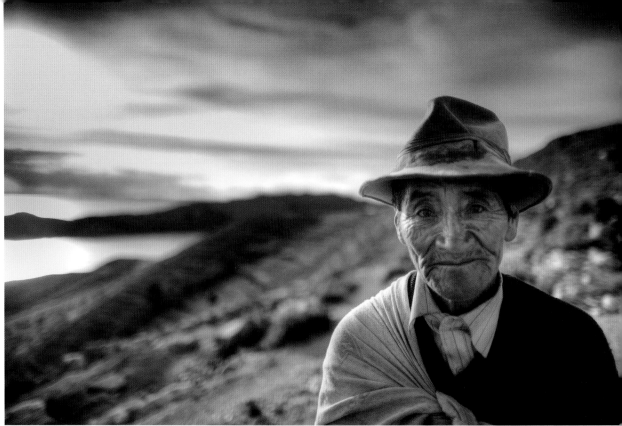

BOLIVIA 2/10 – BRIEF ENCOUNTER

BEFORE I keep forgetting and rush up some steps to check the view before virtually collapsing in a breathless cardiac heap; I'm not yet acclimatized to the thin air. But there are plenty of views to scrutinize. As the sun dips over Peru the shepherds bring in their flocks of sheep, donkeys and llamas. It's a view that is South America in a nutshell.

DURING The kids here are commercial little sods – they all blatantly hustle for money as soon as a camera is detected. It's disappointing and sad, but the way of the world. I'm not playing ball; although the money is relatively insignificant, paying just magnifies the problem and the resultant pictures look contrived. I'm not averse to a contribution if someone has put themselves out for me but then again all my best travel portraits have come about from often uplifting chance encounters – grubby cash has rarely changed hands. This brazen soliciting has left me momentarily dispirited. I need to get my 'mojo' back.

There's a campesino approaching with his sheep. I accost him and point questioningly at my camera as I mangle the Spanish language. Yes! For this trip I have been reunited with the lens that was such a hit in Laos – the super-fast 24mm f/1.4. I want to use the wide angle to place this proud man in his environment, but the light is a nightmare; bright sun backlights the scene. Although this is a chance encounter, I have preconceived the basic concept and am ready with a 0.9ND grad filter fitted. When these opportunities occur there's no time for fiddling with filter rings. As I quickly compose and focus I'm aware of the problems. The filter is holding back the sky but highlights will still blow and my subject's face is in shadow; it's a contrast hell hole of a lighting situation. What I really need is Wendy with a large reflector to bounce light back on his face, but neither is available and this fleeting moment will be over in seconds.

With the lens wide open I make the shot, I'm aware of the 'blinkies' screaming at me (see page 31) but I just have to trust to a combination of extreme highlight recovery and shadow detail to try and salvage a picture. I'm leaning on the exposure latitude of the RAW image too heavily – it's not the way to work ideally but sometimes there's no alternative. Will it work? I'm not convinced but it's worth a try.

AFTER This shot did take some work in post-production to coax every last bit of shadow and highlight detail out. It works much better in monochrome. There are blown highlights in the sky but I'm not too concerned about them. As usual with this fast optic the out-of-focus background gives a sense of the setting. There is no way I could have made this shot ten years ago. I'm learning as I go just what is possible – it's liberating.

A farmer on the Isla del Sol
Lake Titicaca, Bolivia
Canon EOS-1Ds MKIII, 24mm f/1.4 lens, 0.9ND grad filter, ISO 100, 1/250sec at f/1.4

A shy girl weaving
Sucre, Bolivia
Canon EOS 5D MKII, 85mm lens, ISO 400, 1/800sec at f/1.2

BOLIVIA 3/10 – A SHY GIRL

BEFORE Sucre is the capital of Bolivia, although you wouldn't think it. Compared to the oppressive congestion of La Paz it's positively laid back, which allied with the colonial architecture, relatively low altitude and pleasantly balmy climate, make it a good pit stop to recharge the batteries. Bolivia, and especially Sucre, is known for its colourful textiles, so Wendy is in heaven here. I've tagged along to a weaving school to see if I can hide behind her and maybe make some pictures. Well, you never know what will transpire and good pictures don't happen unless I'm out, looking, interacting and making the most of every opportunity.

DURING Girls in colourful shawls are weaving in the square. It looks promising but they are very wary of me. I've been working the situation for about 20 minutes with mixed success, that's long enough for them to get used to me being about but also long enough to outstay my welcome; it's a fine line. I know there's a strong picture to be made here, but every time I raise my camera they shy away, covering their faces and giggling as only teenagers can. I think they like the attention and it's a huge joke but they are still painfully bashful.

With the 85mm f/1.2 lens on the 5D MKII, I'm crouching low, trying to get an angle on a girl with a deep red shawl and a winning smile. I really want to make a picture here; I need more of the faces of Bolivia to balance the elemental landscapes in my trip portfolio so far. I like to return from an adventure with a photo essay of around 10–15 pictures that complement each other – and a comprehensive collection of landscapes, portraits, details and reportage gives me a warm glow of satisfaction that lasts for years.

She's hiding her face. I wait, wide open at f/1.2, finger poised with shutter release half depressed to lock focus. She looks up for just a second before dissolving in another fit of giggles and that's my moment. The pleasing out-of-focus effects of vegetation and the background contribute to the image, as do the props of her loom and the rich colours, but the picture is made by her fleeting eye contact.

A few stony looks from the adults tell me my time is up. There has been a general flow of goodwill and bemused amusement in my direction but I've now exhausted it and the last thing I want to do is antagonize. But is has been fun.

AFTER I agonize whether to crop the image to lose the strong diagonal in the top left corner. In the end I decide not to, as too much is lost. But I'm still not sure. Maybe I need to live with this picture for a while.

BOLIVIA 4/10 –
SALAR DE UYUNI

BEFORE We spent days putting together the logistics for this trip. Sometimes it feels like the actual photography is a tiny part of the game – just being here is an achievement. The trick is to put a flexible plan in place that will dump us in the right place long enough for us to do our stuff. Our journey from Lake Titicaca started on a donkey, continued by boat, foot, bus and now a dusty 4x4 laden with spare wheels. We have Coco behind the wheel and Oswaldo guiding, I have a nueve sombrero and we're officially getting excited as we leave the tarmac far behind. As we pass remote, basic, adobe dwellings I'm wondering at the harsh life for the campesinos on the arid altiplano. In an immense meteorite crater at Maragua we come across a woman and child minding a herd of llamas in a scene unchanged for centuries. We're hoping to reach the Salar de Uyuni for evening light, but a refuelling pit stop in a tiny village reveals we've got a puncture, the first of many, and so Coco gets down and dusty with the jack. Will we make it in time for sunset? Who knows.

DURING We arrive at the Salar de Unuyi just in time as the sun is setting. It's a surreal experience driving across an endless white surface with no reference points but the distant volcanoes on the horizon. I've got no time to location search; I just have to make a snap decision on how to use the beautiful light in this elemental setting right now. It's a landscape that is unique for its complete minimalism. There are no features to latch on to – it's a huge, marble-white nothingness. So how do I express this photographically? I can't fight it; the absence becomes the allure.

To the north rises the shapely Volcán Tunupa. I ask Coco to drive across the salt pan until we are directly to the south and the volcano is side.lit by the last rays of the day. The light is gorgeous with not a trace of haze and the hexagonal patterning of the salt pan is catching glowing gold – it's stupendous. But I must do the job now, as the light will be gone in minutes. There's no time for gawping or contemplation; we've travelled a long way for this moment. The 15mm fisheye lens warps the horizon – it's a picture relying on the tried-and-tested formula of strong shapes, simple composition and sumptuous light. With nothing on the western horizon to block the sun I can use the warm rays to the bitter end. I'm rapidly getting hooked on the quality of the light here in Bolivia. This is magical.

AFTER I continue shooting as the twilight glows through the sky. As darkness falls we drive on to Tahua; a lodge made of salt is our abode tonight.

The Salar de Uyuni at dusk
Bolivia
Canon EOS-1Ds MKIII, 15mm lens, ISO 100, 1/30sec at f/10

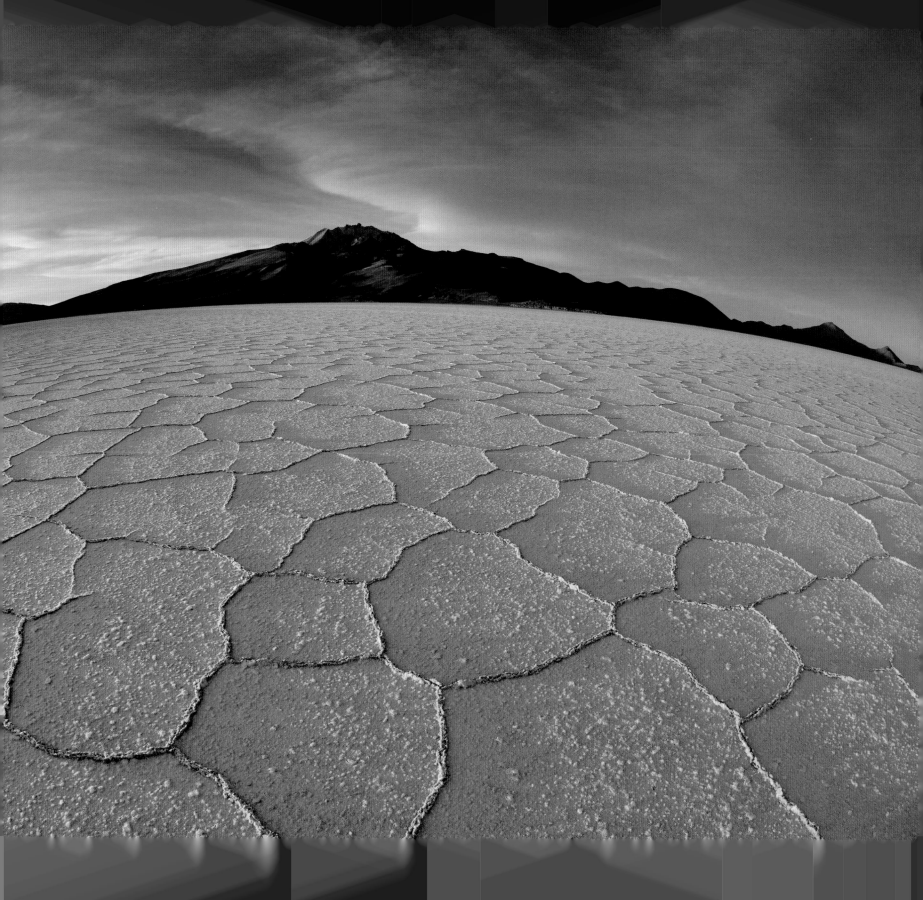

Far From the Madding Crowd

We're dusty and crusty, running short of memory, in desperate need of a laundry, and buzzing with the pull of South America. Lagunas, flamingos, volcanos, flat tyres, salt pans, llamas, deserts, thin air … and Boney M. On the first day in the 4x4, Coco and Oswaldo, our driver and guide, interpreted our wry exclamations as enthusiasm for this particular genre of '70s fluff and turned the volume up, and so we lurched down the boulder-strewn tracks towards the Salar de Unuyi to the strains of Daddy, Daddy Cool. Well I guess these trips are all about challenges.

A few months ago, sitting in the evening with the ice clinking in my glass of Edradour (it's the only way to do trip research), I read about this remote south western corner of Bolivia bordering Chile and Argentina, saw a few pictures on the Internet, and just knew we had to come. It is a long, tortuous journey from Milborne Port to the Reserva Eduardo Avaroa via Heathrow, Miami and La Paz, with an interlude on Lake Titicaca. What with the challenges of altitude, the complete absence of recognizable roads, Ra Ra Rasputin and hostile terrain, just getting here was difficult.

To the Canadian couple we came across in the badlands of twisted rock formations and huge volcanos somewhere between San Pedro de Quemez and Ojo de Perdiz, in a campervan with no 4WD, dwindling fuel reserves, knackered suspension and only a hazy idea of where they were; did you make it? There is a fine line between adventure and madness. Local knowledge is everything on these epics, hence Coco and Oswaldo. Three flat tyres changed and repaired in one fairly typical day in the dust and blistering high-altitude sun; I reckon they outdo the Ferrari pit crew. And their ability to navigate the bewildering criss-crossing of indeterminate tracks in the desert means we'll happily endure Boney M.

So after scrambled huevos at 3am and a 90-minute drive through the desert night, this time accompanied by an ersatz cover of Tie a Yellow Ribbon, we arrived at Laguna Colorado just as the twilight was seeping through the sky from the east. What a sight – flocks of flamingos on the steaming laguna, backed by the classic shape of a not-so-long-ago active volcano. This continent beguiled me long ago as a young deck cadet on the MV 'Port Alfred', back when Boney M were in the charts. It still does.

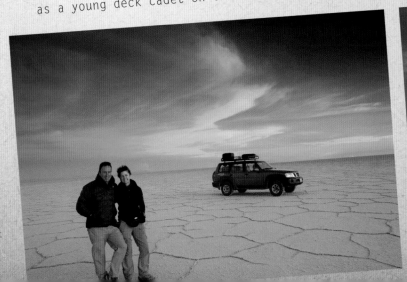

Laguna Colorada
Eduardo Avaroa Andean Fauna National Reserve, Bolivia
Canon EOS-1Ds MKIII, 24–70mm lens, ISO 100, 1/125sec at f/6.3

BOLIVIA 5/10 – PRIMARY COLOUR

BEFORE Wendy's having a moment with her camera. Immersed as I am with my flamingo photography, I can't really divert to spend precious minutes scrolling through menus. It's times like these you long for simplicity in camera design. I lend her my 5D MKII with 100–400mm lens and off she goes to create. She has a unique eye for colour, shape and texture and it shows in her pictures. It just serves to illustrate the importance of perceptive vision over all else. She sticks with her Canon G9 compact because of its portability – she is never without it and consequently her photography has progressed in leaps and bounds.

DURING Up high in the bright crystal-clear light of day we can see how the lake got its name. I make a picture with the bold primary colours of the blue, polarized, high-altitude sky streaked with cloud against the bright red of the water, slashed with the white of the sand spits. Of course there's the inevitable volcano in the frame; they're never far away in the Andes. All morning from dawn until now we have had this elemental landscape to ourselves. It has been a very special time.

AFTER Onwards and upwards; over a pass the altimeter in my watch tells me is 4900m high. We've sorted Wendy's problem, it was a locked memory card. Why do these niggles always occur at the worst times? Familiarity of equipment is crucial.

We're heading north again. At the park entrance a young backpacking couple plead for a lift to Uyuni; their driver has run out of fuel. We're full to capacity and headed in a different direction, but it doesn't stop us feeling guilty about leaving them. Another Landcruiser stops and out spill eight backpackers, including a lad who looks like death warmed up from severe altitude sickness. We press on.

The long days of arduous travel are taking their toll – we're all completely exhausted and three punctures that afternoon haven't helped. The latest means our last spare is now in use as we tiptoe the last few kilometres to Villa Mar. Another night in an empty hostel lies ahead. I wonder what's for dinner tonight. I really fancy some dry meat with rice and potatoes. Ah well, we didn't come for the nightlife.

BOLIVIA 6/10 –
LAGUNA COLORADA

BEFORE Ojo de Perdiz is a hostel far from anywhere at the end of a very long, vague dirt track; an outpost of Bolivia near the frontier with Chile at 4500m, ringed by volcanoes, windy, dusty and freezing. I'm chatting to the manager, an Argentinean with a young family, and reflecting on their life in such a remote, bleak spot. He faces a monthly 12-hour journey one way to Uyuni for supplies; it must be like being posted to the moon.

We have another top night ahead; the Big Event of two hours of electricity is followed by the usual overcooked meat and vegetables boiled to oblivion, accompanied by water. Nurse Wendy rules that no alcohol is allowed at this altitude. We'll be in bed by 8.30pm and waking up in the night short of breath. But adventures don't come without a few hardships, and tomorrow we're headed for what could be one of the highlights of the trip.

DURING We're hopping around, trying to get into our thermal underwear by torchlight at 3.30am. Incredibly the lady of the house is up to serve us breakfast by candlelight; I can't imagine that in a Keswick B&B. Then we're underway, lurching through the rock formations beneath a night sky laden with stars, headed for Laguna Colorada. I'm excited but uneasy. From the pictures I've seen it looks a stunning location, but I'm approaching blind with no idea where the best vantage points are. With the faint glow of dawn tingeing the eastern sky I'm not going to have time to scout about. I'll just have to surrender my destiny to fate this morning.

Our timing is perfect, thanks to Oswaldo and Coco. They sure are earning their Bolivanos – they've been real stars, completely reliable and trustworthy. Employing guides is always a risk; horror stories abound and you never know quite what you're going to get. Generally we prefer to be totally self-sufficient but local knowledge is a must in places like this.

We approach from the north; the ground drops away and there beneath lies the Laguna in the cool twilight, peppered with the distinctive shapes of flamingos and the imposing bulk of a perfectly shaped volcano beyond. All the long days of travel have been worth it.

Out of the car and immediately I'm battling with the tripod legs. The twilight colour is spreading through the sky via the swirled clouds, which reflect in the shallow waters. I manoeuvre to get the best positioning of the flamingos in relation to the volcano. Again, by default, I opt for a simple, bold composition using the strong shapes. The 70–200mm lens is at 120mm and a 0.6ND grad filter balances the difference in contrast between the sky and the reflections. An exposure of 1/8sec is OK, I wouldn't want anything longer as the distinctive shapes of the flamingos and their reflections make the picture.

AFTER I just couldn't pull myself away and ended up with memory cards full of pink feathers on legs. Well, we don't see many flamingos in Somerset.

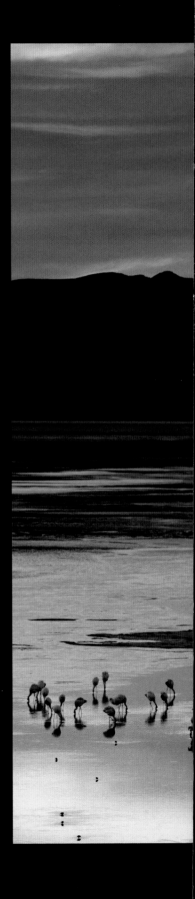

**Flamingos on Laguna
Colorada at dawn**
*Eduardo Avaroa Andean Fauna
National Reserve, Bolivia
Canon EOS-1Ds MKIII,
70–200mm lens, 0.6ND grad
filter, ISO 100, 1/8sec at f/8*

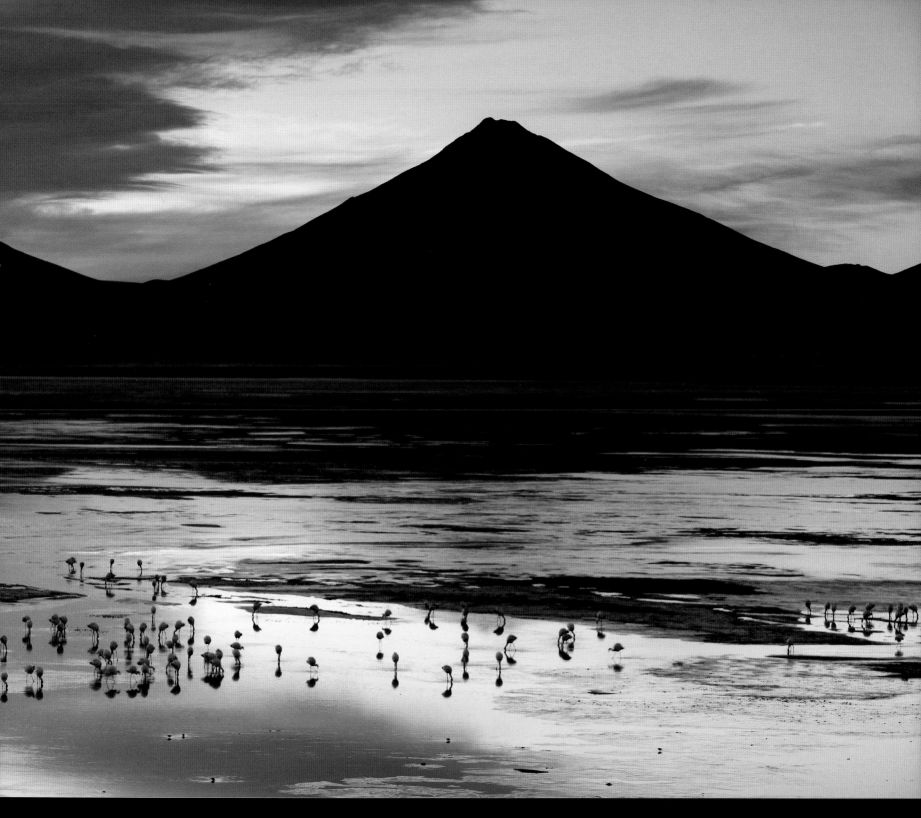

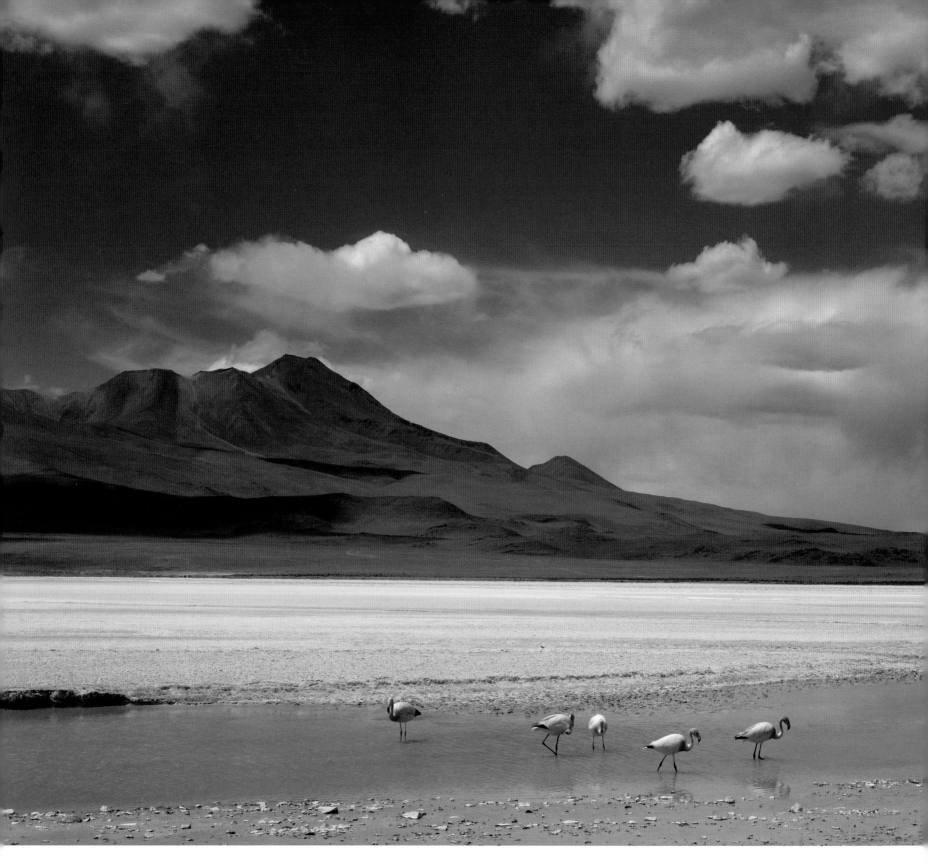

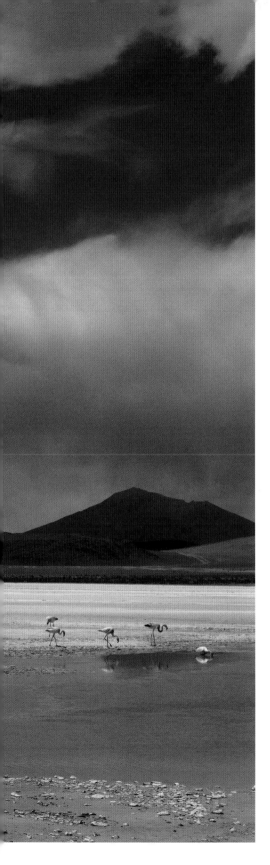

BOLIVIA 7/10 – ANDEAN ADVENTURES

BEFORE I can hear the air passing through the feathers of the condors above. They've been circling, keeping an eye on me as I squint through the eyepiece. Do I look like carrion? Are they contemplating the possibility of lunch? They are a symbol of this wild and wonderful continent and I'll not begrudge them their interest.

We are somewhere near the Salar de Chiguana in the wild and barren region en route from San Pedro de Quemez, I think. I have nothing but Oswaldo's word for that of course; there are no signposts, roads or Little Chefs here, just big volcanic peaks dominating a landscape of weird, twisted rock formations. The volcanoes are streaked with the reds and greens of oxides, the deep blue, high-altitude skies are flecked with cloud and completely devoid of any haze, and lagunas are fringed with streaks of chemical colour and populated by pink flamingos.

DURING Somehow the clarity of the light and the reflective white of the expansive salty shores make shooting at midday an option. I'm struggling to work out exactly why; it's in contravention of all I've ever preached. The light is harsh and practically vertical, but I can't deny the stark, desolate beauty of the elemental landscape in this light. These adventures just keep forcing me to question my perceived wisdoms.

I yank the salt-encrusted Lowepro out from in among the jumble of gear in the back. These trips are hard on equipment; cameras and lenses get banged about and coated in dust just like us and everything else we own. It's one of the reasons why I use professional specification gear rather than the cheaper offerings from independent manufacturers; the build quality is just so much more rugged. Photographic gear shouldn't have a cushioned life – being shaken and stirred in the high Andes is what it's for.

As I shoot the picture the strains of Bonnie Tyler waft from the car – Coco's playing his '80s power ballads again. The condors seem unimpressed with A Total Eclipse of the Heart and soar away.

AFTER The photography here has just been pure and simple fun. The clarity of the light at this altitude is startling and the land is harsh and beautiful. The full arsenal of lenses is in daily use, everything from 14 to 400mm. I'm chopping and changing between my 1Ds MKIII and 5D MKII bodies. With the latter we've been shooting video clips along the way; a good excuse for extravagant hand gestures in front of epic Andean vistas. And Wendy has been continuing to show just what is possible with a perceptive eye and a humble compact camera. She is adamant she saw a couple of UFOs in the sparkling night sky over the Salar de Unuyi the other night. Good stuff Bolivian wine, not that we can partake much at this height.

More flamingos
Near the Salar de Chiguana, Bolivia
Canon EOS 5D MKII, 24–70mm lens, ISO 100, 1/200sec at f/14

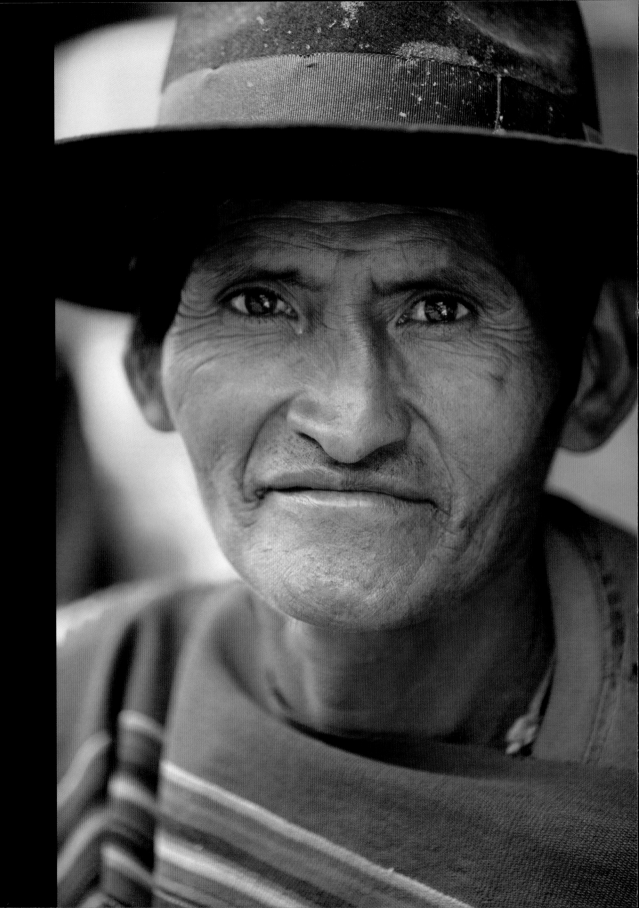

BOLIVIA 8/10 –
TARABUCO MARKET

BEFORE We're now at the stage of the trip when we're starting to fantasize about bacon sandwiches and our own bathroom. Brushing your teeth with bottled water is a novelty that soon wears off. But before the long journey home we've got the last leg of our trip in the countryside around Sucre, shooting Village People – the Boney M phase is over.

The market at Tarabuco is proving to be a rich hunting ground. Despite the fact that it's very much on the tourist map we seem to be the object of much bemused curiosity. Perhaps it's the big white lens – the 70–200mm with the lens hood on is imposing. Whatever, the curiosity is working in our favour and the variety of the twisted and gnarled faces of Bolivia on display this morning in amongst the stalls beats our local supermarket hands down. Wendy's expressing interest in all sorts of stuff we don't need just to aid the picture-making process, and I'm on a roll. Numerous crusty peasants have been shot; I just love it when these situations develop, I wish I could make them happen to order, but I can't.

I may have a long lens on but that's because the perspective for tight head shots of a focal length around 135mm is perfect, not because I'm wary of getting too close. Once I get in the zone like this it's great fun requesting pictures one after another – acceptances exhilarate, rejections are forgotten.

DURING The light in amongst the narrow alleys and stalls is tricky; harsh sunlight beams down vertically, plunging faces under wide-brimmed hats into dark shadow. Sheets of coloured plastic hanging over the stalls to give shade cast a pall of colour on anything beneath. My only option is to shoot in the open shade, ensuring nothing too bright is in the background. It's a tall order as people are milling about and jostling, but this is the challenge of travel photography.

A man with warm eyes and crooked nose gazes happily into my lens. His hat, face and poncho immediately locate the setting. As usual, I'm wide open at f/2.8 so the background is attractively blurred. The camera's White Balance is still set to Daylight; with all the different coloured light bouncing around I could consider activating Auto WB, but I don't, despite the fact that a tarpaulin overhead sheds a blue cast across the scene. I prefer to tweak colour balance at the RAW conversion stage; I've got far more control that way.

AFTER In post-production I dial in a dash of warmth to negate some of the blue, but opt to retain some. Why? I can't tell you. The cool cast was part of the atmosphere and there are no rules; who says flesh tones have to be neutral?

A local man in the market
Tarabuco, Bolivia
Canon EOS 5D MKII, 70–200mm lens, ISO 500,
1/250sec at f/2.8

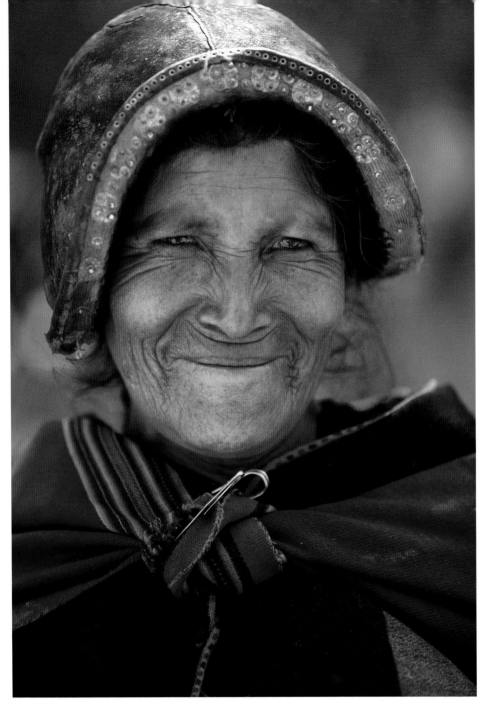

A local woman in the market
Tarabuco, Bolivia
Canon EOS 5D MKII,
70–200mm lens, ISO 500,
1/1600sec at f/2.8

BOLIVIA 9/10 – THAT HAPPY STATE OF EQUANIMITY

BEFORE It's the last day of the trip. This afternoon we start the long journey back. It has been a real adventure and I'm confident some reasonable pictures have been nailed. This, in many ways, is the most satisfying stage of a trip; contentment at what's been achieved permeates my soul and any last-minute pictures are a bonus. For a few weeks, that happy state of equanimity will remain until I gradually start to champ at the bit again. Too much time bogged down in reality in front of the computer will start me questioning whether I'm an ex-photographer living on past glories and the need to get out in the field behind the lens again will build to breaking point. And so the cycle that has dominated my professional life continues. There's a certain comfort in its predictability.

DURING Every day for the last month I've had the camera in my hands. Photography, like any activity, thrives on practise, and with daily use basic camera craft becomes second nature. This picture came together in seconds; there was no fiddling with aperture, exposure and focus while the subject lost the will to live. The strong shapes of her hat, shawl, nose and eyes are all in harmony and there's nothing in the frame to confuse or distract. Decisions about composition in an impromptu picture like this are made mostly instinctively; it has to be so. There's no time for agonizing over the rule of thirds, her wistful smile will have long been replaced with weary exasperation. And by the way, her strange hat, which seems de rigueur here, is an echo from history. It mimics the shape of the helmets of the Conquistadores who colonized the Andes for Spain in the 15th century.

AFTER The composition of this picture doesn't conform exactly to the rule of thirds. I've heard of camera club judges who measure to the millimetre to determine adherence to the Golden Rule, but in the end it's just a guide. If her nose and eyes were dead central this picture would be very different. Sometimes deliberately doing that can work, but this time I've offset them slightly. For me, these fleeting decisions are intuitive.

BOLIVIA 10/10 – FLEETING INSPIRATION

BEFORE The taxi is waiting to whisk us to the airport; one more bite of the cherry here in the market at Tarabuco?

DURING A fearsome man in a Conquistador hat eyes me suspiciously. Sunlight is bouncing off the adobe wall opposite, lighting his face diffusely as he's standing in the shade against a white wall. With the 85mm f/1.2 lens, I crouch slightly, instinct has taken over. I'm breaking all the rules here, I'm too close to give the best portrait perspective, his shoulders are square to the camera, the composition is central and I'm looking up at him. Yet this works, it's a slightly unsettling picture but it gets the attention.

AFTER Time to go; the last trip for Full Frame is over. Bolivia has been an adventure – I'll pass on the cuisine but the time spent high on the altiplano was breathlessly exhilarating. Am I pleased with the pictures? I'm not sure, there's always room for improvement and that's what these ten Full Frame trips have all been about. I do know that looking at this picture of our jolly friend in Tarabuco market now makes me realize how far my photography has come since just ten years ago. I can't remember any of the mental processes that produced this image; a momentary opportunity was capitalized on with fleeting inspiration and instinct. And now flicking through the pictures from Laos, South Africa, Umbria and all the rest convinces me that all this talk of comfort zones and challenges isn't just hot air.

No matter how serious you are about photography, be it just holiday snaps or a professional calling, we photographers can only continue to improve if we keep pushing ourselves. In our busy lives, finding the time for photography projects in between all the clutter of commitments isn't easy but specific projects drive forward photographic development, and the more demanding the project the better. Ultimately, pushing beyond the limits of our photographic experiences is just plain fun, and fun is what photography should be about. The flexibility we have at our fingertips with the latest cameras, lenses and software is incredible. In the right hands that translates into better pictures, images we just couldn't have made in the film era. Concentrating on quality over quantity is the key; knowing how to enjoy our triumphs and learn from the mistakes helps. The ideas and inspirations that are the lifeblood of our creativity need nurturing.

I don't think anyone believes me, but it's true: after over 25 years as a pro I feel as if I'm just starting to scratch the surface of what's possible in photography. I'm devastated that these ten Full Frame shoots are over; they've been pure photographic joy. I'll just have to concoct an excuse for some more.

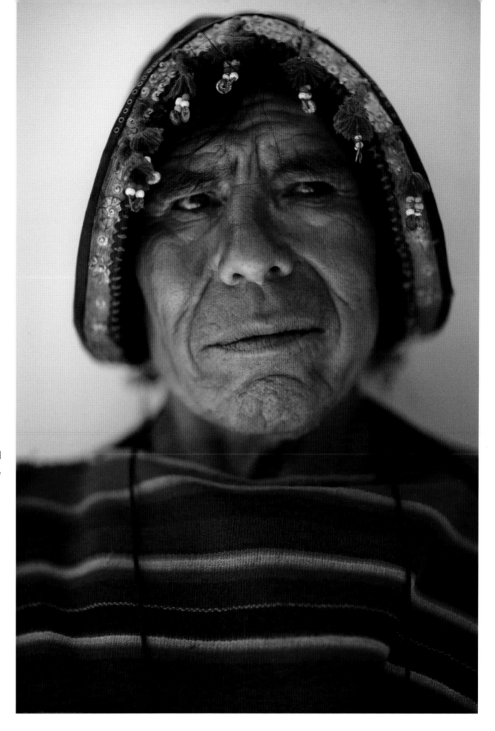

A local man in the market
Tarabuco, Bolivia
Canon EOS 5D MKII, 85mm lens, ISO 200, 1/3200sec at f/1.2

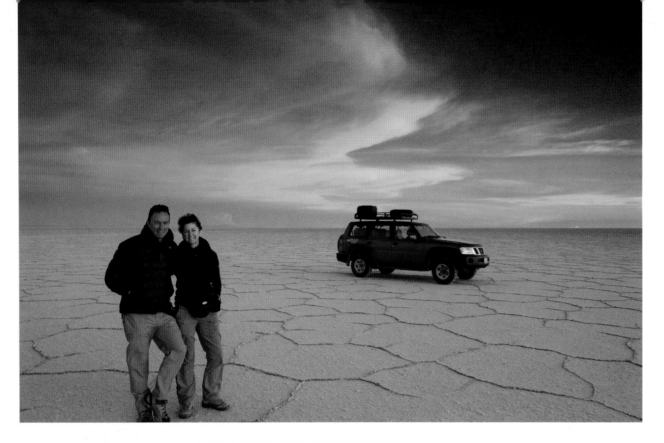

ACKNOWLEDGEMENTS

It's been a long long time since I was a one-man band. If I didn't have such a highly talented and committed bunch of professionals working behind the scenes I couldn't possibly do what I do. I know without a shadow of doubt they are the best in the photographic business, so I'd like to profusely thank the *Chasing the Light Crew*:

Sharyn Meeks: our Rock of Stability, who holds the fort whilst we're swanning around on the Altiplano. I have no idea how we ever managed without her.

Mike Mould: a Man of Many Talents; videographer, producer, technical guru and website developer. He's even starting to get used to the dawn rises.

Kerry Banner: our PR Guru, who's unflagging enthusiasm just keeps us moving forward relentlessly. She knows the business better then any, and has an extremely impressive collection of scarves.

Matt Hunt: officially the Most Useful Bloke to Know in the world. He sorts out all our never ending IT issues, and is a sound man with a big fluffy microphone to boot.

Jon Gooding: colleague, fellow photographer and friend who helps with the workshops and the red wine.

And of course, my wife Wendy, the love of my life, who's influence permeates everything: my pictures, our travels and writing, not to mention the never ending office work, Road Shows, workshops... She is the solitary figure treading boldly in many a vista, and has put up with all of my photographer's foibles and puerile jokes on long dusty drives for several decades now— a feat of truly remarkable endurance.

The gang at David & Charles are a joy to work with, in particular Neil Baber, Sarah Callard, Ame Verso and Jodie Lystor.

ABOUT THE AUTHOR

David Noton is one of the world's most renowned landscape and travel photographers with over 24 years experience. Born in Bedfordshire in 1957, David took his first photographs on a Kodak Instamatic he was given for his 13th birthday. He now runs his own highly successful freelance photography company, based in Sherborne, Dorset.

For many years David worked for the UK's National Trust on countless commissions and he co-authored the NT publication Coast. He is the author of the extremely successful and critically-acclaimed book, *Waiting for the Light*, which was also published by David and Charles. The book was launched at an accompanying exhibition which attracted over 27,000 visitors.

David's pictures are now published all over the world and he writes widely for a range photographic magazines and websites. David also runs regular talks and workshops across the UK and abroad.

Index